PAINTING AND EXPERIENCE IN
FIFTEENTH CE

P9-ELO-875

Michael Baxandall is Professor of the History of the Classical Tradition at the Warburg Institute, University of London. His publications include *Giotto and the Orators*, *Limewood Sculptors of Renaissance Germany*, and *Patterns of Intention*.

PAINTING AND EXPERIENCE IN FIFTEENTH CENTURY ITALY

A primer in the social history of pictorial style

SECOND EDITION

Michael Baxandall

Oxford New York

OXFORD UNIVERSITY PRESS

Oxford University Press, Walton Street, Oxford OX2 6DP
Oxford New York
Athens Auckland Bangkok Bombay
Calcutta Cape Town Dar es Salaam Delhi
Florence Hong Kong Istanbul Karachi
Kuala Lumpur Madras Madrid Melbourne
Mexico City Nairobi Paris Singapore
Taipei Tokyo Toronto

and associated companies in
Berlin Ibadan

Oxford is a trade mark of Oxford University Press

First published 1972
First issued as an Oxford University Press paperback 1974
Second Edition 1988

British Library Cataloguing in Publication Data
Data available

Library of Congress Cataloging in Publication Data
Baxandall, Michael.
Painting and experience in fifteenth century Italy: a primer in
the social history of pictorial style/Michael Baxandall.—2nd
ed. p. cm. Bibliography: p. Includes index.
1. Painting, Italian. 2. Painting—Renaissance—Italy. 3. Art patronage—Italy.
4. Art and society—Italy. 5. Artists and patrons—Italy. 6. Italy—Civilization—
1268–1559. 7. Renaissance—Italy. I. Title.
ND615.B32 1988 795.5—dc19
ISBN 0-19-282144-X (pbk.)

13 15 17 19 20 18 16 14 12

Printed in Hong Kong

Preface to the Second Edition

THE main change in this edition is that the original Italian or Latin of passages previously given only in English translation has been included under Texts and References. Such errors as I am aware of have been corrected, and among those to whom I am grateful for pointing out errors are Maria Pia and Piergiorgio Dragone, the translators and editors of the augmented Italian edition (Einaudi, Turin, 1978), who scrutinised references and transcriptions; Michael Bury, who spotted a bad reading in the Italian of Giovanni Santi's poem; Martin Kemp, who objected to there being turkeys—as opposed to guinea-fowl—in Mantua well before the discovery of America; John White, who noted that the top of Niccolò da Tolentino's hat in Plate 49 is properly read as rectangular rather than polygonal; and Richard Wollheim, who found no ultramarine where I had in the old Plate 4, which is now replaced. In a few cases I have updated bibliographical references.

Preface to the First Edition

THIS essay grew out of some lectures given in the history school of the University of London. The lectures were meant to show how the *style* of pictures is a proper material of social history. Social facts, I argued, lead to the development of distinctive visual skills and habits: and these visual skills and habits become identifiable elements in the painter's style. With some complications the same argument underlies this book. It is therefore addressed to people with a general historical curiosity about the Renaissance rather than to people interested just in Renaissance painting, who might well find it insensitive and flighty by turns. This is not a way of saying I think it vacuous as art history.

The first chapter looks at the structure of the fifteenth-century picture trade—through contracts, letters and accounts—to find an economic basis for the cult of pictorial skill. The second chapter explains how the visual skills evolved in the daily life of a society become a determining part in the painter's style, and it finds examples of these vernacular visual skills uniting the pictures and the social, religious and commercial life of the time. This involves relating the style of painting to experience of such activities as preaching, dancing and gauging barrels. The third chapter assembles a basic fifteenth-century equipment for looking at fifteenth-century pictures: it examines and illustrates sixteen concepts used by the best lay critic of painting in the period, Cristoforo Landino, in his description of Masaccio, Filippo Lippi, Andrea del Castagno and Fra Angelico. The book ends by pointing out that social history and art history are continuous, each offering necessary insights into the other.

Acknowledgements

I am indebted to Dr. Jennifer Montagu for much help in obtaining photographs for this book. Acknowledgements are due to the collections by whose permission the objects illustrated are reproduced and to the following sources of photographs: Staatliche Museen, Berlin (6, 7); Alinari, Florence (2, 3, 5, 9, 10, 11, 21, 22, 24(a), 24(d), 25, 31, 35, 36, 37, 43, 45, 48, 64, 65, 71, 75, 78, 81); Foto Scala, Florence (I, II, III, IV); Soprintendenza alle Gallerie, Florence (29, 46, 68); Studio Gérondal, Lille (76); Courtauld Institute of Art, London (54, 67, 77, 79); National Gallery, London (4, 20, 27, 40, 49, 51); Warburg Institute, London (1, 8, 13, 14, 15, 17, 18, 19, 23, 24(c), 32, 33, 39, 44, 47, 52, 53, 55, 56, 57, 58, 59, 60, 63, 69, 70, 72, 73); Alte Pinakothek, Munich (12, 50); Metropolitan Museum of Art, New York (30); Bibliothèque Nationale, Paris (42); Service de Documentation Photographique, Musées Nationaux, Paris (26, 34, 61, 74); Gabinetto Fotografico Nazionale, Rome (62); Museum Boymansvan Beuningen, Rotterdam (28, 41); National Gallery of Art, Washington (24(b), 38, 80).

Contents

I. CONDITIONS OF TRADE

 1. Introduction 1

 2. Contracts and the client's control 3

 3. Art and matter 14

 4. The value of skill 17

 5. Perception of skill 23

II. THE PERIOD EYE

 1. Relative perception 29

 2. Pictures and knowledge 32

 3. The cognitive style 36

 4. The function of images 40

 5. *Istoria* 45

 6. The body and its language 56

 7. Figure patterns 71

 8. The value of colours 81

 9. Volumes 86

 10. Intervals and proportions 94

 11. The moral eye 103

III. PICTURES AND CATEGORIES

 1. Words and pictures 109

 2. Giovanni Santi's twenty-five painters 111

 3. Cristoforo Landino 115

 4. Categories 118

 (a) nature 119

 (b) relief 121

 (c) purity 122

(d) ease 123
(e) perspective 124
(f) grace 128
(g) ornateness 131
(h) variety 133
(i) composition 135
(j) colouring 137
(k) design 139
(l) difficulty 141
(m) foreshortening 143
(n) promptness 145
(o) blitheness 147
(p) devotion 148

5. Conclusion 151

TEXTS AND REFERENCES 155

INDEX 181

I. Conditions of trade

1. A FIFTEENTH-CENTURY painting is the deposit of a social relationship. On one side there was a painter who made the picture, or at least supervised its making. On the other side there was somebody else who asked him to make it, provided funds for him to make it and, after he had made it, reckoned on using it in some way or other. Both parties worked within institutions and conventions—commercial, religious, perceptual, in the widest sense social—that were different from ours and influenced the forms of what they together made.

The man who asked for, paid for, and found a use for the painting might be called the *patron*, except that this is a term that carries many overtones from other and rather different situations. This second party is an active, determining and not necessarily benevolent agent in the transaction of which the painting is the result: we can fairly call him a *client*. The better sort of fifteenth-century painting was made on a bespoke basis, the client asking for a manufacture after his own specifications. Ready-made pictures were limited to such things as run-of-the-mill Madonnas and marriage chests painted by the less sought after artists in slack periods; the altar-pieces and frescoes that most interest us were done to order, and the client and the artist commonly entered into a legal agreement in which the latter committed himself to delivering what the former, with a greater or lesser amount of detail, had laid down.

The client paid for the work, then as now, but he allotted his funds in a fifteenth-century way and this could affect the character of the paintings. The relationship of which the painting is the deposit was among other things a commercial relationship, and some of the economic practices of the period are quite concretely embodied in the paintings. Money is very important in the history of art. It acts on painting not only in the matter of a client being willing to spend money on a work, but in the details of how he hands it over. A client like Borso d'Este, the Duke of Ferrara, who makes a point of paying for his paintings by the square foot—for the frescoes in the Palazzo Schifanoia Borso's rate was ten Bolognese *lire* for the square *pede*—will tend to get a different

sort of painting from a commercially more refined man like the Florentine merchant Giovanni de' Bardi who pays the painter for his materials and his time. Fifteenth-century modes of costing manufactures, and fifteenth-century differential payments of masters and journeymen, are both deeply involved in the style of the paintings as we see them now: paintings are among other things fossils of economic life.

And again, pictures were designed for the client's use. It is not very profitable to speculate about individual clients' motives in commissioning pictures: each man's motives are mixed and the mixture is a little different in each case. One active employer of painters, the Florentine merchant Giovanni Rucellai, noted he had in his house works by Domenico Veneziano, Filippo Lippi, Verrocchio, Pollaiuolo, Andrea del Castagno and Paolo Uccello —along with those of a number of goldsmiths and sculptors—'the best masters there have been for a long time not only in Florence but in Italy.' His satisfaction about personally owning what is good is obvious. Elsewhere, speaking now more of his very large expenditure on building and decorating churches and houses, Rucellai suggests three more motives: these things give him 'the greatest contentment and the greatest pleasure because they serve the glory of God, the honour of the city, and the commemoration of myself.' In varying degrees these must have been powerful motives in many painting commissions; an altarpiece in a church or a fresco cycle in a chapel certainly served all three. And then Rucellai introduces a fifth motive: buying such things is an outlet for the pleasure and virtue of spending money well, a pleasure greater than the admittedly substantial one of making money. It is a less whimsical remark than it seems at first. For a conspicuously wealthy man, particularly someone like Rucellai who had made money by charging interest, by usury indeed, spending money on such public amenities as churches and works of art was a necessary virtue and pleasure, an expected repayment to society, something between a charitable donation and the payment of taxes or church dues. As such gestures went, one is bound to say, a painting had the advantage of being both noticeable and cheap: bells, marble paving, brocade hangings or other such gifts to a church were more expensive. Finally, there is a sixth motive which Rucellai—a man whose descriptions of things and whose record as a builder are not those of a visually insensitive person—does not mention but which one is ready to attribute to him, an element of enjoyment in looking at good paintings; in another context he might not have been shy of speaking about this.

2

The pleasure of possession, an active piety, civic consciousness of one or another kind, self-commemoration and perhaps self-advertisement, the rich man's necessary virtue and pleasure of reparation, a taste for pictures: in fact, the client need not analyse his own motives much because he generally worked through institutional forms—the altarpiece, the frescoed family chapel, the Madonna in the bedroom, the cultured wall-furniture in the study—which implicitly rationalized his motives for him, usually in quite flattering ways, and also went far towards briefing the painter on what was needed. And anyway for our purpose it is usually enough to know the obvious, that the primary use of the picture was for looking at: they were designed for the client and people he esteemed to look at, with a view to receiving pleasing and memorable and even profitable stimulations.

These are all points this book will return to. For the moment, the one general point to be insisted on is that in the fifteenth century painting was still too important to be left to the painters. The picture trade was a quite different thing from that in our own late romantic condition, in which painters paint what they think best and then look round for a buyer. We buy our pictures ready-made now; this need not be a matter of our having more respect for the artist's individual talent than fifteenth-century people like Giovanni Rucellai did, so much as of our living in a different sort of commercial society. The pattern of the picture trade tends to assimilate itself to that of more substantial manufactures: post-romantic is also post-Industrial Revolution, and most of us now buy our furniture ready-made too. The fifteenth century was a period of bespoke painting, however, and this book is about the customer's participation in it.

2. In 1457 Filippo Lippi painted a triptych for Giovanni di Cosimo de' Medici; it was intended as a gift to King Alfonso V of Naples, a minor ploy in Medici diplomacy. Filippo Lippi worked in Florence, Giovanni was sometimes out of the city, and Filippo tried to keep in touch by letter:

I have done what you told me on the painting, and applied myself scrupulously to each thing. The figure of St. Michael is now so near finishing that, since his armour is to be of silver and gold and his other garments too, I have been to see Bartolomeo Martelli: he said he would speak with Francesco Cantansanti about the gold and what you want, and that I should do exactly what you wish. And he chided me, making out that I have wronged you.

Now, Giovanni, I am altogether your servant here, and shall be so in deed. I have had fourteen florins from you, and I wrote to you that my expenses would come to thirty florins, and it comes to that much because the picture is rich in its ornament. I beg you to arrange with Martelli to be your agent in this work, and if I need something to speed the work along, I may go to him and it will be seen to. . . .

If you agree . . . to give me sixty florins to include materials, gold, gilding and painting, with Bartolomeo acting as I suggest, I will for my part, so as to cause you less trouble, have the picture finished completely by 20 August, with Bartolomeo as my guarantor . . . And to keep you informed, I send a drawing of how the triptych is made of wood, and with its height and breadth. Out of friendship to you I do not want to take more than the labour costs of 100 florins for this: I ask no more. I beg you to reply, because I am languishing here and want to leave Florence when I am finished. If I have presumed too much in writing to you, forgive me. I shall always do what you want in every respect, great and small.

<div style="text-align: right">

Valete. 20 July 1457.
Fra Filippo the painter, in Florence.

</div>

Underneath the letter Filippo Lippi provided a sketch of the triptych as planned (plate 1). Left to right, he sketched a St.

1. Filippo Lippi. *Sketch of an Altarpiece* (1457). Florence, Archivio di Stato (Med. av. Pr., VI, no. 258). Pen.

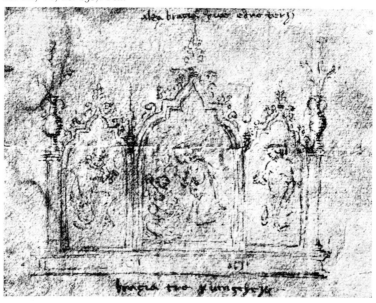

Bernard, an Adoration of the Child, and a St. Michael; the frame of the altarpiece, the point about which he is particularly asking approval, is drawn in a more finished way.

A distinction between 'public' and 'private' does not fit the functions of fifteenth-century painting very well. Private men's commissions often had very public roles, often in public places; an altarpiece or a fresco cycle in the side-chapel of a church is not private in any useful sense. A more relevant distinction is between commissions controlled by large corporate institutions like the offices of cathedral works and commissions from individual men or small groups of people: collective or communal undertakings on the one hand, personal initiatives on the other. The painter was typically, though not invariably, employed and controlled by an individual or small group.

It is important that this should have been so, because it means that he was usually exposed to a fairly direct relationship with a lay client—a private citizen, or the prior of a confraternity or monastery, or a prince, or a prince's officer; even in the most complex cases the painter normally worked for somebody identifiable, who had initiated the work, chosen an artist, had an end in view, and saw the picture through to completion. In this he differed from the sculptor, who often worked for large communal enterprises—as Donatello worked so long for the Wool Guild's administration of the Cathedral works in Florence—where lay control was less personal and probably very much less complete. The painter was more exposed than the sculptor, though in the nature of things clients' day-to-day interference is not usually recorded; Filippo Lippi's letter to Giovanni de' Medici is one of rather few cases where one can clearly sense the weight of the client's hand. But in what areas of the art did the client directly intervene?

There is a class of formal documents recording the bare bones of the relationship from which a painting came, written agreements about the main contractual obligations of each party. Several hundred of these survive, though the greater part refer to paintings that are now lost. Some are full-dress contracts drawn up by a notary, others are less elaborate *ricordi*, memoranda to be held by each side: the latter have less notarial rhetoric but still had some contractual weight. Both tended to the same range of clauses.

There are no completely typical contracts because there was no fixed form, even within one town. One agreement less untypical than many was between the Florentine painter, Domenico

Ghirlandaio, and the Prior of the Spedale degli Innocenti at Florence; it is the contract for the *Adoration of the Magi* (1488) still at the Spedale (plate 2):

> Be it known and manifest to whoever sees or reads this document that, at the request of the reverend Messer Francesco di Giovanni Tesori, presently Prior of the Spedale degli Innocenti at Florence, and of Domenico di Tomaso di Curado [Ghirlandaio], painter, I, Fra Bernardo di Francesco of Florence, Jesuate Brother, have drawn up this document with my own hand as agreement contract and commission for an altar panel to go in the church of the abovesaid Spedale degli Innocenti with the agreements and stipulations stated below, namely:
>
> That this day 23 October 1485 the said Francesco commits and entrusts to the said Domenico the painting of a panel which the said Francesco has had made and has provided; the which panel the said Domenico is to make good, that is, pay for; and he is to colour and paint the said panel all with his own hand in the manner shown in a drawing on paper with those figures and in that manner shown in it, in every particular according to what I, Fra Bernardo, think best; not departing from the manner and composition of the said drawing; and he must colour the panel at his own expense with good colours and with powdered gold on such ornaments as demand it, with any other expense incurred on the same panel, and the blue must be ultramarine of the value about four florins the ounce; and he must have made and delivered complete the said panel within thirty months from today; and he must receive as the price of the panel as here described (made at his, that is, the said Domenico's expense throughout) 115 large florins if it seems to me, the abovesaid Fra Bernardo, that it is worth it; and I can go to whoever I think best for an opinion on its value or workmanship, and if it does not seem to me worth the stated price, he shall receive as much less as I, Fra Bernardo, think right; and he must within the terms of the agreement paint the predella of the said panel as I, Fra Bernardo, think good; and he shall receive payment as follows—the said Messer Francesco must give the abovesaid Domenico three large florins every month, starting from 1 November 1485 and continuing after as is stated, every month three large florins. . . .
>
> And if Domenico has not delivered the panel within the abovesaid period of time, he will be liable to a penalty of fifteen large florins; and correspondingly if Messer Francesco does not keep to the abovesaid monthly payments he will be liable to a penalty of the whole amount, that is, once the panel is finished he will have to pay complete and in full the balance of the sum due.

Both parties sign the agreement.

This contract contains the three main themes of such agreements: (i) it specifies what the painter is to paint, in this case through his commitment to an agreed drawing; (ii) it is explicit

2. Domenico Ghirlandaio. *Adoration of the Magi* (1488). Florence, Spedale degli Innocenti. Panel.

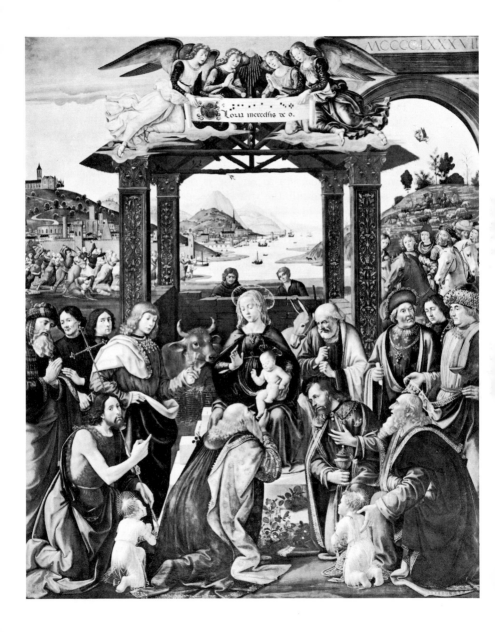

about how and when the client is to pay, and when the painter is to deliver; (iii) it insists on the painter using a good quality of colours, specially gold and ultramarine. Details and exactness varied from contract to contract.

Instructions about the subject of a picture do not often go into great detail. A few contracts enumerate the individual figures to be represented, but the commitment to a drawing is more usual and was clearly more effective: words do not lend themselves to very clear indication of the sorts of figure wanted. The commitment was usually a serious one. Fra Angelico's altarpiece of 1433 for the Linen-maker's Guild at Florence was of this kind (plate 3); in view of the sanctity of his life the matter of price was exceptionally entrusted to his conscience—190 florins or however much less he considers proper—but, saintliness only trusted so far, he is bound not to deviate from his drawing. Around the drawing there would have been discussion between the two sides. In 1469 Pietro Calzetta contracted to paint frescoes in the Gattamelata chapel of S. Antonio at Padua, and the stages by which agreement would be reached are clearly stated in the contract. The donor's representative, Antonfrancesco de' Dotti, is to state the subjects to be painted; Calzetta will agree to these subjects; he will produce a design (*designum cum fantasia seu instoria*) and give it to Antonfrancesco; on the basis of this Antonfrancesco will give further instructions on the painting and finally decide whether the finished product is acceptable. If there was difficulty in describing the sort of finish wanted, this could often be done by reference to another picture: for example, Neri di Bicci of Florence undertook in 1454 to colour and finish an altarpiece in S. Trinita after the same fashion as the altarpiece he had made for a Carlo Benizi in S. Felicità in 1453.

Payment was usually in the form of one inclusive sum paid in instalments, as in Ghirlandaio's case, but sometimes the painter's expenses were distinguished from his labour. A client might provide the costlier pigments and pay the painter for his time and skill: when Filippino Lippi painted the life of St. Thomas in S. Maria sopra Minerva at Rome (1488–93) Cardinal Caraffa gave him 2,000 ducats for his personal part and paid for his assistants and the ultramarine separately. In any case the two headings of expenses and of the painter's labour were the basis for calculating payment: as Neri de Bicci noted, he was paid 'for gold and for applying it and for colours and for my workmanship.' The sum agreed in a contract was not quite inflexible, and

8

3. Fra Angelico. *Tabernacle of the Linen-makers* (1433). Florence, Museo di S. Marco. Panel.

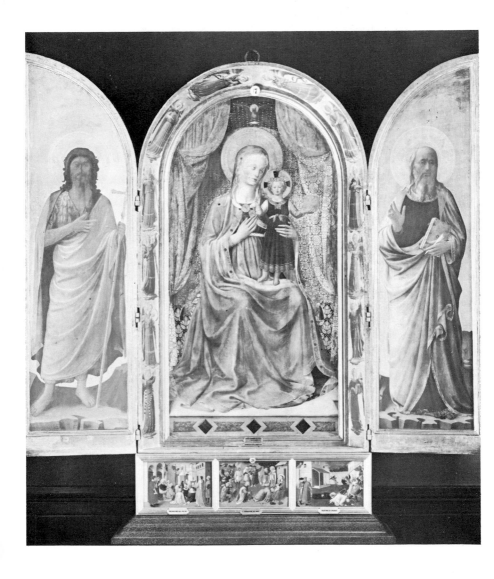

4. Stefano di Giovanni, called Sassetta. *St. Francis Giving his Cloak to a Poor Soldier* (1437/44). London, National Gallery. Panel.

if a painter found himself making a loss on a contract he could usually renegotiate: in the event Ghirlandaio, who had undertaken to provide a predella for the Innocenti altarpiece under the original 115 florins, got a supplementary seven florins for this. If the painter and client could not agree on the final sum, professional painters could act as arbitrators, but usually matters did not come to this point.

Ghirlandaio's contract insists on the painter using a good quality of colours and particularly of ultramarine. The contracts' general anxiety about the quality of blue pigment as well as of gold was reasonable. After gold and silver, ultramarine was the most expensive and difficult colour the painter used. There were cheap and dear grades and there were even cheaper substitutes, generally referred to as German blue. (Ultramarine was made from powdered lapis lazuli expensively imported from the Levant; the powder was soaked several times to draw off the colour and the first yield—a rich violet blue—was the best and most expensive. German blue was just carbonate of copper; it was less splendid in its colour and, much more seriously, unstable in use, particularly in fresco.) To avoid being let down about blues, clients specified ultramarine; more prudent clients stipulated a particular grade—ultramarine at one or two or four florins an ounce. The painters and their public were alert to all this and the exotic and dangerous character of ultramarine was a means of accent that we, for whom dark blue is probably no more striking than scarlet or vermilion, are liable to miss. We can follow well enough when it is used simply to pick out the principal figure of Christ or Mary in a biblical scene, but the interesting uses are more subtle than this. In Sassetta's panel of *St. Francis Giving his Cloak to a Poor Soldier* (plate 4) the gown St. Francis gives away is an ultramarine gown. In Masaccio's expensively pigmented *Crucifixion*, the vital narrative gesture of St. John's right arm is an ultramarine gesture. And so on. Even beyond this the contracts point to a sophistication about blues, a capacity to discriminate between one and another, with which our own culture does not equip us. In 1408 Gherardo Starnina contracted to paint in S. Stefano at Empoli frescoes, now lost, of the *Life of the Virgin*. The contract is meticulous about blue: the ultramarine used for Mary is to be of the quality of two florins to the ounce, while for the rest of the picture ultramarine at one florin to the ounce will do. Importance is registered with a violet tinge.

Of course, not all artists worked within institutions of this kind; in particular, some artists worked for princes who paid them a

salary. Mantegna, who worked from 1460 until his death in 1506 for the Gonzaga Marquises of Mantua, is a well documented case and Lodovico Gonzaga's offer to him in April 1458 is very clear: 'I intend to give you fifteen ducats monthly as salary, to provide lodgings where you can live comfortably with your family, to give you enough grain each year to cover generously the feeding of six mouths, and also the firewood you need for your own use. . . .' Mantegna, after much hesitation, accepted and in return for his salary not only painted frescoes and panels for the Gonzagas (plate 5), but filled other functions as well. Lodovico Gonzaga to Mantegna, 1469:

I desire that you see to drawing two guinea-fowl from the life, one cock and one hen, and send them to me here, since I want to have them woven by my tapesters: you can have a look at the guinea-fowl in the garden at Mantua.

Cardinal Francesco Gonzaga to Lodovico Gonzaga, 1472:

. . . I beg you to order Andrea Mantegna . . . to come and stay with me [at Foligno]. With him I shall entertain myself by showing him my engraved gems, figures of bronze and other fine antiques; we will study and discuss them together.

Duke of Milan to Federico Gonzaga, 1480:

I am sending you some designs for pictures which I beg you to have painted by your Andrea Mantegna, the famous painter . . .

Federico Gonzaga to Duke of Milan, 1480:

I received the design you sent and urged Andrea Mantegna to turn it into a finished form. He says it is more a book illuminator's job than his, because he is not used to painting little figures. He would do much better a Madonna or something, a foot or a foot and half long, say, if you are willing . . .

Lancillotto de Andreasis to Federico Gonzaga, 1483:

I have bargained with the goldsmith Gian Marco Cavalli about making the bowls and beakers after Andrea Mantegna's design. Gian Marco asks three lire, ten soldi for the bowls and one and a half lire for the beakers . . . I am sending you the design made by Mantegna for the flask, so that you can judge the shape before it is begun.

In practice Mantegna's position was not quite as tidy as Gonzaga's offer proposed. His salary was not always regularly paid; on the other hand, he was given occasional privileges and gifts of land

5. Andrea Mantegna. *Marchese Lodovico Gonzaga Greeting his Son Cardinal Francesco Gonzaga* (1474). Mantua, Palazzo Ducale, Camera degli Sposi. Fresco.

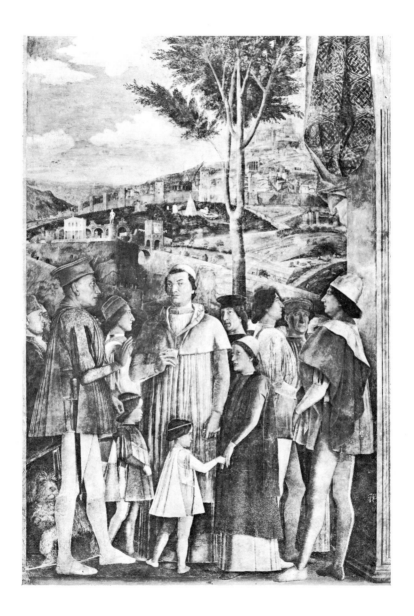

or money, and fees from outside patrons. But Mantegna's position was unusual among the great Quattrocento painters; even those who produced paintings for princes were more commonly paid for a piece of work than as permanent salaried retainers. It was the commercial practice expounded in the contracts, and seen at its clearest in Florence, that set the tone of Quattrocento patronage.

To return to the contracts, though one can generalize this far about them, their details vary a great deal from case to case; and, what is more interesting, there are gradual changes of emphasis in the course of the century. What was very important in 1410 was sometimes less important in 1490: what 1410 had not specially concerned itself with sometimes demanded an explicit commitment in 1490. Two of these shifts of emphasis—one towards less insistence, the other towards more—are very important, and one of the keys to the Quattrocento lies in recognizing that they are associated in an inverse relationship. While precious pigments become less prominent, a demand for pictorial skill becomes more so.

3. As the century progressed contracts became less eloquent than before about gold and ultramarine. They are still commonly mentioned and the grade of ultramarine may even be specified in terms of florins to the ounce—nobody could want the blue to flake off their picture—but they are less and less the centre of attention and the gold is increasingly intended for the frame. Starnina's undertaking of 1408 about different grades of blue for different parts of the picture is very much of his moment: there is nothing quite like it in the second half of the century. This lessening preoccupation with the precious pigments is quite consistent with the paintings as we see them now. It seems that clients were becoming less anxious to flaunt sheer opulence of material before the public than they had previously been.

It would be futile to try to account for this sort of development simply within the history of art. The diminishing role of gold in paintings is part of a general movement in western Europe at this time towards a kind of selective inhibition about display, and this shows itself in many other kinds of behaviour too. It was just as conspicuous in the client's clothes, for instance, which were abandoning gilt fabrics and gaudy hues for the restrained black of Burgundy. This was a fashion with elusive moral overtones; the atmosphere of the mid-century is caught very well in an anecdote told about King Alfonso of Naples by the Florentine bookseller Vespasiano da Bisticci:

There was a Sienese ambassador at Naples who was, as the Sienese tend to be, very grand. Now King Alfonso usually dressed in black, with just a buckle in his cap and a gold chain round his neck; he did not use brocades or silk clothes much. This ambassador however dressed in gold brocade, very rich, and when he came to see the King he always wore this gold brocade. Among his own people the King often made fun of these brocade clothes. One day he said, laughing to one of his gentlemen, 'I think we should change the colour of that brocade.' So he arranged to give audience one day in a mean little room, summoned all the ambassadors, and also arranged with some of his own people that in the throng everyone should jostle against the Sienese ambassador and rub against his brocade. And on the day it was so handled and rubbed, not just by the other ambassadors, but by the King himself, that when they came out of the room no-one could help laughing when they saw the brocade, because it was crimson now, with the pile all crushed and the gold fallen off it, just yellow silk left: it looked the ugliest rag in the world. When he saw him go out of the room with his brocade all ruined and messed, the King could not stop laughing. . . .

The general shift away from gilt splendour must have had very complex and discrete sources indeed—a frightening social mobility with its problem of dissociating oneself from the flashy new rich; the acute physical shortage of gold in the fifteenth century; a classical distaste for sensuous licence now seeping out from neo-Ciceronian humanism, reinforcing the more accessible sorts of Christian asceticism; in the case of dress, obscure technical reasons for the best qualities of Dutch cloth being black anyway; above all, perhaps, the sheer rhythm of fashionable reaction. Many such factors must have coincided here. And the inhibition is not part of a comprehensive shift away from public opulence: it was selective. Philippe le Bon of Burgundy and Alfonso of Naples were as lush as ever—if not more so—in many other facets of their public lives. Even within the limitation of black costume one could be as conspicuously expensive as before, cutting the finest Netherlandish fabrics wastefully on the cross. The orientation of display shifted—one direction inhibited, another developed—and display itself went on.

The case of painting was similar. As the conspicuous consumption of gold and ultramarine became less important in the contracts, its place was filled by references to an equally conspicuous consumption of something else—skill. To see how this was so—how skill could be the natural alternative to precious pigment, and how skill could be clearly understood as a conspicuous index of consumption—one must return to the money of painting.

A distinction between the value of precious material on the

one hand and the value of skilful working of materials on the other is now rather critical to the argument. It is a distinction that is not alien to us, is indeed fully comprehensible, though it is not usually central to our own thinking about pictures. In the early Renaissance, however, it was *the* centre. The dichotomy between quality of material and quality of skill was the most consistently and prominently recurring motif in everybody's discussion of painting and sculpture, and this is true whether the discussion is ascetic, deploring public enjoyment of works of art, or affirmative, as in texts of art theory. At one extreme one finds the figure of Reason using it to condemn the effect on us of works of art in Petrarch's dialogue *Physic against Fortune*: 'it is the *preciousness*, as I suppose, and not the *art* that pleases you.'

At the other extreme Alberti uses it in his treatise *On painting* to argue for the painter representing even golden objects not with gold itself but through a skilful application of yellow and white pigments:

There are painters who use much gold in their pictures (plate 6), because they think it gives them majesty: I do not praise this. Even if you were painting Virgil's Dido—with her gold quiver, her golden hair fastened with a gold clasp, purple dress with a gold girdle, the reins and all her horse's trappings of gold—even then I would not want you to use any gold, because to represent the glitter of gold with plain colours brings the craftsman more admiration and praise.

One could multiply instances almost indefinitely, the most heterogeneous opinions being united only by their dependence on the same dichotomy between material and skill.

But intellectual concepts are one thing and crass practice is something else: the action of one on the other is usually difficult to demonstrate because it is not likely to be direct or simple. What gave Petrarch's and Alberti's distinction its special charge and geared it immediately into the dimension of practical business was that the same distinction was the whole basis of costing a picture, as indeed any manufacture. One paid for a picture under these same two headings, matter and skill, material and labour, as Giovanni d'Agnolo de' Bardi paid Botticelli for an altarpiece (plate 7) to go in the family chapel at S. Spirito:

Wednesday 3 August 1485:
At the chapel at S. Spirito seventy-eight florins fifteen soldi in payment of seventy-five gold florins in gold, paid to Sandro Botticelli on his reckoning, as follows—two florins for ultramarine, thirty-eight florins for

gold and preparation of the panel, and thirty-five florins for his brush [*pel suo pennello*].

There was a neat and unusual equivalence between the values of the theoretical and the practical. On the one hand, ultra-marine, gold for painting with and for the frame, timber for the panel (material); on the other Botticelli's brush (labour and skill).

4. There were various ways for the discerning client to switch his funds from gold to 'brush'. For example, behind the figures in his picture he could specify landscapes instead of gilding:

> The painter also undertakes to paint in the empty part of the pictures (plate 8)—or more precisely on the ground behind the figures—landscapes and skies [*paese et aiere*] and all other grounds too where colour is put: except for the frames, to which gold is to be applied. . . .
>
> (Pinturicchio at S. Maria de' Fossi, Perugia. 1495)

A contract might even itemize what the client had in mind for his landscapes. When Ghirlandaio contracted in 1485 to paint frescoes for Giovanni Tornabuoni in the choir of S. Maria

6. Antonio Vivarini. *Epiphany* (about 1440). Berlin, Staatliche Museen. Panel.

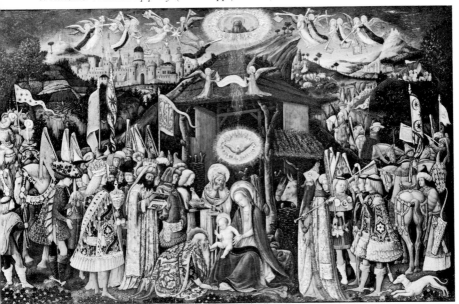

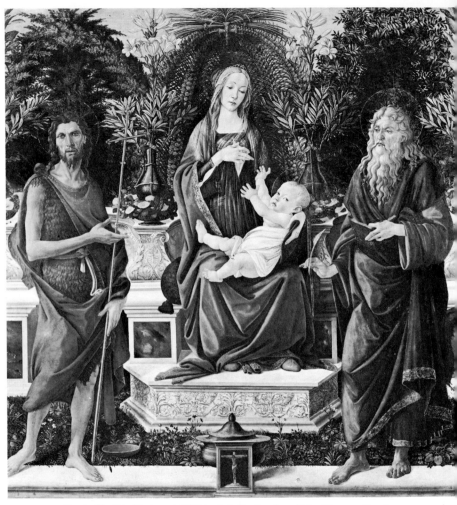

7. Botticelli. *The Virgin and Child* (1485). Berlin, Staatliche Museen. Panel.

Novella at Florence he agreed to include 'figures, buildings, castles, cities, mountains, hills, plains, rocks, costumes, animals, birds, and beasts of every kind.' Such a demand ensured an expenditure of labour, if not skill.

There was another and more sure means of becoming an expensive purchaser of skill, already gaining ground in the middle of the century: this was the very great relative difference,

in any manufacture, in the value of the master's and the assistants' time within each workshop. We can see that with the painters this difference was substantial. For instance, in 1447 Fra Angelico was in Rome painting frescoes for the new Pope Nicholas V. His work was paid for not with the comprehensive figure usual in commissions from private men or small secular groups but on the basis of his and three assistants' time, materials being provided. An entry from the Vatican accounts will show the four men's respective rates:

23 May 1447.
To Fra Giovanni di Pietro of the Dominican Order, painter working on the chapel of St. Peter, on 23 May, forty-three ducats twenty-seven soldi, towards his allowance of 200 ducats per annum, for the period 13 March to the end of May . . . 43 florins 27 soldi
To Benozzo da Leso, painter of Florence working in the abovesaid chapel, on the same day eighteen florins twelve soldi towards his allowance of seven florins the month for the period 13 March to the end of May . . . 18 florins 12 soldi
 To Giovanni d'Antonio della Checha, painter in the same chapel, on the same day two ducats forty-two soldi, towards two and two-fifths

8. Bernardino Pinturicchio. *St. Augustine and the Child*, from the Pala di S. Maria de' Fossi (1495). Perugia, Galleria. Panel.

months at one florin the month, for the period up to the end of May . . .

2 florins 42 soldi

To Jacomo d'Antonio da Poli, painter in the same chapel, on 23 May, three florins, his allowance for three months to run up to the end of May at the rate of one florin the month . . . 3 florins

The annual rate for each of the four, keep excluded, would therefore be:

Fra Angelico	200 florins	
Benozzo Gozzoli	84 florins	⎫
Giovanni della Checha	12 florins	⎬ 108 florins
Jacomo da Poli	12 florins	⎭

When the team moved to Orvieto later in the year they got the same rates, except for Giovanni della Checha whose pay doubled from one to two florins the month. Clearly much money could be spent on skill if a disproportionate amount of a painting— disproportionate not by our standards but by theirs—were done by the master of a shop in place of his assistants.

It was this that happened. The contract for Piero della Francesca's *Madonna della Misericordia* (plate 9):

11 June 1445.

Pietro di Luca, Prior, . . . [and seven others] in the behalf and name of the Fraternity and Members of S. Maria della Misericordia have committed to Piero di Benedetto, painter, the making and painting of a panel in the oratory and church of the said Fraternity, of the same form as the panel which is there now, with all the material for it and all the costs and expenses of the complete furnishing and preparation of its painting assembly and erection in the said oratory: with those images figures and ornaments stated and agreed with the abovesaid Prior and advisor or their successors in office and with the other abovesaid officers of the Fraternity; to be gilded with fine gold and coloured with fine colours, and specially with ultramarine blue: with this condition, that the said Piero should be bound to make good any defect the said panel shall develop or show with the passing of time through failure of material or of Piero himself, up to a limit of ten years. For all this they have agreed to pay 150 florins, at the rate of five lire five soldi the florin. Of which they have undertaken to give him on demand fifty florins now and the balance when the panel is finished. And the said Piero has undertaken to make paint decorate and assemble the said panel in the same breadth height and shape as the wooden panel there at present, and to deliver it complete assembled and set in place within the next three years; and that *no painter may put his hand to the brush other than Piero himself.*

This was a panel painting; for large scale fresco commissions the demand could be softened. When Filippino Lippi contracted in

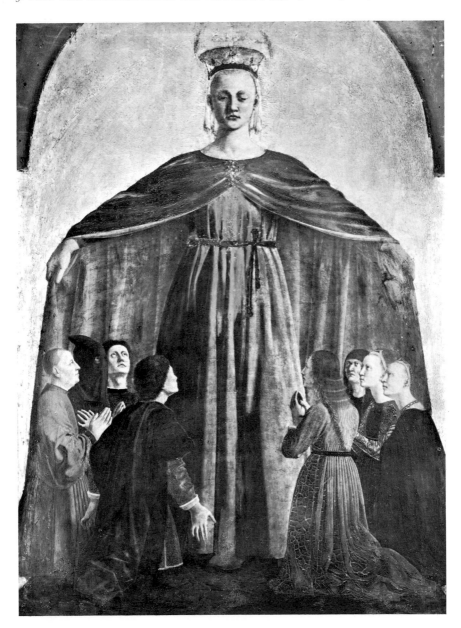

1487 to paint frescoes in the Strozzi chapel of S. Maria Novella
he undertook that the work should be '. . . all from his own hand,
and particularly the figures' (*tutto di sua mano, e massime le figure*):
the clause may be a little illogical, but the implication is obvious
—that the figures, more important and difficult than architec-
tural backgrounds, should have a relatively large component of

10. Luca Signorelli. *The Doctors of the Church* (1499/1500). Orvieto, Cathedral,
Cappella di S. Brizio. Fresco.

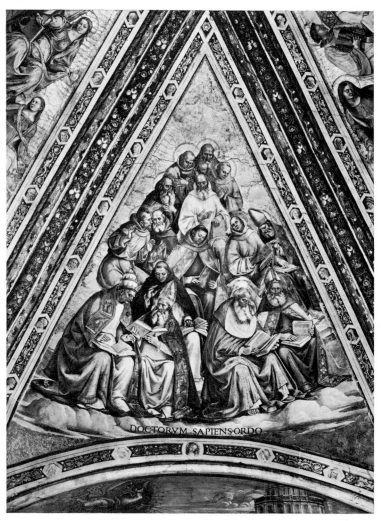

Filippino's personal handiwork in them. There is a precise and realistic clause in Signorelli's contract of 1499 for frescoes in Orvieto Cathedral (plate 10):

The said master Luca is bound and promises to paint [1] all the figures to be done on the said vault, and [2] especially *the faces and all the parts of the figures from the middle of each figure upwards*, and [3] that no painting should be done on it without Luca himself being present. . . . And it is agreed [4] that all the mixing of colours should be done by the said master Luca himself. . . .

This was one interpretation of how far a master should personally intervene in the carrying out of his designs, on a very large-scale fresco undertaking. And in general the intention of the later contracts is clear: the client will confer lustre on his picture not with gold but with mastery, the hand of the master himself.

By the middle of the century the expensiveness of pictorial skill was very well known. When St. Antoninus, Archbishop of Florence, discussed in his *Summa Theologica* the art of goldsmiths and their proper payment, he used the painters as an example of payment relative to individual skill: 'The goldsmith who endows his works with better skill should be paid more. As is the case in the art of painting, where a great master will demand much more pay—two or three times more—than an unskilled man for making the same type of figure.'

The fifteenth-century client seems to have made his opulent gestures more and more by becoming a conspicuous buyer of skill. Not all clients did so: the pattern described here is a perceptible drift in fifteenth-century contracts, not a norm with which they all comply. Borso d'Este was not the only princely primitive out of touch with the decent commercial practice of Florence and Sansepolcro. But there were enough enlightened buyers of skill, spurred on by an increasingly articulate sense of the artists' individuality, to make the public attitude to painters very different in 1490 from what it had been in 1410.

5. We have come this far with the documents: There were various ways of diverting funds from material to skill: one might direct that a panel have representational rather than gilt backgrounds; more radically, one could demand and pay for a relatively high proportion of the great master's expensive personal attention. For the picture still to make a handsome impression this expensive skill must manifest itself clearly to the beholder. In what specific characters it did this, what were recognized as hallmarks

of the skilled brush, the contracts do not tell us. There is no reason
why they should, of course.

And at this point it would be convenient to turn to the records
of public response to painting, if only these were not so dis-
ablingly thin. The difficulty is that it is at any time eccentric to
set down on paper a verbal response to the complex non-verbal
stimulations paintings are designed to provide: the very fact of

11. Filippino Lippi. *The Vision of St. Bernard* (about 1486). Florence, Badia. Panel.

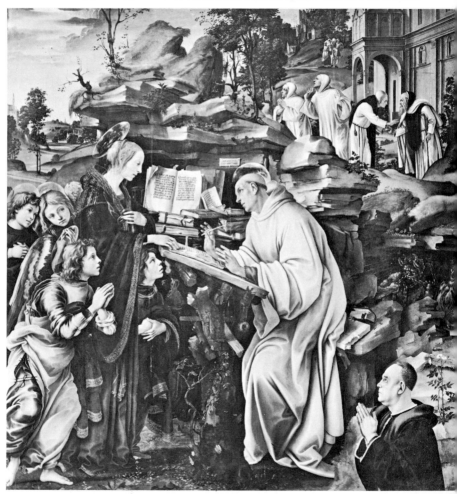

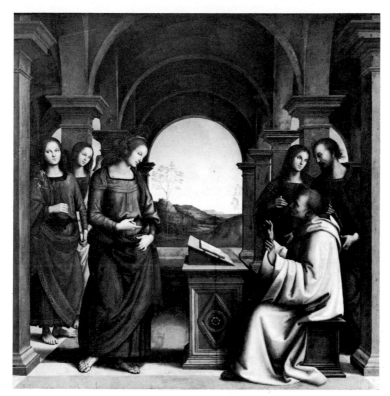

12. Perugino. *The Vision of St. Bernard* (about 1494). Munich, Alte Pinakothek. Panel.

doing so must make a man untypical. There are some fifteenth-century descriptions of the quality of painters, but there are very few indeed one can confidently see as representative of some fairly broad collective view. Some, like Ghiberti's Commentaries, are ineligible because they are written by men who are really artists; some are the work of learned men imitating the ancient art criticism of writers like the elder Pliny. Most of them, because they limit themselves to saying a picture is 'good' or 'skilful', are representative enough but from our point of view unhelpful.

An innocent account of paintings—the everyday vernacular way of talking about their qualities and differences happening to be put down on paper—is obviously something that would only occur under unusual circumstances. There is one specially good example. In about 1490 the Duke of Milan had it in mind

to employ some painters at the Certosa di Pavia and his agent in Florence sent in a memorandum about four painters known there —Botticelli (plate 7), Filippino Lippi (plate 11), Perugino (plate 12), Ghirlandaio (plate 2):

Sandro de Botticello pictore Excellen^mo in tavola et in muro: le cose sue hano aria virile et sono cum optima ragione et integra proportione. Philippino di Frati Philippo optimo: Discipulo del sopra dicto et figliolo del piu singulare maestro di tempo suoi: le sue cose hano aria piu dolce: non credo habiano tanta arte. El Perusino Maestro singulare: et maxime in muro: le sue cose hano aria angelica, et molto dolce. Dominico de Grilandaio bono maestro in tavola et piu in muro: le cose sue hano bona aria, et e homo expeditivo, et che conduce assai lavaro: Tutti questi predicti maestri hano facto prova di loro ne la capella di papa syxto excepto che philippino. Ma tutti poi allospedaletto del M^co Laur^o et la palma e quasi ambigua.

Sandro Botticelli, an excellent painter both on panel and on wall. His things have a *virile air* and are done with the best *method* and complete *proportion*.
Filippino, son of the very good painter Fra Filippo Lippi: a pupil of the above-mentioned Botticelli and son of the most outstanding master of his time. His things have a *sweeter air* than Botticelli's; I do not think they have as much *skill*.
Perugino, an exceptional master, and particularly on walls. His things have an *angelic air*, and very *sweet*.
Domenico Ghirlandaio, a good master on panels and even more so on walls. His things have a *good air*, and he is an expeditious man and one who gets through much work.
All these masters have made proof of themselves in the chapel of Pope Sixtus IV, except Filippino. All of them later also in the Spedaletto of Lorenzo il Magnifico, and the palm of victory is pretty much in doubt.

The chapel of Pope Sixtus IV refers to the frescoes on the wall of the Sistine Chapel in the Vatican; the frescoes at Lorenzo de' Medici's villa of Spedaletto near Volterra have not survived.

A few obvious things emerge clearly: that the distinction between fresco and panel painting is sharp; that the painters are seen very much as individuals in competition; and, more subtly, that there are discriminations to be made not only about one artist being simply *better* than another, but also about one artist being *different* in character from another. But though the report is obviously a genuine attempt to inform, to convey to Milan the differing qualities of each artist, it is curiously baffling. How much and what does the writer actually know about the painter's *method* or *ragione?* What does *manly* or *virile* air mean in relation to

the painting of Botticelli? In what form is *proportion* perceived in Botticelli? Is it some vague sense of rightness, or did the writer have the equipment to distinguish proportional relationships? What does *sweet* air mean in the context of Filippino, and how is it affected by a relative lack of *skill*? Is Perugino's *angelic* air some identifiable religious quality or a matter of general sentiment? When he speaks of Ghirlandaio's *good air* is this just unspecific praise, or does it refer to some particular stylishness in the area of the French and English versions of the phrase, *de-bon-air*? Of course, when we look at the paintings we can give *a* sense, our sense, to the Milanese agent's remarks, but it is unlikely that this sense is his. There is a verbal difficulty, the problem of *virile* and *sweet* and *air* having different nuances for him than for us, but there is also the difficulty that he saw the pictures differently from us.

And this is the problem next in order. Both the painter and his public, both Botticelli and the Milanese agent, belonged to a culture very unlike ours, and some areas of their visual activity had been much conditioned by it. This is something rather distinct from the matter we have so far been looking at, the general expectations of painting involved in the Quattrocento painter-client relationship. The first chapter has been concerned with more or less conscious responses by the painter to the conditions of the picture trade; and it has not isolated particular kinds of pictorial interest. The next chapter will have to enter the deeper water of how Quattrocento people, painters and public, attended to visual experience in distinctively Quattrocento ways, and how the quality of this attention became a part of their pictorial style.

II. The period eye

1. AN OBJECT reflects a pattern of light on to the eye. The light enters the eye through the pupil, is gathered by the lens, and thrown on the screen at the back of the eye, the retina. On the retina is a network of nerve fibres which pass the light through a system of cells to several millions of receptors, the cones. The cones are sensitive both to light and to colour, and they respond by carrying information about light and colour to the brain.

It is at this point that human equipment for visual perception ceases to be uniform, from one man to the next. The brain must interpret the raw data about light and colour that it receives from the cones and it does this with innate skills and those developed out of experience. It tries out relevant items from its stock of patterns, categories, habits of inference and analogy—'round', 'grey', 'smooth', 'pebble' would be verbalized examples —and these lend the fantastically complex ocular data a structure and therefore a meaning. This is done at the cost of a certain simplification and distortion: the relative aptness of the category 'round' overlays a more complex reality. But each of us has had different experience, and so each of us has slightly different knowledge and skills of interpretation. Everyone, in fact, processes the data from the eye with different equipment. In practice these differences are quite small, since most experience is common to us all: we all recognize our own species and its limbs, judge distance and elevation, infer and assess movement, and many other things. Yet in some circumstances the otherwise marginal differences between one man and another can take on a curious prominence.

Suppose a man is shown the configuration in plate 13, a configuration that can be apprehended in various ways. One way would be primarily as a round thing with a pair of elongated L-shaped projections on each side. Another way would be primarily as a circular form superimposed on a broken rectangular form. There are many other ways of perceiving it as well. That which we tend toward will depend on many things— particularly on the context of the configuration, which is suppressed here for the moment—but not least on the interpreting

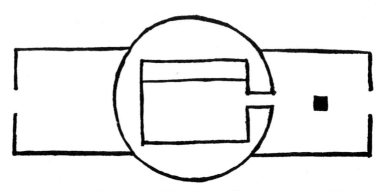

13. Santo Brasca. *Itinerario . . . di Gerusalemme* (Milan, 1481). p. 58 v. Woodcut.

INTERPRET

skills one happens to possess, the categories, the model patterns and the habits of inference and analogy: in short, what we may call one's *cognitive style.* Suppose the man looking at plate 13 is well equipped with patterns and concepts of shape like those in plate 14 and is practised in using them. (In fact, most of the people plate 13 was originally made for were proud of being so equipped.) This man will be disposed to the second of the ways of perceiving the configuration. He will be less likely to see it just as a round thing with projections, and more likely to see it primarily as a circle superimposed on a rectangle: he possesses these categories and is practised at distinguishing such patterns in complicated shapes. To this extent he will *see* plate 13 differently from a man without resources of this kind.

Let us now add a context to plate 13. It occurs in a description of the Holy Land printed in Milan in 1481 and it has the caption: 'Questo e la forma del sancto sepulchro de meser iesu christo.' (This is the shape of the Holy Sepulchre of Our Lord Jesus Christ). The context adds two particularly important factors to the perception of the configuration. First, one now knows that it has been made with the purpose of representing something: the man looking at it refers to his experience of representational conventions and is likely to decide that it belongs to the ground-plan convention—lines representing the course walls would follow on the ground if one were looking vertically down at a structure. The groundplan is a relatively abstract and analytical convention for representing things, and unless it is within his culture—as it is within ours—the man may be puzzled as to how to interpret the figure. Second, one has been cued to the fact that prior

30

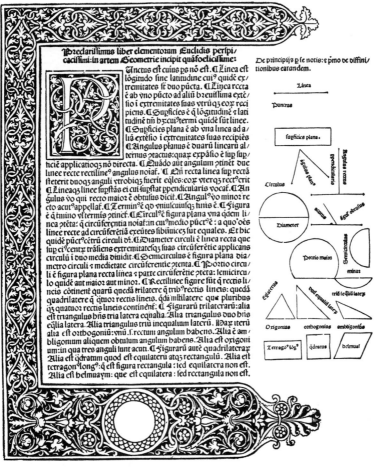

14. Euclid. *Elementa geometriae* (Venice, 1482). p. 2 r. Woodcut.

experience of buildings is relevant here, and one will make inferences accordingly. A man used to fifteenth-century Italian architecture might well infer that the circle is a circular building, with a cupola perhaps, and that the rectangular wings are halls. But a fifteenth-century Chinese, once he had learned the ground-plan convention, might infer a circular central court on the lines of the new Temple of Heaven at Peking.

So here are three variable and indeed culturally relative kinds of thing the mind brings to interpreting the pattern of light

31

15. Bartolo da Sassoferrato. *De fluminibus* (Rome, 1483). p. 18 r. Woodcut.

plate 13 casts on the retina: a stock of patterns, categories and methods of inference; training in a range of representational conventions; and experience, drawn from the environment, in what are plausible ways of visualizing what we have incomplete information about. In practice they do not work serially, as they are described here, but together; the process is indescribably complex and still obscure in its physiological detail.

2. All this may seem very distant from the way we look at a picture, but it is not. Plate 15 is the representation of a river and at least two distinct representational conventions are being used in it. The mermaids and the miniature landscape on the left are represented by lines indicating the contours of forms, and the point of view is from a slightly upward angle. The course of the river and the dynamics of its flow are registered diagrammatically and geometrically, and the point of view is from vertically above. A linear ripple convention on the water surface mediates between one style of representation and the other. The first convention is more immediately related to what we see, where the second is more abstract and conceptualized—and to us now rather unfamiliar—but they both involve a skill and a willingness to interpret marks on paper as representations simplifying an aspect of reality within accepted rules: we do not *see* a tree as a white plane surface circumscribed by black lines. Yet the tree is only a crude version of what one has in a picture, and the variable pressures on perception, the cognitive style, also operate on anyone's perception of a painting.

We will take Piero della Francesca's *Annunciation* fresco at

Arezzo (Colour Plate I) as an example. In the first place, understanding the picture depends on acknowledging a representational convention, of which the central part is that a man is disposing pigments on a two-dimensional ground in order to refer to something that is three-dimensional: one must enter into the spirit of the game, which is not the groundplan game but something Boccaccio described very well:

> The painter exerts himself to make any figure he paints—actually just a little colour applied with skill to a panel—similar in its action to a figure which is the product of Nature and naturally has that action: so that it can deceive the eyes of the beholder, either partly or completely, making itself be taken for what it really is not.

In fact, since our vision is stereoscopic, one is not normally long deceived by such a picture to the point of completely supposing it real. Leonardo da Vinci pointed this out:

> It is not possible for a painting, even if it is done with the greatest perfection of outline, shadow, light and colour, to appear in the same relief as the natural model, unless that natural model were looked at from a great distance and with only one eye.

He adds a drawing (plate 16) to demonstrate why this is so: A and B are our eyes, C the object seen, E-F space behind it, D-G the area screened by a painted object, but in real life seen. But the convention was that the painter made his flat surface very suggestive of a three-dimensional world and was given credit for doing so. Looking at such representations was a fifteenth-century Italian institution, and involved in the institution were certain expectations; these varied according to the

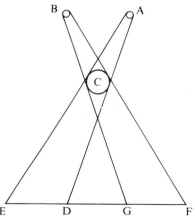

16. After Leonardo da Vinci. Stereoscopic vision. From *Libro di pittura*, Vatican Library, MS. Urb. lat. 1270, fol. 155 v.

33

placing of the picture—church or *salone*—but one expectation was constant: the beholder expected *skill*, as we have seen. Quite what sort of skill he expected will occupy us presently, but the point to be noticed now is that a fifteenth-century man looking at a picture was curiously on his mettle. He was aware that the good picture embodied skill and he was frequently assured that it was the part of the cultivated beholder to make discriminations about that skill, and sometimes even to do so verbally. The most popular fifteenth-century treatise on education, for example, Pier Paolo Vergerio's *On noble behaviour* of 1404, reminded him: 'The beauty and grace of objects, both natural ones and those made by man's art, are things it is proper for men of distinction to be able to discuss with each other and appreciate.' Looking at Piero's painting, a man with intellectual self-respect was in no position to remain quite passive; he was obliged to discriminate.

This brings us to the second point, which is that the picture is sensitive to the kinds of interpretative skill—patterns, categories, inferences, analogies—the mind brings to it. A man's capacity to distinguish a certain kind of form or relationship of forms will have consequences for the attention with which he addresses a picture. For instance, if he is skilled in noting proportional relationships, or if he is practiced in reducing complex forms to compounds of simple forms, or if he has a rich set of categories for different kinds of red and brown, these skills may well lead him to order his experience of Piero della Francesca's *Annunciation* differently from people without these skills, and much more sharply than people whose experience has not given them many skills relevant to the picture. For it is clear that some perceptual skills are more relevant to any one picture than others: a virtuosity in classifying the ductus of flexing lines—a skill many Germans, for instance, possessed in this period—or a functional knowledge of the surface musculature of the human body would not find much scope on the *Annunciation*. Much of what we call 'taste' lies in this, the conformity between discriminations demanded by a painting and skills of discrimination possessed by the beholder. We enjoy our own exercise of skill, and we particularly enjoy the playful exercise of skills which we use in normal life very earnestly. If a painting gives us opportunity for exercising a valued skill and rewards our virtuosity with a sense of worthwhile insights about that painting's organization, we tend to enjoy it: it is to our taste. The negative of this is the man without the sorts of skill in terms of which the painting is ordered: a German calligrapher confronted by a Piero della Francesca, perhaps.

Thirdly again, one brings to the picture a mass of information and assumptions drawn from general experience. Our own culture is close enough to the Quattrocento for us to take a lot of the same things for granted and not to have a strong sense of misunderstanding the pictures: we are closer to the Quattrocento mind than to the Byzantine, for instance. This can make it difficult to realize how much of our comprehension depends on what we bring to the picture. To take two contrasting kinds of such knowledge, if one could remove from one's perception of Piero della Francesca's *Annunciation* both (a) the assumption that the building units are likely to be rectangular and regular, and (b) knowledge of the Annunciation story, one would have difficulty in making it out. For the first, in spite of Piero's rigorous perspective construction—itself a mode of representation the fifteenth-century Chinese would have had problems with—the logic of the picture depends heavily on our assumption that the loggia projects at a right angle from the back wall: suppress this assumption and one is thrown into uncertainty about the whole spatial layout of the scene. Perhaps the loggia is shallower than one thought, its ceiling sloping down backwards and its corner thrusting out towards the left in an acute angle, then the tiles of the pavement will be lozenges, not oblongs . . . and so on. A clearer case: remove the assumption of regularity and rectangularity from the loggia architecture of Domenico Veneziano's *Annunciation* (plate 17)—refuse to take for granted either that the

17. Domenico Veneziano. *The Annunciation* (about 1445). Cambridge, Fitzwilliam Museum. Panel.

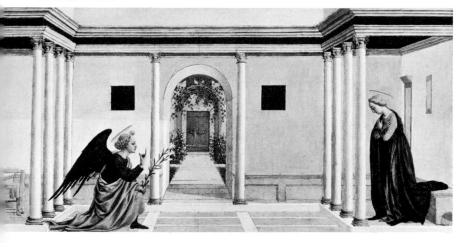

walls of the courtyard meet at right angles or that the fore-shortened rows of columns are spaced at the same intervals as the row seen face on—and the picture space abruptly telescopes into a shallow little area.

Regarding knowledge of the story, if one did not know about the Annunciation it would be difficult to know quite what was happening in Piero's painting; as a critic once pointed out, if all Christian knowledge were lost, a person could well suppose that both figures, the Angel Gabriel and Mary, were directing some sort of devout attention to the column. This does not mean that Piero was telling his story badly; it means he could depend on the beholder to recognize the Annunciation subject promptly enough for him to accent, vary and adjust it in rather advanced ways. In this case, Mary's stance frontal to us serves various purposes: first, it is a device Piero uses to induce participation by the beholder; second, it counters on this occasion the fact that its position in the chapel at Arezzo causes the beholder to see the fresco rather from the right; third, it helps to register a particular moment in Mary's story, a moment of reserve towards the Angel previous to her final submission to her destiny. For fifteenth-century people differentiated more sharply than us between successive stages of the Annunciation, and the sort of nuance we now miss in Quattrocento representations of the Annunciation is one of the things that will have to engage us later.

3. Renaissance people were, as has been said, on their mettle before a picture, because of an expectation that cultivated people should be able to make discriminations about the interest of pictures. These very often took the form of a preoccupation with the painter's skill, and we have seen too that this preoccupation was something firmly anchored in certain economic and intellectual conventions and assumptions. But the only practical way of publicly making discriminations is verbally: the Renaissance beholder was a man under some pressure to have words that fitted the interest of the object. The occasion might be one when actual enunciation of words was appropriate, or it might be one when internal possession of suitable categories assured him of his own competence in relation to the picture. In any event, at some fairly high level of consciousness the Renaissance man was one who matched concepts with pictorial style.

This is one of the things that makes the kind of culturally relative pressures on perception we have been discussing so very important for Renaissance perception of pictures. In our own

culture there is a class of over-cultivated person who, though he is not a painter himself, has learned quite an extensive range of specialized categories of pictorial interest, a set of words and concepts specific to the quality of paintings: he can talk of 'tactile values', or of 'diversified images'. In the fifteenth century there were some such people, but they had relatively few special concepts, if only because there was then such a small literature of art. Most of the people the painter catered for had half-a-dozen or so such categories for the quality of pictures—'foreshortening', 'ultramarine at two florins an ounce', 'drapery' perhaps, and a few others we shall be meeting—and then were thrown back on their more general resources.

Like most of us now, his real training in consciously precise and complex visual assessment of objects, 'both natural ones and those made by man's art', was not on paintings but on things more immediate to his well-being and social survival:

The beauty of the horse is to be recognized above all in its having a body so broad and long that its members correspond in a regular fashion with its breadth and length (plates 18–19). The head of the horse should be proportionately slender, thin and long. The mouth wide and sharply cut; the nostrils broad and distended. The eyes should not be hollowed nor deeply recessed; the ears should be small and carried like spears; the neck long and rather slender towards the head, the jaw quite slender and thin, the mane sparse and straight. The chest should be broad and fairly round, the thighs not tapering but rather straight and even, the croup short and quite flat, the loins round and rather thick, the ribs and other like parts also thick, the haunches long and even, the crupper long and wide. . . . The horse should be taller before than behind, to the same degree a deer is, and should carry its head high, and the thickness of its neck should be proportionable with its chest. Anyone who wants to be a judge of horses' beauty must consider all the parts of the horse discussed above as parts related in proportion to the height and breadth of the horse. . . .

But there is a distinction to be made between the general run of visual skills and a preferred class of skills specially relevant to the perception of works of art. The skills we are most aware of are not the ones we have absorbed like everyone else in infancy, but those we have learned formally, with conscious effort: those which we have been taught. And here in turn there is a correlation with skills that can be talked about. Taught skills commonly have rules and categories, a terminology and stated standards, which are the medium through which they are teachable. These two things—the confidence in a relatively advanced

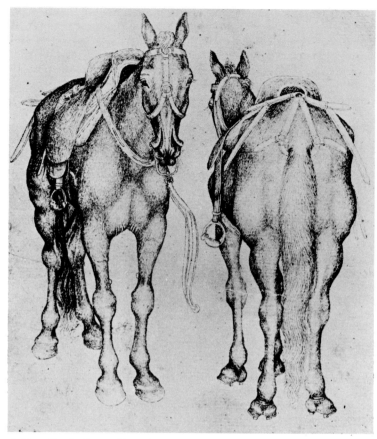

18. Pisanello. *Studies of a Horse* (Cod. Vallardi 2468). Paris, Louvre. Pen and chalk.

and valued skill, and the availability of verbal resources associated with them—make such skills particularly susceptible to transfer in situations such as that of a man in front of a picture.

This raises a problem. We have been moving towards a notion of a Quattrocento cognitive style. By this one would mean the equipment that the fifteenth-century painter's public brought to complex visual stimulations like pictures. One is talking not about all fifteenth-century people, but about those whose response to works of art was important to the artist—the patronizing classes, one might say. In effect this means rather a small proportion of the population: mercantile and professional men, acting as

members of confraternities or as individuals, princes and their courtiers, the senior members of religious houses. The peasants and the urban poor play a very small part in the Renaissance culture that most interests us now, which may be deplorable but is a fact that must be accepted. Yet among the patronizing classes there were variations, not just the inevitable variation from man to man, but variation by groups. So a certain profession, for instance, leads a man to discriminate particularly efficiently in identifiable areas. Fifteenth-century medicine trained a physician to observe the relations of member to member of the human body as a means to diagnosis, and a doctor was alert and equipped to notice matters of proportion in painting too. But while it is clear that among the painter's public there were many

19. After Leonardo da Vinci. *Dimensions of a horse*. New York, Pierpont Morgan Library, MS. M.A., 1139, fol. 82 r. Pen and chalk.

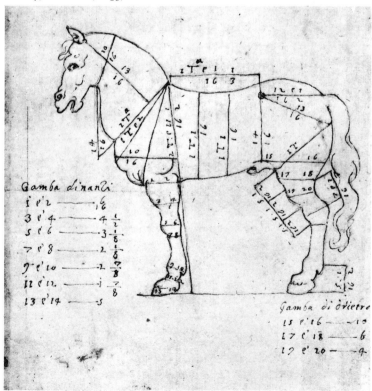

subgroups with special visual skills and habits—the painters themselves were one such subgroup—this book will be concerned with more generally accessible styles of discrimination. A Quattrocento man handled affairs, went to church, led a social life; from all of these activities he acquired skills relevant to his observation of painting. It is true that one man would be stronger on business skills, another on pious skills, another on polite skills; but every man had something of each of these, whatever the individual balance, and it is the highest common factor of skill in his public that the painter consistently catered for.

To sum up: some of the mental equipment a man orders his visual experience with is variable, and much of this variable equipment is culturally relative, in the sense of being determined by the society which has influenced his experience. Among these variables are categories with which he classifies his visual stimuli, the knowledge he will use to supplement what his immediate vision gives him, and the attitude he will adopt to the kind of artificial object seen. The beholder must use on the painting such visual skills as he has, very few of which are normally special to painting, and he is likely to use those skills his society esteems highly. The painter responds to this; his public's visual capacity must be his medium. Whatever his own specialized professional skills, he is himself a member of the society he works for and shares its visual experience and habit.

We are concerned here with Quattrocento cognitive style as it relates to Quattrocento pictorial style. This chapter must now exemplify the kinds of visual skill a Quattrocento person was distinctively equipped with, and try to show how these were relevant to painting.

4. Most fifteenth-century pictures are religious pictures. This is self-evident, in one sense, but 'religious pictures' refers to more than just a certain range of subject matter; it means that the pictures existed to meet institutional ends, to help with specific intellectual and spiritual activities. It also means that the pictures came within the jurisdiction of a mature body of ecclesiastical theory about images. There is no sign of the more academic elaborations of this theory being active in many people's minds during the fifteenth century, though they were quite often rehearsed by the theologians, but a few of the basic principles still set standards for the pictures much more real for the public mind than some of the artistic theory we make so much of now.

What was the religious function of religious pictures? In the

Church's view the purpose of images was threefold. John of Genoa's late thirteenth-century *Catholicon*, still a standard dictionary of the period, summarized them in this way:

Know that there were three reasons for the institution of images in churches. *First*, for the instruction of simple people, because they are instructed by them as if by books. *Second*, so that the mystery of the incarnation and the examples of the Saints may be the more active in our memory through being presented daily to our eyes. *Third*, to excite feelings of devotion, these being aroused more effectively by things seen than by things heard.

In a sermon published in 1492 the Dominican Fra Michele da Carcano gives an orthodox Quattrocento expansion of this:

. . . images of the Virgin and the Saints were introduced for three reasons. *First*, on account of the ignorance of simple people, so that those who are not able to read the scriptures can yet learn by seeing the sacraments of our salvation and faith in pictures. It is written: 'I have learned that, inflamed by unconsidered zeal, you have been destroying the images of the saints on the grounds that they should not be adored. And we praise you wholeheartedly for not allowing them to be adored, but we blame you for breaking them . . . For it is one thing to adore a painting, but it is quite another to learn from a painted narrative what to adore. What a book is to those who can read, a picture is to the ignorant people who look at it. Because in a picture even the unlearned may see what example they should follow; in a picture they who know no letters may yet read.' St. Gregory the Great wrote these words to Serenus, Bishop of Marseilles. *Second*, images were introduced on account of our emotional sluggishness; so that men who are not aroused to devotion when they hear about the histories of the Saints may at least be moved when they see them, as if actually present, in pictures. For our feelings are aroused by things seen more than by things heard. *Third*, they were introduced on account of our unreliable memories Images were introduced because many people cannot retain in their memories what they hear, but they do remember if they see images.

If you commute these three reasons for images into instructions for the beholder, it amounts to using pictures as respectively lucid, vivid and readily accessible stimuli to meditation on the Bible and the lives of Saints. If you convert them into a brief for the painter, they carry an expectation that the picture should tell its story in a clear way for the simple and in an eye-catching and memorable way for the forgetful, and with full use of all the emotional resources of the sense of sight, the most powerful as well as the most precise of the senses.

Of course, the matter could not always be as simple and as

rational as this; there were abuses both in people's responses to pictures and in the way the pictures themselves were made. Idolatry was a standing preoccupation of theology: it was fully realized that simple people could easily confuse the image of divinity or sanctity with divinity or sanctity itself, and worship it. There were widely reported phenomena that tended to go with irrational responses to the images; a story in Sicco Polentone's *Life of St. Anthony of Padua* printed in 1476:

Pope Boniface VIII . . . had the old and ruinous Basilica of St. John Lateran at Rome rebuilt and redecorated with much care and expense, and he listed by name which saints were to be depicted in it. The painters of the Order of Minor Friars were preeminent in this art and there were two particularly good masters from this Order. When these two had painted up all the saints the Pope had ordered, on their own initiative they added in a blank space pictures of Sts. Francis and Anthony. When the Pope heard about this he was angered by their disrespect of his orders. 'I can tolerate the St. Francis,' he said, 'as it is now done. But I insist on the St. Anthony being removed completely.' However all the people sent by the Pope to carry out this command were thrown down to the ground, fiercely knocked about and driven away by a terrible, resounding, gigantic spirit. When the Pope heard of this, he said: 'Let the St. Anthony alone, then, since we can see he wants to stay; in conflict with him, we can only lose more than we gain.'

But idolatry never became as publicly scandalous and pressing a problem as it did in Germany; it was an abuse on which theologians regularly discoursed, but in a stereotyped and rather unhelpful way. Lay opinion usually felt able to dismiss it as an abuse of pictures that did not constitute a condemnation of the institution of images itself; as the humanist Chancellor of Florence Coluccio Salutati had described it:

I think [an ancient Roman's] feelings about their religious images were no different from what we in the full rectitude of our faith feel now about the painted or carved memorials of our Saints and Martyrs. For we perceive these not as Saints and as Gods but rather as images of God and the Saints. It may indeed be that the ignorant vulgar think more and otherwise of them than they should. But one enters into understanding and knowledge of spiritual things through the medium of sensible things, and so if pagan people made images of Fortune with a cornucopia and a rudder—as distributing wealth and controlling human affairs—they did not deviate very much from the truth. So too, when our own artists represent Fortune as a queen turning with her hands a revolving wheel, so long as we apprehend that picture as something made by a man's hand, not something itself divine but a similitude of divine providence, direction and order—and representing indeed not

its essential character but rather the winding and turning of mundane affairs—who can reasonably complain?

The abuse was agreed to exist in some measure but did not stimulate churchmen to new thoughts or action on the problem.

As for the pictures themselves, the Church realized there were sometimes faults against theology and good taste in their conception. S. Antonino, Archbishop of Florence, sums up the three main errors:

Painters are to be blamed when they paint things contrary to our Faith—when they represent the Trinity as one person with three heads, a monster; or, in the Annunciation, an already formed infant, Jesus, being sent into the Virgin's womb, as if the body he took on were not of her substance; or when they paint the infant Jesus with a hornbook, even though he never learned from man. But they are not to be praised either when they paint apocryphal matter, like midwives at the Nativity, or the Virgin Mary in her Assumption handing down her girdle to St. Thomas on account of his doubt (plate 20), and so on. Also, to paint curiosities into the stories of Saints and in churches, things that do not serve to arouse devotion but laughter and vain thoughts—monkeys, and dogs chasing hares and so on, or gratuitously elaborate costumes— this I think unnecessary and vain.

Subjects with heretical implications, apocryphal subjects, subjects obscured by a frivolous and indecorous treatment. Again, all three of these faults did exist. Christ was erroneously shown learning to read in many paintings. The apocryphal story of St. Thomas and the Virgin's girdle was the largest sculptured decoration on S. Antonino's own cathedral church at Florence, the Porta della Mandorla, and appears in numerous paintings. Gentile da Fabriano's *Adoration of the Magi* (plate 21), painted for the Florentine merchant and humanist Palla Strozzi in 1423, has the monkeys, dogs and elaborate costumes S. Antonino considered unnecessary and vain. But, also again, the complaint is not new or particularly of its time; it is just a Quattrocento version of a stock theologian's complaint, voiced continually from St. Bernard to the Council of Trent. When S. Antonino looked at the painting of his time he might well have felt that, on the whole, the Church's three functions for painting were fulfilled: that most pictures were (1) clear, (2) attractive and memorable, (3) stirring registrations of the holy stories. If he had not, he was certainly the man to say so.

So the first question—What was the religious function of religious paintings?—can be reformulated, or at least replaced by a new question: What sort of painting would the religious

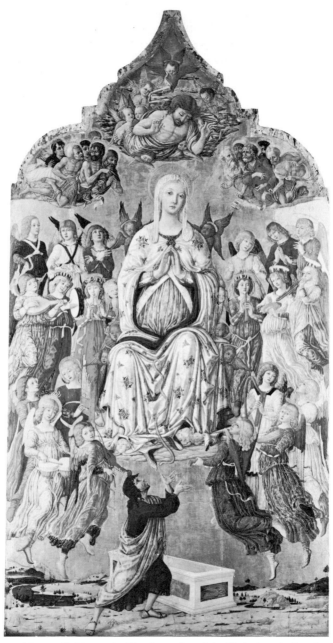

20. Matteo di Giovanni. *The Assumption of the Virgin* (1474). London,
National Gallery. Panel.

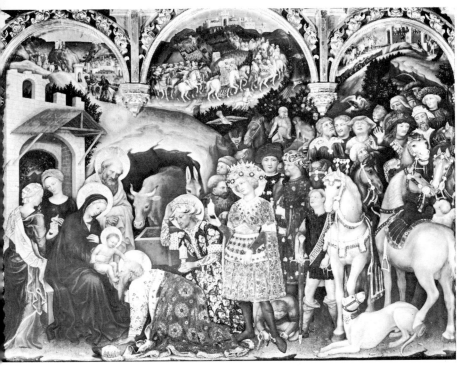

21. Gentile da Fabriano. *The Adoration of the Magi* (1423). Florence, Uffizi. Panel.

public for pictures have found lucid, vividly memorable, and emotionally moving?

5. The painter was a professional visualizer of the holy stories. What we now easily forget is that each of his pious public was liable to be an amateur in the same line, practised in spiritual exercises that demanded a high level of visualization of, at least, the central episodes of the lives of Christ and Mary. To adapt a theological distinction, the painter's were exterior visualizations, the public's interior visualizations. The public mind was not a blank tablet on which the painters' representations of a story or person could impress themselves; it was an active institution of interior visualization with which every painter had to get along. In this respect the fifteenth-century experience of a painting was not the painting we see now so much as a marriage between the painting and the beholder's previous visualizing activity on the same matter.

So it is important before all else to know roughly what sort of activity this was. One handbook that is usefully explicit is the *Zardino de Oration*, the *Garden of Prayer*, written for young girls in 1454 and later printed in Venice. The book explains the need for internal representations and their place in the process of prayer:

The better to impress the story of the Passion on your mind, and to memorise each action of it more easily, it is helpful and necessary to fix the places and people in your mind: a city, for example, which will be the city of Jerusalem—taking for this purpose a city that is well known to you. In this city find the principal places in which all the episodes of the Passion would have taken place—for instance, a palace with the supper-room where Christ had the Last Supper with the Disciples, and the house of Anne, and that of Caiaphas, with the place where Jesus was taken in the night, and the room where He was brought before Caiaphas and mocked and beaten. Also the residence of Pilate where he spoke with the Jews, and in it the room where Jesus was bound to the Column. Also the site of Mount Calvary, where he was put on the Cross; and other like places. . . .

And then too you must shape in your mind some people, people well-known to you, to represent for you the people involved in the Passion—the person of Jesus Himself, of the Virgin, Saint Peter, Saint John the Evangelist, Saint Mary Magdalen, Anne, Caiaphas, Pilate, Judas and the others, every one of whom you will fashion in your mind.

When you have done all this, putting all your imagination into it, then go into your chamber. Alone and solitary, excluding every external thought from your mind, start thinking of the beginning of the Passion, starting with how Jesus entered Jerusalem on the ass. Moving slowly from episode to episode, meditate on each one, dwelling on each single stage and step of the story. And if at any point you feel a sensation of piety, stop: do not pass on as long as that sweet and devout sentiment lasts. . . .

This sort of experience, a visualizing meditation on the stories particularized to the point of perhaps setting them in one's own city and casting them from one's own acquaintance, is something most of us now lack. It gave the painter's exterior visualizations a curious function.

The painter could not compete with the particularity of the private representation. When beholders might approach his painting with preconceived interior pictures of such detail, each person's different, the painter did not as a rule try to give detailed characterizations of people and places: it would have been an interference with the individual's private visualization if he had. Painters specially popular in pious circles, like Perugino (plate 22), painted people who are general, unparticularized, inter-

22. Perugino. *Lamentation over the Dead Christ* (1495). Florence, Palazzo Pitti. Panel.

changeable types. They provided a base—firmly concrete and very evocative in its patterns of people—on which the pious beholder could impose his personal detail, more particular but less structured than what the painter offered.

It was not only a painter like Perugino that worked within conditions of this kind, though his response to them was much appreciated. A great deal of the quality of the most central experiences of Quattrocento painting–let us say, of Masaccio's *Tribute Money* (plate 65) or Bellini's *Transfiguration* (Colour Plate II) —derives from the same situation. Bellini does not offer the detail of persons and places the public provided for itself. He complements the beholder's interior vision. His persons and places

are generalized and yet massively concrete, and they are marshalled in patterns of strong narrative suggestion. Neither of these qualities, the concrete and the patterned, are what the beholder provided for himself since you cannot provide these qualities in mental images, as a little introspection shows; neither could come fully into play before the physical sense of sight was actually resorted to. The painting is the relic of a cooperation between Bellini and his public: the fifteenth-century experience of the *Transfiguration* was an interaction between the painting, the configuration on the wall, and the visualizing activity of the public mind—a public mind with different furniture and dispositions from ours. We enjoy the *Transfiguration*, the painter's part in all this, because we are stimulated by its imbalance, its hypertrophy of the weightily concrete and eloquently patterned at the permissible expense of the particular, which Bellini could count on being contributed by the other side. We should only deceive ourselves if we thought we can have the experience of the *Transfiguration* Bellini designed, or that it expresses in any simple way a spirit or a state of mind. The best paintings often express their culture not just directly but complementarily, because it is by complementing it that they are best designed to serve public needs: the public does not need what it has already got.

What the *Zardino de Oration* describes are private exercises in imaginative intensity and sharpness. The painter was addressing people who were publicly exercised in the same matter too, and in more formal and analytical ways. The best guide we now have to the public exercises is the sermon. Sermons were a very important part of the painter's circumstances: preacher and picture were both part of the apparatus of a church, and each took notice of the other. The fifteenth century was the last fling of the medieval type of popular preacher: the fifth Lateran Council of 1512–17 took measures to suppress them. It is one of the underlying cultural differences between the fifteenth and sixteenth centuries in Italy. The popular preachers were no doubt tasteless and inflammatory sometimes, but they filled their teaching function irreplaceably; certainly they drilled their congregations in a set of interpretative skills right at the centre of the fifteenth-century response to paintings. Fra Roberto Caracciolo da Lecce (plate 23) is a convenient example: Cosimo de' Medici thought he dressed too sharply for a priest, and his sense of the dramatic was strong—during a sermon on the Crusade he stripped off his habit to reveal, Erasmus noted with distaste, the crusader's

FRAR VBER TO

23. Fra Roberto Caracciolo. *Prediche vulghare* (Florence, 1491). Woodcut.

livery and armour underneath—but his sermons as we have them
are decorous enough. In the course of the church year, as festival
followed festival, a preacher like Fra Roberto moved over much
of the painters' subject matter, explaining the meaning of events
and rehearsing his hearers in the sensations of piety proper to each.
The Nativity (Colour Plate IV) embodies mysteries of (1) humility,
(2) poverty, (3) joy, each being subdivided and referred to the
material details of the event. *The Visitation* (plate 38) embodies
(1) benignity, (2) maternity, (3) laudability; benignity declares
itself in (a) invention, Mary's act of seeking the distant Elizabeth
out, (b) salutation, (c) conversation—and so on. Such sermons
were a very thorough emotional categorization of the stories,
closely tied to the physical, and thus also visual, embodiment of the
mysteries. The preacher and painter were *repetiteur* to each other.

 To look a little more closely at one sermon, Fra Roberto
preaching on the Annunciation distinguishes three principal
mysteries: (1) the Angelic Mission, (2) the Angelic Salutation

49

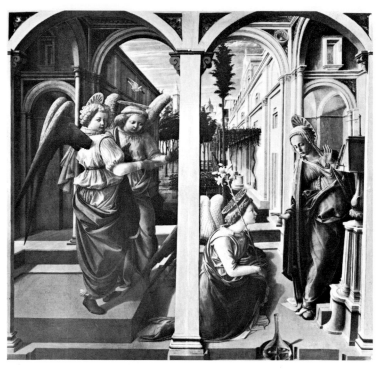

24a. *The Annunciation in Florence.* 1440–60. *Disquiet:* Filippo Lippi. Florence, S. Lorenzo. Panel.

and (3) the Angelic Colloquy. Each of these is discussed under five main heads. For the Angelic Mission, Fra Roberto expounds (a) Congruity—the Angel as the proper medium between God and mortal; (b) Dignity—Gabriel being of the highest order of angels ('the painters' licence to give angels wings to signify their swift progress in all things' is here noted); (c) Clarity—the Angel manifesting itself to the corporeal vision of Mary; (d) Time—Friday 25 March, perhaps at sunrise or perhaps at midday (there are arguments for either), but certainly at the season when the earth is covering itself with grasses and flowers after the winter; (e) Place—Nazareth, meaning 'Flower', pointing to the symbolic relation of flowers to Mary. For the Angelic Salutation Fra Roberto is much briefer: the Salutation implies (a) honour, the Angel kneeling to Mary, (b) exemption from the pains of child-birth, (c) the giving of grace, (d) union with God, and (e) the unique beatitude of Mary, both Virgin and Mother.

So far what Fra Roberto has said is mainly preliminary or marginal to the painter's visual drama of Mary. It is the third mystery, the Angelic Colloquy, that throws clear light on the fifteenth-century feeling for what, on the level of human emotion, happened to her in the crisis the painter had to represent. Fra Roberto analyses the account of St. Luke (I: 26–38) and lays out a series of five successive spiritual and mental conditions or states attributable to Mary:

The third mystery of the Annunciation is called Angelic Colloquy; it comprises five Laudable Conditions of the Blessed Virgin:

1. *Conturbatio* — Disquiet
2. *Cogitatio* — Reflection
3. *Interrogatio* — Inquiry
4. *Humiliatio* — Submission
5. *Meritatio* — Merit

The first laudable condition is called *Conturbatio*; as St. Luke writes, when the Virgin heard the Angel's salutation—'*Hail, thou art highly favoured, the Lord is with thee: blessed art thou among women*'—*she was troubled*. This disquiet, as Nicholas of Lyra writes, came not from incredulity but from wonder, since she was used to seeing angels and marvelled not at the fact of the Angel's apparition so much as at the lofty and grand salutation, in which the Angel made plain for her such great and marvellous things, and at which she in her humility was astonished and amazed (plate 24(a)).

Her second laudable condition is called *Cogitatio*: she *cast in her mind what manner of salutation this should be*. This shows the prudence of the most Holy Virgin. So then *the angel said unto her, Fear not, Mary: for thou hast found favour with God. And, behold, thou shalt conceive in thy womb, and bring forth a son, and shalt call his name JESUS* . . . (plate 24(b)).

The third laudable condition is called *Interrogatio. Then said Mary unto the angel, How shall this be, seeing I know not a man?* that is to say, . . . 'seeing I have the firm resolve, inspired by God and confirmed by my own will, never to know a man?' Francis Mayron says of this: 'One could say the glorious Virgin desired to be a virgin more than to conceive the Son of God without virginity, since virginity is laudable, while to conceive a son is only honourable, being not a virtue but the reward for virtue; and the virtue is more desirable than its reward, since virtue subsumes merit whereas reward does not.' For that reason this modest, pure, chaste, maidenly lover of virginity inquired how a virgin could conceive . . . (plate 24(c)).

The fourth laudable condition is called *Humiliatio*. What tongue could ever describe, indeed, what mind could contemplate the movement and style with which she set on the ground her holy knees? Lowering her head she spoke: *Behold the handmaid of the Lord*. She did not say 'Lady'; she did not say 'Queen'. Oh profound humility! oh extraordinary gentleness! 'Behold', she said, 'the slave and servant of my Lord.' And then,

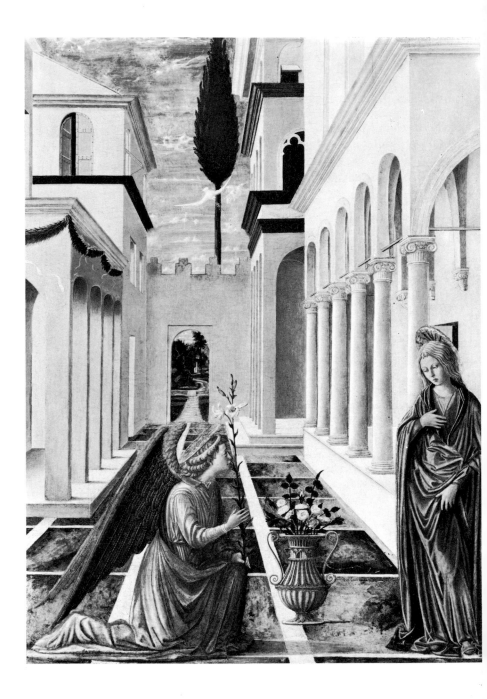

The Annunciation in Florence. 1440–60.

24*b*. (left) *Reflection:* Master of the Barberini Panels. Washington, National Gallery of Art, Kress Collection. Panel.

24*c*. *Inquiry:* Alesso Baldovinetti. Florence, Uffizi. Panel.

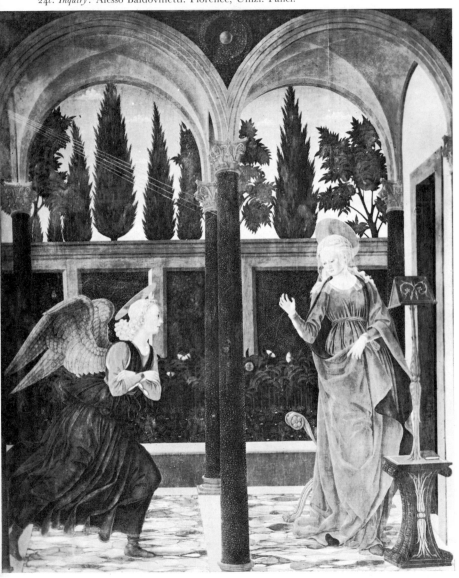

24d. The Annunciation in Florence. 1440–60. Submission: Fra Angelico. Florence, Museo di S. Marco. Fresco.

lifting her eyes to heaven, and bringing up her hands with her arms in the form of a cross, she ended as God, the Angels, and the Holy Fathers desired: *Be it unto me according to thy word* (plate 24(d)).

The fifth laudable condition is called *Meritatio* . . . When she had said these words, the Angel departed from her. And the bounteous Virgin at once had Christ, God incarnate, in her womb, according with that wonderful condition I spoke of in my ninth sermon. So we can justly suppose that in the moment when the Virgin Mary conceived Christ her soul rose to such lofty and sublime contemplation of the action and sweetness of divine things that, in the presence of the beatific vision, she passed beyond the experience of every other created being. And the bodily sensations of the Child being present in her womb rose again with indescribable sweetness. Probably, in her profound humility, she raised her eyes to heaven and then lowered them towards her womb with many tears, saying something like: 'Who am I, that have conceived God incarnate etc. . . .'

The imaginary monologue continues and brings Fra Roberto's sermon to its climax.

The last of the five Laudable Conditions, *Meritatio*, followed after the departure of Gabriel and belongs with representations of the Virgin on her own, the type now called *Annunziata* (plate 50); the other four—successively Disquiet, Reflection, Inquiry and Submission—were divisions within the sublime narrative of Mary's response to the Annunciation that very exactly fit the painted representations. Most fifteenth-century Annunciations are identifiably Annunciations of Disquiet, or of Submission, or—these being less clearly distinguished from each other—of Reflection and/or Inquiry. The preachers coached the public in the painters' repertory, and the painters responded within the current emotional categorization of the event. And though we, unprompted by Fra Roberto, respond to a general sense of excitement or thoughtfulness or humility in a picture of the scene, the more explicit categories of the fifteenth century can sharpen our perception of differences. They remind us, for instance, that Fra Angelico in his many Annunciations never really breaks away from the type of *Humiliatio*, while Botticelli (plate 25) has a dangerous affinity with *Conturbatio*; that a number of marvellous fourteenth-century ways of registering *Cogitatio* and *Interrogatio* become blurred and decay in the fifteenth century, in spite of occasional revival by a painter like Piero della Francesca; or that around 1500 painters were experimenting particularly with more complex and restrained types of *Conturbatio* than that of the tradition used by Botticelli; they shared Leonardo's distaste for the violent mode:

55

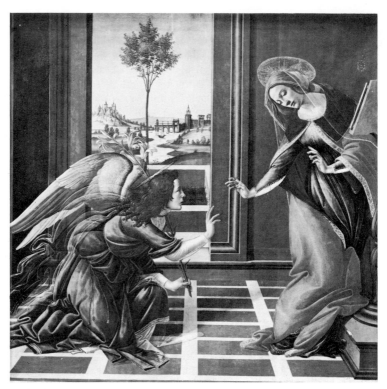

25. Botticelli. *The Annunciation* (about 1490). Florence, Uffizi. Panel.

. . . some days ago I saw the picture of an angel who, in making the Annunciation, seemed to be trying to chase Mary out of her room, with movements showing the sort of attack one might make on some hated enemy; and Mary, as if desperate, seemed to be trying to throw herself out of the window. Do not fall into errors like these.

Fifteenth-century pictorial development happened within fifteenth-century classes of emotional experience.

6. The effective unit of the stories was the human figure. The figure's individual character depended less on its physiognomy— a private matter largely left for the beholder to supply, as we have seen—than on the way it moved. But there were exceptions to this, and particularly the figure of Christ.

The figure of Christ was less open to the personal imagination than others because the fifteenth century was still lucky enough

to think it had an eye-witness account of his appearance. It was in a forged report from a fictitious Lentulus, Governor of Judea, to the Roman Senate:

A man of average or moderate height, and very distinguished. He has an impressive appearance, so that those who look on him love and fear him. His hair is the colour of a ripe hazel-nut. It falls straight almost to the level of his ears; from there down it curls thickly and is rather more luxuriant, and this hangs down to his shoulders. In front his hair is parted into two, with the parting in the centre in the Nazarene manner. His forehead is wide, smooth and serene, and his face is without wrinkles or any marks. It is graced by a slightly reddish tinge, a faint colour. His nose and mouth are faultless. His beard is thick and like a young man's first beard, of the same colour as his hair; it is not particularly long and is parted in the middle. His aspect is simple and mature. His eyes are brilliant, mobile, clear, splendid. He is terrible when he reprehends, quiet and kindly when he admonishes. He is quick in his movements but always keeps his dignity. No one ever saw him laugh, but he has been seen to weep. He is broad in the chest and upstanding; his hands and arms are fine. In speech he is serious, sparing and modest. He is the most beautiful among the children of men.

Not many paintings contradict this pattern.

The Virgin was less consistent, in spite of the putative portraits by St. Luke, and there was an established tradition of discussion about her appearance. There was, for example, the problem of her complexion: dark or fair. The Dominican Gabriel Barletta gives the traditional view in a sermon on the Virgin's beauty— quite a common theme of sermons, though rather symbolically approached:

You ask: Was the Virgin dark or fair? Albertus Magnus says that she was not simply dark, nor simply red-haired, nor just fair-haired. For any one of these colours by itself brings a certain imperfection to a person. This is why one says: 'God save me from a red-haired Lombard', or 'God save me from a black-haired German', or 'from a fair-haired Spaniard', or 'from a Belgian of whatever colour'. Mary was a blend of complexions, partaking of all of them, because a face partaking of all of them is a beautiful one. It is for this reason medical authorities declare that a complexion compounded of red and fair is best when a third colour is added: black. And yet this, says Albertus, we must admit: she was a little on the dark side. There are three reasons for thinking this—firstly by reason of complexion, since Jews tend to be dark and she was a Jewess; secondly by reason of witness, since St. Luke made the three pictures of her now at Rome, Loreto and Bologna, and these are brown-complexioned; thirdly, by reason of affinity. A son commonly takes after his mother, and vice versa; Christ was dark, therefore. . . .

This sort of thing still left room for the imagination. As for the Saints, though many carried some physical mark as an identifying emblem—like St. Paul's baldness—they were usually open to the individual taste and the painter's own traditions.

Still, as the humanist Bartolomeo Fazio pointed out, 'painting a proud man is one thing, painting a mean or an ambitious or a prodigal one is something else.' Many figures do express an ethos independently of any relation with other figures. We probably miss very little through not reading faces in a fifteenth-century way; their complex medical physiognomics were too academic to be a viable resource for the painter, and the commonplaces of popular physiognomics do not change that much:

. . . the eyes are the windows of the soul: almost everyone knows what their colour, what their restlessness, what their sharpness indicates. Something worth mentioning, though, is that people with long eyes are malicious and immoral. And if the white of the eye is widely extended and visible all round, this shows shamelessness; if it is concealed, not visible at all, this shows unreliability.

26. Andrea Mantegna. Detail of a Bowman, from *St. Sebastion* (about 1475). Paris, Louvre. Canvas.

27. Bernardino Pinturicchio. *Scene from the Odyssey* (about 1509). London, National Gallery. Fresco.

Leonardo da Vinci, however, distrusted physiognomics as a false science; he restricted the painter's observation to the marks left by past passion on the face:

It is true that the face shows indications of the nature of men, their vices and temperaments. The marks which separate the cheeks from the lips, the nostrils from the nose, and the eye-sockets from the eyes, clearly show whether men are cheerful and often laugh. Men who have few such marks are men who engage in thought. Men whose faces are deeply carved with marks are fierce and irascible and unreasonable. Men who have strongly marked lines between their eyebrows are also irascible. Men who have strongly marked horizontal lines on their foreheads are full of sorrow, whether secret or admitted.

If a painter makes much of this sort of thing, we will pick it up anyway (plate 26).

59

We may miss very much more by not sharing these people's sense of close relation between movement of the body and movement of the soul and mind. A painting like Pinturicchio's *Scene from the Odyssey* (plate 27) seems to be using a language we only half understand. Is the urgent and well-dressed young man in the foreground expostulating or narrating, with his open hand and emphatic finger? Is the turbanned man with the raised palm registering surprise, dismay or perhaps even sympathy? Is the half-figure on the extreme right, with hand on heart and upturned glance, indicating a pleasant or unpleasant emotion? What is Penelope herself feeling? Collectively these questions become the general question: What is the subject of this picture? Does it represent Telemachus telling Penelope of his search for Odysseus, or does it show the Suitors surprising Penelope in her ruse of unravelling the shroud she claims to be weaving? We do not know enough of the language to be sure about it.

Physical expression of the mental and spiritual is one of Alberti's main preoccupations in his treatise on painting:

Movements of the soul are recognized in movements of the body . . . There are movements of the soul, called affections—grief, joy, fear, desire and others. There are movements of the body: growing, shrinking, ailing, bettering, moving from place to place. We painters, wanting to show movements of the mind with movements of the body's parts, use only the movements from place to place.

It is equally a preoccupation of Guglielmo Ebreo's treatise on dancing:

The virtue of dancing is as an action demonstrative of spiritual movement, conforming with the measured and perfect consonances of a harmony that descends pleasurably through our sense of hearing to the intellectual parts of our cordial senses; there it generates certain sweet movements which, as if enclosed contrary to their own nature, strive to escape and make themselves manifest in active movement.

It is much reflected in fifteenth-century judgements of people, their gravity or levity, aggressiveness or amiability. And Leonardo again lays great emphasis and spends many pages on its importance for the appreciation of painting: 'the most important things in the discussion of painting are the movements proper to the mental condition of each living being.' But though he insists again and again on the need to distinguish one sort of movement from another, he naturally finds it difficult to describe in words the particular movements he means: he planned to describe the movements of 'anger, pain, sudden fear, weeping, flight, desire,

command, indifference, solicitude, and so on', but never actually did so.

This sort of sensibility and the standards behind it are elusive now—not least because we no longer believe the old pneumatic physiology through which they were rationalized. One sees them clearly only in the rather uninteresting form of a scale of freedom of movement proper to different types of people, from the vigour of young sparks to the restraint of elderly sages: as Alberti says, philosophers should not behave like fencers. But in gesture (plate 28), the most conventionalized physical expression of feeling, and in some ways the most useful for reading pictures, there are a few bearings to be found.

There are no dictionaries to the Renaissance language of gestures, though there are sources which offer suggestions about a gesture's meaning: they have little authority and must be used with tact, but suggestions borne out by consistent use in pictures do have a useful hypothetical role. Leonardo suggested two sources for the painter to draw on for gestures—orators, and dumb men. We can half follow him in this and look at two kinds of men who recorded some of their gestures—preachers, and monks bound to silence. Only a few hints come from the latter, lists of the language of signs developed in the Benedictine order for use during periods of silence. From the several hundred signs in the lists, half-a-dozen are worth trying on paintings; for instance:

Affirmation: lift your arm gently . . . so that the back of the hand faces the beholder.

Demonstration: a thing one has seen may be noted by opening the palm of the hand in its direction.

Grief: pressing the breast with the palm of the hand.

Shame: covering the eyes with the fingers.

Thus we are encouraged, for example, to read Masaccio's *Expulsion from Paradise* (plate 29) in a more precise way, as combining in the paired figures two inflections of emotion: it is Adam (*lumina tegens digitis*) who expresses shame, Eve (*palma premens pectus*) only grief. Any reading of this kind depends on context; even in the Benedictine lists a hand on the heart, a smile, and eyes raised to heaven indicated joy, not grief. And it is possible that Quattro-cento people themselves could mistake the meaning of a gesture or movement. S. Bernardino of Siena complained in one of his sermons that painters showed St. Joseph in the Nativity resting his chin on his hand (Colour Plate IV), indicating melancholy; but Joseph was a cheerful old man, he says, and should be shown so.

61

28. Florentine, mid 15th century. *Eight studies of a hand*. Rotterdam, Museum Boymans-van Beuningen. Chalk and wash.

29. (right) Masaccio. *The Expulsion from Paradise* (about 1427). Florence, S. Maria del Carmine. Fresco.

Though the gesture does often indicate melancholy, as at death beds, it is also used in the sense of meditation, as a Nativity context would suggest. Of course, it sometimes means both (plate 30).

A more useful and rather more authoritative source is through the preachers, skilled visual performers with a codified range of gesticulation not special to Italy. An Italian preacher could tour northern Europe successfully preaching even in places like Brittany and getting his effect largely through gesture and the quality of his delivery. Many Italians must have followed Latin sermons by the same means. There was biblical authority of a sort for this art of gesture: 'One must suppose that Christ used gesture when he said "Destroy this temple" (John II: 19)— putting his hand on his breast and looking towards the temple.' The preacher was taught to accent his texts in a similar way:

Sometimes the preacher should try to speak with horror and excitement, as in *Except ye turn, and become as little children, ye shall in no wise enter the Kingdom of heaven.* (Matthew 18: 3)
Sometimes with irony and derision, as in *Dost thou still hold fast thine integrity?* (Job 2: 9)
Sometimes with an agreeable expression, drawing the hands towards oneself [*attractio manuum*], as in *Come unto me, all thee that labour and art heavy laden, and I will give you rest.* (Matthew 11: 28)
Sometimes with elation and pride, as in *They are come from a far country unto me, even from Babylon.* (Isaiah 39: 3)
Sometimes with disgust and indignation, as in *Let us make a captain, and let us return into Egypt.* (Numbers 14: 4)
Sometimes with joy, raising the hands up [*elevatio manuum*], as in *Come, ye blessed of my Father . . .* (Matthew 25: 34)

The problem was always, where to draw the line; Thomas Waley's mid-fourteenth-century *De modo componendi sermones* urged:

. . . let the preacher be very careful not to throw his body about with unrestrained movement—now suddenly lifting up his head high, now suddenly jerking it down, now turning to the right and now with strange rapidity to the left, now stretching out both hands as if embracing East and West, now suddenly knitting the hands together, now extending his arms immoderately, now suddenly pulling them back. I have seen preachers who behaved very well in other respects, but who threw themselves about so much they seemed to be fencing with somebody, or to be insane enough to throw themselves and their pulpit to the ground, were there not people there to restrain them.

Fra Mariano da Genazzano—a preacher particularly admired for his delivery by the humanist Poliziano—collected his freely falling tears in cupped hands and threw them at the congregation. Such excesses were unusual enough to cause the comment through which we know about them, but a more moderate and traditional set of histrionic accents was evidently normal. There is a succinct English list of the conservative minimum in the third edition of the *Mirror of the World*, from the 1520s:

[1] . . . whan thou spekest of a solempne mater to stande vp ryghte with lytell mevynge of thy body, but poyntynge it with thy fore fynger.
[2] And whan thou spekyst of any cruell mater or yrefull cause to bende thy fyst and shake thyn arme.
[3] And whan thou spekyst of any heuenly or godly thynges to loke vp and pointe towards the skye with thy finger.
[4] And whan thou spekest of any gentilnes, myldeness, or humylyte, to ley thy handes vpon thy breste.
[5] And whan thou spekest of any holy mater or devocyon to holde vp thy handes.

Developing a list like this in one's mind, revising and enlarging it from one's experience of the pictures, is a necessary part of looking at Renaissance pictures. Handling the same matter as the

30. Vittore Carpaccio. *The Dead Christ with St. Jerome and Job* (about 1490). New York, Metropolitan Museum of Art. Panel.

31. Fra Angelico. *The Coronation of the Virgin* (about 1440–5). Florence, S. Marco.
Fresco.

preachers, in the same place as the preachers, the painters let
the preachers' stylized physical expressions of feeling enter the
paintings. The process can be watched under way in Fra
Angelico's *Coronation of the Virgin* (plate 31). Fra Angelico uses
the fifth gesture on our list to make six preachers—or at least six
distinguished members of the Order of Preachers—give a massive
cue to our response: when you speak of any holy matter or
devotion, hold up you hands. The gestures were useful for diversi-
fying a clutch of Saints, as in Perugino's fresco in the Sistine
Chapel of the *Charge to St. Peter* (plate 32). They were often useful
for injecting a richer narrative meaning into a group (plate 12).

66

This was pious gesture. Secular gesture was not discontinuous with it, but had a range of its own, difficult to pin down: unlike the pious kind, no one taught it in books, it was more personal, and it changed with fashion. A convenient example, and useful for reading some good paintings, is a gesture used in the second half of the century to indicate invitation or welcome. It can be studied in a woodcut of 1493 (plate 33) illustrating a Florentine edition of Jacobus de Cessolis' *Liber scaccorum*, a medieval allegory of the social order as a chess-board; the Queen's Bishop's Pawn is an innkeeper in the allegory, and one of three attributes by which one recognizes him is to be his gesture of invitation—'he has his right hand extended in the manner of a person who invites.' The palm of the hand is slightly raised and the fingers are allowed to fan slightly downwards.

Prompted by the woodcut we can find this gesture playing a

32. Perugino. *Donation of the Keys to St. Peter* (detail). Vatican. Sistine Chapel. Fresco.

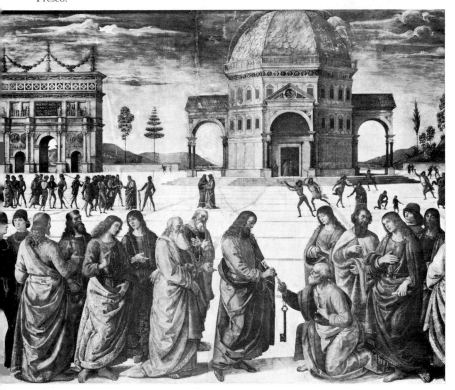

Lfexto fchacho dinanz ialalfino mãco pre
fe quefta forma. Che fu un huomo che ha
ueua lamano diritta ftefa amodo di perfo
na che inuitaffe. Nella man manca haueua uno pane et

33. Queen's Bishop's Pawn (The Innkeeper). From Jacobus de Cessolis. *Libro di giuocho delli scacchi* (Florence, 1493/94). Woodcut.

part in many paintings; even when we already know that the painting represents an encounter, knowing the gesture helps us to read it more crisply, because the gesture lends itself to different expressive inflections. In Botticelli's fresco of *A young man received by the Liberal Arts* (plate 34) the principal figure uses a straight-forward form to welcome the youth. Lodovico Gonzaga welcomes his son Cardinal Francesco Gonzaga with a version of seigneural restraint in Mantegna's *Camera degli Sposi* (plate 5). Pinturicchio, always quick with an apt gesture, makes dramatic play with it in a group of three temptresses on their way to tempt St. Antony Abbot (plate 35). Any hearer of Fra Roberto Caracciolo's or another preacher's sermon on St. Antony would know the girls represented the second of four stages of assault on him, *carnalis stimulatio*, and to the discriminating eye the character of the girls is already very clear in an over-free use of their hands. The maiden's handbook *Decor puellarum*, printed in Venice in 1471,

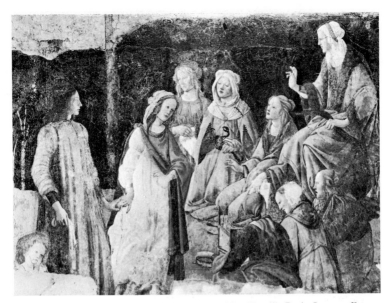

34. Botticelli. *The Liberal Arts Receiving a Young Man* (detail). Paris, Louvre. Fresco.

35. Bernardino Pinturicchio. *St. Antony Abbot and St. Paul the Hermit* (detail). Vatican, Appartamento Borgia. Fresco.

36. Botticelli. *Primavera*. Florence, Uffizi. Panel.

orthodoxly urged 'Whether you are standing still or walking, your right hand must always rest upon your left, in front of you, on the level of your girdle.' Neglecting this rule the middle temptress, though she is being restrained by a colleague with a better sense of timing, is making invitation gestures not with one hand but with two. A more subtle and important case is Botticelli's *Primavera*: here the central figure of Venus (plate 36) is not beating time to the dance of the Graces but inviting us with hand and glance into her kingdom. We miss the point of the picture if we mistake the gesture.

We also miss something if we lack the sense of a certain distinction between religious and profane gesture. It was not a sharp distinction: in particular, a primarily religious gesture is often used for a secular subject and carried a corresponding weight. In the absence of any other guide, the preacher's list can even give a little insight into the mystery of Pinturicchio's *Scene from the Odyssey*. Similarly, his use of the thoroughly secular gesture of invitation by the temptress in *St. Antony and St. Paul* is a profane accent with a purpose. But generally religious pictures lean to pious gesticulation, removing the holy stories a little from

the plane of everyday profane life, establishing a distinct mode of physical events, supra-normal, a distinct grand style.

7. A figure played its part in the stories by interacting with other figures, in the groupings and attitudes the painter used to suggest relationships and actions. The painter was not the only practitioner of this art of grouping: in particular, the same subjects were often represented in sacred drama of one kind or another. This is not true of all cities. In Florence there was a great flowering of religious drama during the fifteenth century, but in Venice such presentations were forbidden. Where they did exist they must have enriched people's visualization of the events they portrayed, and some relationship to painting was noticed at the time. In 1439 a Russian bishop, in Florence for the Council of Florence, saw and described two plays he attended in churches, the *Annunciation* and the *Ascension*. He remarked on the similarity of this or that detail with paintings: 'The Apostles had bare feet and were as one sees in holy images.' 'The angel Gabriel was a beautiful youth, dressed in a gown as white as snow, decorated with gold—exactly as one sees heavenly angels in paintings.' But his and other descriptions of the sacred dramas do not tell us much about what we want to know: the way in which one actor physically addressed another. Two things however seem fairly clear. The first, negative and presumptive, is that the descriptions we have of sacred representations often point to their depending on spectacular effects which have little to do with the refined narrative suggestion of the painter. The plays seen by the Russian bishop in 1439 made their point with elaborate mechanical means, actors suspended on strings, great revolving discs, massed sources of artificial light, people going up and down in wooden clouds. Representations of the stories in the streets, like the St. John's Day celebrations in Florence described by Matteo Palmieri in 1454, because they were less verbal and had a stronger element of the *tableau vivant*, seem closer to the painter, but even they relied on a splendour of numbers: 200 horsemen followed the Three Kings in 1454. There were many more modest shows, of course, but the painter, using the complex and subtle grouping of a few figures to suggest a dramatic event, handling static figures in such a way as to suggest mobile relationships but not contradicting the fact of his figures being immobile, could have only a limited amount in common with any of this.

In the second place, such fragmentary hints as one can find about the acting of the plays suggest that what they had in

common with the pictures may have been, paradoxically, what seem to us anti-dramatic conventions rather than realism. For instance, the plays were introduced by a choric figure, the *festaiuolo*, often in the character of an angel, who remained on the stage during the action of the play as a mediator between the beholder and the events portrayed: similar choric figures, catching our eyes and pointing to the central action, are often used by the painters (plate 37). They are even recommended by Alberti in his *Treatise on Painting*: 'I like there to be a figure which admonishes and instructs us about what is happening in picture. . . .' The Quattrocento beholder would have perceived such choric figures through his experience of the *festaiuolo*. Or

37. Filippo Lippi. *The Virgin Adoring the Child* (about 1465). Florence, Uffizi. Panel.

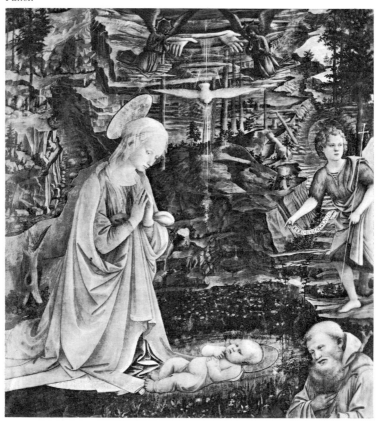

38. Piero di Cosimo. *The Visitation* (about 1490–1500). Washington, National Gallery of Art. Panel.

again, the plays were acted by figures which did not normally leave the stage between their appearances; instead they sat in their respective *sedie* on the stage, rising to speak their lines and move through their actions. The Florentine play of *Abraham and Hagar* has unusually clear directions for this:

When he has finished the prologue, the *festaiuolo* goes to his seat. And Abraham sits in a raised position, and Sarah near him; and at their feet on the right is Isaac, and to the left, rather further away, are Ishmael and Hagar his mother. And at the end of the stage on the right there should be an altar, to which Abraham will go to pray; and at the end of the stage on the left there must be a hill on which is a wood with a large tree where a spring will appear when the moment comes [for the episode of Hagar and the angel].

Hagar and Ishmael take no part for the first few minutes: they wait in their seats, as Abraham will return to his. This convention too has its counterpart in the logic of many paintings (plate 38).

For instance, in Filippo Lippi's *Virgin and Child with Saints* the assisting figures of saints sit awaiting their moment to rise and interpret, much as Prophets did in Florentine plays of the Annunciation.

In any event, with what one knows of these various spectacles one is still some way from the centre of the problem of the quality that interests us in the paintings: which is, how the depicted stance of, say, two figures towards each other can be so richly evocative of an intellectual or emotional relationship—hostility, love, communication—on a level less explicit than assault, embraces, holding of the ear, or even than truncated versions of these actions. The painter worked with nuances: he

39. Aesop and Croesus. From Aesop. *Vita [et] Fabule* (Naples, 1485). Woodcut.

knew that his public was equipped to recognize with little prompting from him that one figure in his painting was Christ, another John the Baptist, and that John was baptizing Christ. His painting was usually a variation on a theme known to the beholder through other pictures, as well as private meditation and public exposition by preachers. Along with various motives of decorum this excluded violent registration of the obvious. The painters' figures play out their roles with restraint.

But this muted mode of physical relationship did feed on a grosser vernacular institution of group and gesture; this does not often intrude into paintings but is occasionally documented in a humbler medium like woodcut book illustration. A woodcut from a book like the Naples *Life and Fables of Aesop* of 1485 (plate 39) works with a vigorous, vulgar and very eloquent group of figures. Even before we have read the text we get a clear intimation from the woodcut of the sort of action under way. The kneeling figure with half-closed hands is apparently appealing to the figure on the throne, whose raised hand suggests he is impressed. The two figures standing on the right are grouped in such a way as to imply association with each other. The one extends a hand as if also in mild appeal; the other, who is surely grinning, half hooks a thumb in the direction of the ship. If we check this against the text, we find that, indeed, the kneeling figure is Aesop, pleading successfully with King Croesus for tribute brought to him by the Samians, on the right, to be returned to Samos.

The painters version of this suggestiveness was muted, but even the most notoriously reticent painter in these matters, Piero della Francesca, relied on the beholder's disposition to read relationships into groups. In his *Baptism of Christ* there is a group of three angels on the left (plate 40) who are used for a device which Piero often exploited. We become aware that one of the figures is staring in a heavy-lidded way either directly at us or an inch or two above or beside our heads. This state institutes a relationship between us and it, and we become sensitive to this figure and its role. He is almost a *festaiuolo*. The role is always a minor one, an attendant angel or a lady-in-waiting; but it will be standing in a close relationship with other similar figures. Often, as in the *Baptism of Christ,* its head will be next to other heads hardly differentiated from it in type, and these are looking with fixed attention at the most central point of the narrative, the baptized Christ or the meeting of Solomon and Sheba. In this way we are invited to participate in the group of figures assisting

40. Piero della Francesca. *The Baptism of Christ* (detail). London, National Gallery. Panel.

at the event. We alternate between our own frontal view of the action and the personal relationship with the angel group, so that we have a compound experience of the event: the clarity of one kind of access is enriched by the intimacy of the other. The device works on us more subtly than a hooked thumb or pointing finger and it also demands more from us: it depends on our disposition to expect and work for tacit relationships with and within a group of people, and this effort on our part gives our recognition of the group's meaning all the more charge. We become active accessories to the event. This transmutation of a vernacular social art of grouping into an art where a pattern of people—not gesticulating or lunging or grimacing people—can still stimulate a strong sense of some psychological interplay, is the problem: it is doubtful if we have the right predispositions to see such refined innuendo at all spontaneously.

76

One fifteenth-century activity like enough the painters' groupings to give us a little insight into this is dancing: specifically the *bassa danza* (plate 41), the slow pacing dance that became popular in Italy during the first half of the century. Several things make the *bassa danza* a helpful parallel, much more so than the religious spectacles. In the first place it was an articulate art with its own treatises—the earliest is by Domenico da Piacenza, evidently written in the 1440's—and its own theoretical terminology: like the art of rhetoric, dancing had five Parts—*aere, maniera, misura, misura di terreno, memoria*. Secondly, the dancers were conceived and recorded as groups of figures in patterns; unlike the French, the Italians did not use a dance notation but described the movements of the figures fully, as if they were being seen by a spectator. Third, the parallel between dancing and painting seems to have suggested itself to fifteenth-century people too. In 1442 Angelo Galli, a poet at Urbino, wrote a sonnet to the painter Pisanello with a list of his qualities:

> Art, *misura, aere* and draughtsmanship,
> *Maniera*, perspective and a natural quality—
> Heaven miraculously gave him these gifts.

41. Guglielmo Ebreo. *Trattato del ballo* (about 1470). Paris, Bibliothèque Nationale, MS. italien 973, miniature on fol. 21 v.

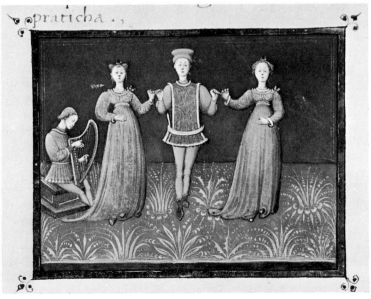

If we take the terms *aere, maniera* and *misura* in their dancing sense, as Domenico da Piacenza and his pupils define them, they are very apt criticism of Pisanello (plate 42). *Aere*, according to Guglielmo Ebreo, is 'airy presence and elevated movement, demonstrating with the figure . . . a smooth and most humane emphasis.' *Maniera*, according to Domenico, is 'a moderate movement, not too much and not too little, but so smooth that the figure is like a gondola oared by two oars through the little waves of a calm sea, these waves rising slowly and falling quickly.' *Misura* is rhythm, but flexible rhythm, 'slowness compensated by quickness.'

We saw how Alberti's treatise on painting and Guglielmo Ebreo's treatise on dancing shared a preoccupation with physical movements as a reflex of mental movements. The dancing manual was the more grandiloquent about it, since this was the whole point of dancing, at least from an intellectual point of view. Domenico da Piacenza cites Aristotle in defence of the art. But as well as principles the treatises offer, in the form of the dances they describe, model figure patterns quite transparently expressive of psychological relationships. The dances were semi-dramatic. In the dance called *Cupido* or *Desire* the men perform a series of convolutions suggesting that they are tied to and are at the same time pursuing their partners, whose role is retreat. In the dance called *Jealousy* three men and three women permute partners and each man goes through a stage of standing by himself, apart from the other figures. In *Phoebus* two women act as a mobile foil for an exhibitionist man; and so on.

How the painters' style of grouping was cognate with this is usually clearest not in religious paintings but in paintings of the new classical and mythological subjects. In these the painter was forced to new invention in a fifteenth-century mode, instead of just refining and adapting the traditional religious patterns to the fifteenth-century sensibility. Botticelli's *Birth of Venus* (plate 43) was painted in the 1480s for Lorenzo di Pierfrancesco de' Medici as the *Primavera* was some years earlier: his cousin Lorenzo di Piero de' Medici, il Magnifico, had composed a dance *Venus*, probably in the 1460s:

> *Bassa danza called Venus, for three persons, composed by*
> *Lorenzo di Piero di Cosimo de' Medici.*

First they do a slow sidestep, and then together they move with two pairs of forward steps, beginning with the left foot; then the middle dancer turns round and across with two reprises, one on the left foot

sideways, and the other on the right foot, also across; and during the time that the middle dancer is carrying out these reprises the other two go forward with two triplet steps and then give half a turn on the right foot in such a way as to face each other; and then they do two reprises, one on the left foot and the other on the right; and then they come towards each other with a triplet, starting from the left foot; then they do a lively turn all together; then the middle dancer comes towards the others with two pairs of forward steps; and at the same time the others make a reverence on the left foot . . .

This is about a third of the dance, which develops along the same lines and is then repeated. The form is always of the two side figures dependent on the central one. Sex is not specified. The similar sense of informed pattern is of course not a matter of the particular dance having influenced the particular picture: it is that both the dance and the picture of Venus were designed for people with the same habit of seeing artistic groups. The sensibility the dance represents involved a public skill at interpreting figure patterns, a general experience of semi-dramatic arrangements that allowed Botticelli and other painters to assume a similar public readiness to interpret their own groups. When he had a new classical subject, with no established tradition for the

43. Botticelli. *The Birth of Venus* (about 1485). Florence, Uffizi. Panel.

arrangement and no assurance that the story was very widely or intimately known, he could let the figures dance their relationship out, as Botticelli lets them in his *Pallas and the Centaur* (plates 44–45). It does not matter much if we are not familiar with the story: the picture can be taken in the spirit of a *ballo in due*, a dance for two.

8. We have been looking at the painters' representations of people in terms of precisely that—represented people assessed not by the standards applied to real people but by standards adapted from experience of real people. At the same time the painters' figures and their environment were also colours and shapes, very intricate ones, and the fifteenth-century equipment for understanding them as such was not altogether the same as ours.

This is a great deal less clear and probably less important in the colours than in the shapes. Assembling symbolic series of colours was a late medieval game still played in the Renaissance. St. Antoninus and others expounded a theological code:

White:	purity
Red:	charity
Yellow-gold:	dignity
Black:	humility

Alberti and others gave an elemental code:

Red:	fire
Blue:	air
Green:	water
Grey:	earth

There was an astrological code, and Leonello d'Este, Marquis of Ferrara, was guided by it in his choice of clothes for the day. There were others too and, of course, the effect is that they largely cancel each other out. Each could be operative only inside very narrow limits: one might refer in one's mind to the heraldic code for coats-of-arms, or to the theological code when contemplating religious habits, and no doubt the astrological code when looking at Leonello d'Este. But unless reference to a code was prompted by special circumstantial cues of this kind, it could not be part of the normal digestion of visual experience. Symbolisms of this class are not important in painting, even though there are sometimes peculiarities consistent with them. There are no secret codes worth knowing about in the painters' colour.

The nearest thing to a code is what we met earlier, a greater

44. Florentine, about 1465–80. *Dancing Couple*. Engraving.

sensitivity than ours to the relative splendour of hues and the
medium of emphasis this offered the painter. Hues were not
equal, were not perceived as equal, and the painter and his
client lived with this fact as well as they could. When Gherardo
Starnina followed his instructions to use two florin blue for the
Virgin and one florin blue for the rest of the picture (p. 11)
he was accenting a theological distinction. There are three levels
of adoration: *latria* is the ultimate worship due only to the
Trinity; *dulia*, the reverence for excellence, is what we owe the
Saints, Angels and Fathers; *hyperdulia*, a more intense form of
this, is due to the Virgin alone. In Starnina's frescoes *hyperdulia*
measured two florins the ounce. No doubt the *latria* due to the
Father, Son and Holy Spirit was expressed in gold accents. The
accent offered by a valuable pigment was not something aban-
doned by the painters once they and their clients had become shy
about flaunting large quantities of such pigments for their own

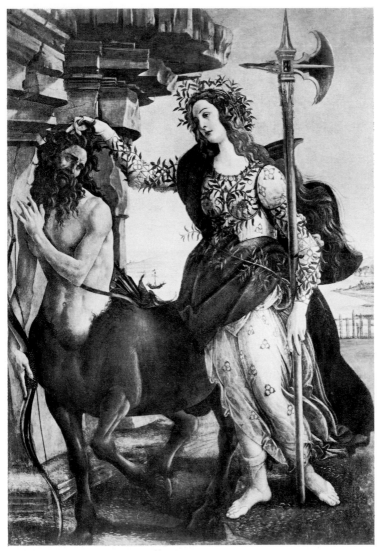

45. Botticelli. *Pallas and the Centaur* (about 1485). Florence, Uffizi. Panel.

sake. There were expensive colours, blues made from lapis lazuli or reds made from silver and sulphur, and there were cheap earth colours like ochre and umber. The eye was caught by the former before the latter (Colour Plate IV).

This may seem a shabby fact to us—though it would be difficult rationally to say quite why—and there was some intellectual and, even more clearly, pictorial distaste for it at the time: the tension is a characteristic part of the period. The distaste expressed itself in an argument for a pure relativity of colour. The most eloquent literary statement came in about 1430 from the humanist Lorenzo Valla, exasperated by a foolish heraldic hierarchy of colours the trecento lawyer Bartolo da Sassoferrato had pompously laid down:

Now let us look at Bartolo's theories of colour . . . the colour gold [*aureus*] is the most noble of colours, he says, because light is represented by it; if someone wished to represent the rays of the sun, the most luminous of bodies, he could not do it more properly than by rays of gold; and it is agreed that there is nothing more noble than light. But if by gold we mean a tawny [*fulvus*] or reddish-yellow [*rutilus*] or yellowish [*croceus*] colour, who was ever so blind or sottish as to call the sun yellowish? Raise your eyes, you ass Bartolo . . . and see whether it is not rather of a silvery white colour [*argenteus*].

Which colour does he put next? . . . Blue, he says, is next—though the word he barbarously uses to denote 'blue' is the effeminate *azurus* rather than *sapphireus*. Air, he says, is represented by this colour. But does not this suggest he is now following the order of the elements? It does. But why did he leave the moon out . . . ? If you put the sun first, then you ought to make the moon second, and if you call the one golden you should call the other silver and next after the sun, just as silver comes second after gold . . . You put sapphire-colour in second place, Bartolo, seduced away from the hierarchy of Heavenly Bodies by the hierarchy of the Elements. Of course you do not think it right to take your examples from metals, stones, grasses and flowers; they would have been more appropriate, but you saw them as humble and abject things, you, O Bartolo, that are constitute of sun and of air alone. For, if we are following the order of elements, you have mentioned two but left two more out; and we, waiting for the grand and lofty progression to continue, feel let down. If the first colour is of fire and the second of air, the third will be of water and the fourth of earth. . . .

But let us pass on. A little later the man says white is the noblest colour and black the lowest; and as for the other colours, they are good to the extent that they approach white and inferior as they approach blackness. There are a number of things to complain about in this. Does he not remember now what he said about gold . . . ? And why do we die silk purple or white linen red, unless we find red more attractive than white? For while white is indeed the plainest and purest colour, it is not invariably the best. . . .

And what shall I say of black? Indeed I find it is not considered of inferior excellence to white: the raven and swan are both holy to Apollo . . . In my view Ethiopians are more beautiful than Indians for

84

the very reason that they are blacker. Why appeal to human authority when it is made puny by the heavenly? . . . If the Maker of all things saw no difference of value in colours, why should we little men do so? Do we know more than God and shame to follow him? In Jesus' name, even if Bartolo did not consider the stones and grasses and flowers and so many other things in his pronouncement on dress and ornament, how can he have overlooked the birds' dress—the cock, peacock, woodpecker, magpie, pheasant and all the rest. . . . Come then, hearken to this man at odds with God and men; and let us impose a law on our Pavia girls, now spring is nearly here, not to presume to weave garlands except as Bartolo prescribes. . . . But enough of this. It is stupid to lay down laws about the dignity of colours.

There are many pictorial statements of a similar argument (Colour Plate II).

Valla's appeal to the limited, not to say medieval, sector of Nature represented by flowery meadows was a conventional move: the sculptor Filarete invoked the same meadows in some rather unhelpful remarks about which hues go well with which:

Learn from Nature and the fine arrangement of flowers in the meadows and grasses. Any colour goes well with green—yellow, red and even blue. You know how well white and black suit each other. Red does not go so well with yellow; it does go well with blue, but better still with green. White and red are good together.

Alberti's remarks on colour harmonies are less simple-minded, and unrelated to the element symbolism he also perfunctorily admitted:

It will be pleasing in a picture if one colour is different from the next. For instance, if you are painting Diana and her band of nymphs, let one nymph have green drapery, another white, another rose, another yellow —different colours for each, and in such a way that light tones are always next to dark tones. If you have this contrast [of hues and of tones], the beauty of the colours will be clearer and more graceful. And there exists a certain affinity of colours, one joined with another producing a pleasing and worthy effect (Colour Plate I). A rose colour and a green or blue colour next to each other give beauty and seemliness to each other. The colour white produces a fresh and graceful effect not only next to grey and yellow but next to almost any colour. Dark colours stand excellently among light ones, and similarly light colours are well if surrounded by dark. Thus will the painter dispose his colours.

Alberti's remarks on colour combination are the most distinguished one finds, and the difficulty of understanding quite what he means is a warning: words were not the medium in which fifteenth-century men, or anyone else, could register their colour sense.

85

9. In Florence, and in most other towns one knows about, a boy in the private or municipal lay schools—the alternatives were the church schools, now rather in decline, or one of the few humanist schools—was educated in two stages. For about four years from the age of six or seven he was at a primary school or *botteghuzza*, where he learned reading and writing with some elementary business correspondence and notarial formulas. Then, for about four years from the age of ten or eleven, most would go on to a secondary school, the *abbaco*. They read a few more advanced books here, like Aesop and Dante, but the weight of the teaching was now on mathematics. A few went on after this to a university to become lawyers, but for most middle-class people the mathematical skills of the secondary school were the climax of their intellectual formation and equipment. Many of their primers and handbooks survive and one can see very clearly what sort of thing this mathematics was: it was a commercial mathematics adapted to the merchant, and both of its principal skills are deeply involved in fifteenth-century painting.

One of these is gauging. It is an important fact of art history that commodities have come regularly in standard-sized containers only since the nineteenth century: previously a container —the barrel, sack or bale—was unique, and calculating its volume quickly and accurately was a condition of business. How a society gauged its barrels and surveyed its quantities is important to know because it is an index of its analytical skills and habits. For instance, in the fifteenth century Germany seems to have gauged its barrels with complex prepared rulers and measures from which the answers could be read off: the job was often done by a specialist. An Italian, by contrast, gauged his barrels with geometry and π:

There is a barrel, each of its ends being 2 bracci in diameter; the diameter at its bung is $2\frac{1}{4}$ bracci and halfway between bung and end it is $2\frac{2}{9}$ bracci. The barrel is 2 bracci long. What is its cubic measure?

This is like a pair of truncated cones. Square the diameter at the ends: $2 \times 2 = 4$. Then square the median diameter $2\frac{2}{9} \times 2\frac{2}{9} = 4\frac{76}{81}$. Add them together: $8\frac{76}{81}$. Multiply $2 \times 2\frac{2}{9} = 4\frac{4}{9}$. Add this to $8\frac{76}{81} = 13\frac{31}{81}$. Divide by $3 = 4\frac{112}{243}$... Now square $2\frac{1}{4} = 2\frac{1}{4} \times 2\frac{1}{4} = 5\frac{1}{16}$. Add it to the square of the median diameter: $5\frac{1}{16} + 4\frac{76}{81} = 10\frac{1}{129}$. Multiply $2\frac{2}{9} \times 2\frac{1}{4} = 5$. Add this to the previous sum: $15\frac{1}{129}$. Divide by 3: $5\frac{1}{3888}$. Add it to the first result: $4\frac{112}{243} + 5\frac{1}{3888} = 9\frac{1792}{3888}$. Multiply this by 11 and then divide by 14 [i.e. multiply by $\frac{5}{4}$]: the final result is $7\frac{23600}{54432}$. This is the cubic measure of the barrel.

It is a special intellectual world.

These instructions for gauging a barrel are from a mathematical handbook for merchants by Piero della Francesca, *De abaco*, and the conjunction of painter and mercantile geometry is very much to the point. The skills that Piero or any painter used to analyse the forms he painted were the same as Piero or any commercial person used for surveying quantities (plate 47). And the connection between gauging and painting Piero himself embodies is very real. On the one side, many of the painters, themselves business people, had gone through the mathematical secondary education of the lay schools: this was the geometry they knew and used. On the other side, the literate public had these same geometrical skills to look at pictures with: it was a medium in which they were equipped to make discriminations, and the painters knew this.

An obvious way for the painter to invoke the gauger's response was to make pointed use of the repertory of stock objects used in the gauging exercises, the familiar things the beholder would have been made to learn his geometry on—cisterns, columns, brick towers, paved floors and the rest. For instance, almost every handbook used a pavilion as an exercise in calculating surface areas; it was a convenient cone, or compound of cylinder and cone, or of cylinder and truncated cone, and one was asked to work out how much cloth would be needed to make the pavilion. When a painter like Piero used a pavilion in his painting (plate 46) he was inviting his public to gauge. It was not that they would try to make calculations about surface areas or volumes, of course, but that they were disposed to recognize the pavilion first as a compound of cylinder and cone, and then secondarily as something deviating from the strict cylinder and cone. The result was a more sharply focussed awareness of the pavilion as an individual volume and shape. There is nothing trivial about Piero's use of his public's skill here; it is a way of meeting the Church's third demand of the painter, that he should use the visual sense's special quality of immediacy and force. The beholder's precise and familiar assessment of the pavilion mediates between his own position in the everyday and the mystery of the Virgin's conception, rather as the three Angels are mediators in the *Baptism of Christ*.

In his public appearances, the painter more normally depended on his public's general disposition to gauge. To the commercial man almost anything was reducible to geometrical figures underlying any surface irregularities—the pile of grain reduced to a cone, the barrel to a cylinder or a compound of

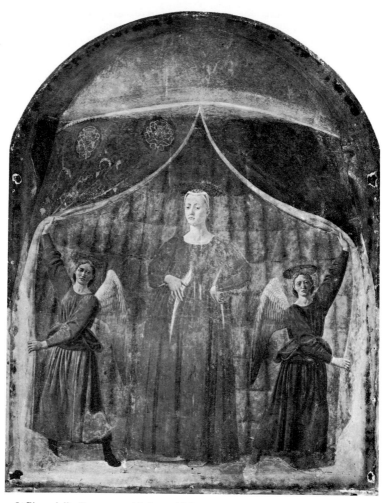

46. Piero della Francesca. *Madonna del Parto* (about 1460). Monterchi, Cimitero. Fresco.

truncated cones, the cloak to a circle of stuff allowed to lapse into a cone of stuff, the brick tower to a compound cubic body composed of a calculable number of smaller cubic bodies, and so on. This habit of analysis is very close to the painter's analysis of appearances (plate 48). As a man gauged a bale, the painter surveyed a figure. In both cases there is a conscious reduction of irregular masses and voids to combinations of manageable

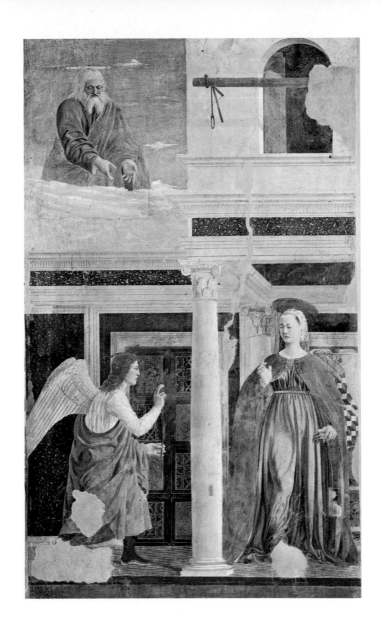

I. Piero della Francesca. *The Annunciation* (about 1455). Arezzo, S. Francesco. Fresco.

II. Giovanni Bellini. *The Transfiguration* (about 1460). Venice, Museo Correr. Panel.

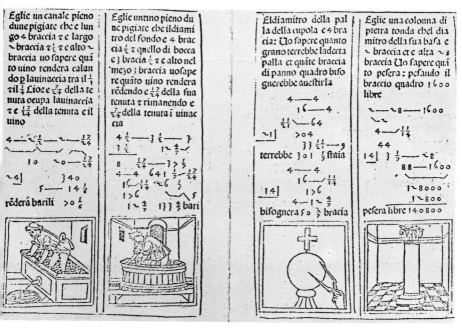

47. Gauging exercises. From Filippo Calandri. *De arimethrica* (Florence, 1491). pp. O iv v.–O v r.

geometric bodies. A painter who left traces of such analysis in his painting (plate 50) was leaving cues his public was well equipped to pick up.

There are several ways of seeing Niccolò da Tolentino's hat in Uccello's *Battle of San Romano* (plate 49). One is as a round hat with a flouncy crown; another is as a compound of a ring and plump squared-off disc disguised as a hat. These are not mutually exclusive: Lorenzo de' Medici, who had this picture in his bedroom, would have seen both and accepted it as a sort of serial geometrical joke. It demands attention initially by its exaggerated size and splendour; then in the second stage by the paradox of the pattern on this most three-dimensional of hats behaving as if it were two-dimensional, spreading itself flatly on the picture plane without regard for the object's shape; then, in the third stage, by a dawning anxiety about the polygon of the crown. Underlying it is something rectilinear, certainly; but is it hexagonal or four-sided? It is a problem hat, and as a way of making Niccolò da Tolentino notice-able the device of paradox and ambiguity is obviously effective,

49. Paolo Uccello. *The Battle of S. Romano* (detail). London, National Gallery. Panel.

though the geometry is less profoundly functional in the narrative than is the case with Piero's pavilion. But to construe the crown at all demands not only certain habits of inference—such as a presumption that the bit you cannot see is a regular continuation of the part you can—not only this, but a factor of energy and interest as well: that is, we will not bother to get this far unless we enjoy the exercise in some way, even if only on the level of exercising skills we value highly. Uccello's pictorial style must meet the proper cognitive style for the picture to work.

The geometrical concepts of a gauger and the disposition to put them to work sharpen a man's visual sense of concrete mass. He is likely to be aware at a higher level of the character of Adam in Masaccio's *Expulsion from Paradise* (plate 29) as a compound of cylinders or of the figure of Mary in Masaccio's *Trinity* (plate 64) as a massive truncated cone, and so of the figure itself. In the Quattrocento social world of the painter this constituted a stimulus to using his available means—in Masaccio's case, the Tuscan con-

48. (left) Giovanni Bellini. *The S. Giobbe Altarpiece* (about 1480). Venice, Accademia. Panel.

50. Antonello da Messina. *Virgin Annunciate* (about 1473). Munich, Alte Pina-kothek. Panel.

vention of suggesting a mass by representing the tones of light and shadow one source of lighting would produce on it—in order to register his volumes clearly, with recognizable skill. A painter working in another convention could use different means to a similar end. For instance, Pisanello came from a north Italian tradition that registered a mass less with tones than with its characteristic edges. He could respond to the gauging sensibility

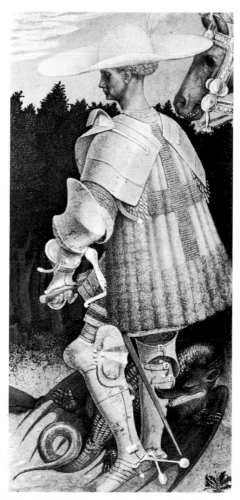

51. Pisanello. *The Virgin and Child with St. George and St. Antony Abbot* (detail). London, National Gallery. Panel.

with figures set in twisted, counterpoised attitudes so that the edge presented to the picture plane spirals round the body like ivy round a column (plate 51). In many parts of Italy people seem to have preferred this convention, perhaps because it was the sort of painting they were used to and perhaps because they liked the mobile impression it made. In any event, Pisanello's *St. George* is a gauger's field-day in its own way.

10. In his treatise *On Civil Life* the Florentine Matteo Palmieri, whose description of the St. John's Day procession we have already met, recommended the study of geometry for sharpening the minds of children. The banker Giovanni Rucellai remembered this, but replaced geometry by arithmetic: 'it equips and spurs on the mind to examine subtle matters.' This arithmetic was the other wing of the commercial mathematics central to Quattrocento culture. And at the centre of their commercial arithmetic was the study of proportion.

On 16 December 1486 Luca Pacioli the mathematician was in Pisa, and during the day he called in at the cloth warehouse of his friend Giuliano Salviati. A Florentine merchant, Onofrio Dini, was also there, and there was conversation. One of the things the Florentine, Onofrio Dini, kept his end up with was the following problem: A man was lying on his death bed and wished to make his will in as foresighted a way as he possibly could. His estate, he reckoned, amounted to the sum of 600 ducats. The man's wife was shortly to give birth to a child, and he wished to make specific provision for both his widow and his orphan. He therefore made this disposition: if the child was a girl then it was to receive 200 ducats only, while the mother would receive 400; if, on the other hand, the child was a boy it was to have 400 ducats and the widow only 200. Shortly afterwards the man died, and in due course his widow's time came. But she gave birth to twins, and, to make things more complicated, one of the twins was a boy and the other a girl. The problem is: if the proportions between mother, son and daughter desired by the deceased are honoured, how many ducats will mother, son and daughter each receive?

Onofrio Dini probably did not realize it, but the game of proportion he was playing was an oriental game: the same problem of the widow and the twins appears in a medieval Arabic book. In turn the Arabs had learned this kind of problem and the arithmetic involved in them from India, for they were a Hindu development of the seventh century or earlier. Along with much other mathematics they were brought to Italy from Islam early in the thirteenth century by Leonardo Fibonacci of Pisa. Italy was full of problems like that of the widow and the twins in the fifteenth century. They had an entirely practical function: underneath the costumes of the widow and the twins are three early capitalists carving up a profit according to their relative investment in some trading venture. It is the mathematics of commercial partnership, and it was in this context that Luca

Pacioli retells Onofrio Dini's story in his *Summa de Arithmetica* of 1494.

The universal arithmetical tool of literate Italian commercial people in the Renaissance was the Rule of Three, also known as the Golden Rule and the Merchant's Key. It was basically a very simple thing; Piero della Francesca explains:

The Rule of Three says that one has to multiply the thing one wants to know about by the thing that is dissimilar to it, and one divides the product by the remaining thing. And the number that comes from this is of the nature of that which is dissimilar to the first term; and the divisor is always similar to the thing which one wants to know about.

For example: seven bracci of cloth are worth nine lire; how much will five bracci be worth?

Do it as follows: multiply the quantity you want to know about by that quantity which seven bracci of cloth are worth—namely, nine. Five times nine makes forty-five. Divide by seven and the result is six and three sevenths.

There were different conventions for laying out the four terms involved:

In the thirteenth century Leonardo Fibonacci had used the rather Islamic form (a). By the fifteenth century many people preferred the terms in a straight line, as in (b). In some copybook contexts the convention grew up in the later Renaissance of connecting the terms with curved lines, as in (c). Nowadays we would represent the relationships as in (d), but this notation was not used before the seventeenth century. The curved lines in notation (c) were not just decoration: they noted the relationships between the terms, because a series of terms in the Rule of Three is in geometric proportion. It is in the nature of the form and the operation that (1) the first term stands to the third term as the second stands to the fourth, and also that (2) the first term stands to the second term as the third stands to the fourth, and also that (3) if one multiplies the first term by the fourth term the product will be the same as the product of the second and third terms. A man noted these relationships as a means of checking his calculations.

Libbre cento di Firenze fanno in Vinegia libbre
c.xiiii.& duo septimi alsoctile: Libbre cento di Fi
renze fanno in Vinegia libbre.lxxi.& duo septimi
algrosso. Libbra una doro filato di Vinegia fa infi
renze once undici danar.xiiii. Once octo dariento
sodo di Vinegia fa infirenze once octo danar dieci
Braccia quaranta di panno difirenze fanno in Vi
negia braccia trentacinque & mezo. Staia tre & me
zo in tre & tre quarti di grano di firenze fa in Vi
negia staia uno. Cogno uno & un terzo diuino di
firenze fa in Vinegia anfore uno. Moggio uno di
uallonia che in Vinegia staia dodici pesa in Firen
ze libbre octocencinquanta in nouecento. Miglia
io uno dolio di Vinegia che da mitri quaranta tor
na in Firenze orcia uenti & un octauo o circa pesa
ilmirro dellolio in Vinegia libbre treta once tre al
grosso & ei amisura libbre.xxv.

❡ Firenze con Padoua. Capi. xxiii.
Libbre cento di Firenze fanno i Padoua libbre.c.
xiiii.& duo septimi.

❡ Firenze con Cremona. Capi. xxiiii.
Libbre cento di Firenze fanno in Cremona.cento
tredici in cento quatordici. Cane dieci di panno di
firenze fanno in Cremona braccia quaranta.

❡ Firenze con Milano: Capi. xxv.
Libbre cento di Firéze fanno in Milano lib.c.v.
Libbra una darieto di firéze fa in Milano once
❡ Firenze con Viena del dalfinato. Ca. xxvi.
Marcho uno dariento diuienna fa in firenze once
octo danar tredici.
❡ Firenze con Ziara: Capi. xxvii.
Libbre cento di Ziara di stiauonia fanno in firen
ze libbre.lxxxxix. Marcho uno dariento di Ziara
fa in Firenze once octo danar dieci
❡ Firéze con Raugia dischiauonia. Ca: xxviii
Libbre cento di cera di Raugia fanno in firéze lib
bre cento cinque. Libbra una darieto di Raugia fa
in Firenze once undici & mezo.
❡ Firenze con Chiarenza. Capi xxix.
Cane dieci di panno di chiarenza fanno in Firen
ze.xi.& mezo. Moggio un duua passa dichiaren
za fanno infirenze libbre.lxxviii. Moggio uno di
ualonia di chiarenza fa in Firenze libbre Lib
bre.c.di firéze fanno in chiaréza libbre.lxxxviii
Once.i.di firéze fa in chiaréza pó.vi.& un quar
to. Moggio uno di grano di chiarenza fa in Firéze
staia uentidua.
❡ Firéze con Modon & Coró della morea. ca.30.
b ii

52. Florentine measures in exchange with those of other towns. From *Libro di
mercatantie et usanze de paesi* (Florence, 1481). pp. b i v.–b ii r.

The Rule of Three was how the Renaissance dealt with prob-
lems of proportion. Problems of proportion include: pasturage,
brokerage, discount, tare allowance, the adulteration of com-
modities, barter, currency exchange. These were very much more
prominent than they are now. For instance, exchange problems
were of an extraordinary complexity because each substantial
city had not only its own currency but its own weights and
measures. Plate 52 is a page from a Florentine *Libro di mer-
catantie* of 1481 and deals with the differential between Florentine
and some other cities' measures. Quattrocento people addressed
this formidable confusion with the Rule of Three, and a good half
of any of their treatises on arithmetic is given up to it. The
difficulties were not of the form itself, which is simple, but of
reducing a complex problem to the form, with the right terms in
the right places; and for problems like compound interest the
form was extended so that, instead of three initial terms, one
might have many more.

So fifteenth-century people became adept through daily

96

53. Proportion exercises. From Filippo Calandri. *De arimethrica* (Florence, 1491), pp. l ii v.—l iii r.

practice in reducing the most diverse sort of information to a form of geometric proportion: A stands to B as C stands to D. For our purpose, the important thing is the identity of skill brought both to partnership or exchange problems and to the making and seeing of pictures. Piero della Francesca had the same equipment for a barter deal as for the subtle play of intervals in his pictures (Colour Plate I), and it is interesting that it should be in relation to the commercial rather than the pictorial use that he expounds it. The commercial man had skills relevant to the proportionality of Piero's painting, for the small step from the internal proportions of a partnership to the internal proportions of a physical body was naturally taken in the normal course of commercial exercises. In plate 53 for instance, are two proportion problems done on a goblet and on a fish. The lid, bowl and foot of the cup, and the head, body and tail of the fish are set in proportion—not in dimension but in the commercially relevant matter of weight. The operations are cognate with those involved in studying the proportions of a man's head, as Leonardo described them in plate 54:

97

From *a* to *b*—that is, from the roots of the hair in front to the top of the head—should be equal to *cd*—that is, from the bottom of the nose to the meeting of the lips in the middle of the mouth; from the inner corner of the eye *m* to the top of the head *a* is equal to the distance from *m* down to the chin *s*; *s*, *c*, *f* and *b* are equidistant each from the next.

54. Leonardo da Vinci. *Study of the proportions of a head*. Windsor, Royal Library, No. 12601. Pen.

The painter's study of the proportions of the human body was usually a quite primitive affair in its mathematics, compared with what the merchants were used to.

The merchants' geometric proportion was a method of precise awareness of ratios. It was not harmonic proportion, of any convention, but it was the means by which a convention of

55. Leonardo da Vinci. *Calculation with the Rule of Three* (6:8 9:12). London, British Museum, MS. Arundel 263, fol. 32 r.

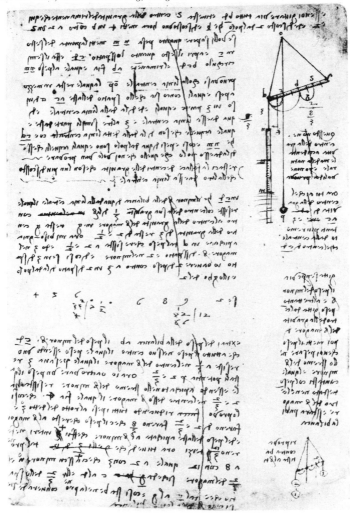

56. The harmonic scale. From Franchino Gafurio.*Theorica Musice* (Naples, 1480), title page. Woodcut.

harmonic proportion must be handled. More than this, even, its compact suggestiveness carried within itself a tendency towards harmonic proportion. In plate 55 Leonardo is using the Rule of Three for a problem about weights in a balance, and comes up with the four terms 6 8 9 (12): it is a very simple sequence that any merchant would be used to. But it is also the sequence of the Pythagorean harmonic scale—tone, diatessaron, diapente, and diapason—as it was discussed in fifteenth-century musical and architectural theory (plate 56). Take four pieces of string, of equal consistency, 6, 8, 9 and 12 inches long, and vibrate them under equal tension. The interval between 6 and 12 is an octave; between 6 and 9 and between 8 and 12 a fifth; between 6 and 8 and between 9 and 12 a fourth; between 8 and 9 a major tone. This is the whole basis of western harmony, and the Renaissance could note it in the form of the Rule of Three: Pietro Cannuzio's *Rules of Music's Flowers* even put this notation of the harmonic scale at the top of its title page (plate 57), an invitation to the mercantile eye. In Raphael's *School of Athens* the attribute of Pythagoras is a tablet with the same motif numbered VI, VIII, IX, XII. The harmonic series of intervals used by the musicians and sometimes by architects and painters was accessible to the skills offered by the commercial education.

Of course, the danger here is of over-statement: it would be absurd to claim that all these commercial people went around looking for harmonic series in pictures. The point to be made is less forthright. It is, first, that Quattrocento education laid exceptional value on certain mathematical skills, on gauging and the Rule of Three. These people did not know more mathematics than we do: most of them knew less than most of us. But they knew their specialized area absolutely, used it in important matters more often than we do, played games and told jokes with it, bought luxurious books about it, and prided themselves on their prowess in it; it was a relatively much larger part of their formal intellectual equipment. In the second place, this specialization constituted a disposition to address visual experience, in or out of pictures, in special ways: to attend to the structure of complex forms as combinations of regular geometrical bodies and as intervals comprehensible in series. Because they were practised in manipulating ratios and in analysing the volume or surface of compound bodies, they were sensitive to pictures carrying the marks of similar processes. Thirdly there is a continuity between the mathematical skills used by commercial people and those used by the painter to produce the pictorial

57. The harmonic scale. From Pietro Cannuzio. *Regule florum musices* (Florence, 1510), title page. Woodcut.

proportionality and lucid solidity that strike us as so remarkable now. Piero's *De abaco* is the token of this continuity. The status of these skills in his society was an encouragement to the painter to assert them playfully in his pictures. As we can see, he did. It was for *conspicuous* skill his patron paid him.

11. This chapter has been becoming progressively more secular in its matter, but this may be a little deceptive. Indeed, it is possible that pictorial qualities which seem to us theologically neutral—proportion, perspective, colour, variety, for example— were not quite this. An imponderable is the moral and spiritual eye (plate 58), apt to interpret various kinds of visual interest in moral and spiritual terms. There are two kinds of pious Quattrocento literature which give hints, though no more than hints, about how this might enrich the perception of paintings. One is a type of book or sermon on the sensible quality of paradise, and the other is a text in which properties of normal visual perception are explicitly moralized.

In the first, vision is the most important of the senses, and the delights awaiting it in heaven are great. Bartholomew Rimber-

58. The moral and spiritual eye. From Petrus Lacepiera. *Libro de locchio morale et spirituale* (Venice, 1496), title page. Woodcut.

tinus's *On the Sensible Delights of Heaven*, printed in Venice in 1498 and a very complete account of these matters, distinguishes three kinds of improvement on our mortal visual experience: a greater beauty in the things seen, a greater keenness in the sense of sight, and an infinite variety of objects for vision. The greater beauty lies in three particulars: more intense light, clearer colour, and better proportion (above all in the body of Christ); the greater keenness of sight includes a superior capacity to make discriminations between one shape or colour and another, and the ability to penetrate both distance and intervening solids. As another treatise with the same title, Celso Maffei's *On the Sensible Delights of Heaven* of 1504, summed up: 'Vision will be so keen that the slightest differences and variations in colour will be discernible, and it will not be impeded by distance or by the interposition of solid bodies.' The last of these notions is the strangest to us; Bartholomew Rimbertinus had explained the thinking behind it:

An intervening object does not impede the vision of the blessed . . . If Christ, even though himself in heaven after his Ascension, saw his dear Mother still on earth and at prayer in her chamber, clearly distance and the interposition of a wall does not hinder their vision. The same is true when an object's face is turned away from the viewer so that an opaque body intervenes . . . Christ could see the face of his mother when she was prostrate on the ground . . . as if he were looking directly at her face. It is clear that the blessed can see the front of an object from the back, the face through the back of the head.

The nearest mortal experience could come to this, perhaps, was through a strict perspective convention applied to a regular configuration, as happens in Piero della Francesca's drawing of a well-head (plate 59).

But in the second kind of text some aspects of our normal mortal perception are discussed. Peter of Limoges' *De oculo morali et spirituali* (*On the Moral and Spiritual Eye*) was a fourteenth-century book which had some vogue in Italy late in the fifteenth century: an Italian translation *Libro del occhio morale* was printed in 1496. Its programme was clear:

. . . many things are expounded in holy discourse relating to our vision and our physical eye. From this it is clear that a consideration of the eye and of such things as appertain to it is a very useful means of knowing more fully about the divine wisdom.

One of the ways the author carries this out is to take a number of familiar optical curiosities—that a stick half in water looks bent,

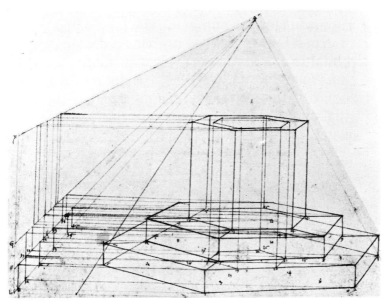

59. Piero della Francesca. *A Well-head.* From *De prospectiva pingendi*, Parma, Biblioteca Palatina, MS. 1576, fol. 20 v.

for instance, and that if one puts a finger in front of a candle flame one sees two fingers—and moralizes them. He calls them 'Thirteen marvellous things about the vision of the eye which contain spiritual information.' The eleventh of the marvels is an example with a bearing on the perception of pictures:

The eleventh marvel of vision
It is proved by the science of perspective that if one is deprived of direct rays or lines of sight, one cannot be sure of the quantity or size of the object one sees; on the other hand, one can make out its size very well if one does see it along direct lines of sight. This is clear in the case of objects seen now through air, now through water [, the size of which is difficult to judge]. Similarly we can recognize a sin and realize its relative quantity from a man who looks at sin directly and with the eye of reason. A doctor of the church or other learned man looks straight at sin. . . . The sinner, however, when he commits sin does not recognize the exact degree of error of his sin, and does not look at it by direct line of sight but rather by an oblique and broken line of sight . . .

It would not be difficult to modulate this into a moralization of the Quattrocento painter's linear perspective.

The basic principle of the linear perspective they used is in

Efono dua torri in nun piano che luna e alta 8 o braccia et laltra e alta 9 o braccia : et dal luna tor re allaltra,e 1 0 0 braccia : et intra queste dua torri e una fonte dacqua in tal luogho che mouendosi due uccegli uno diciascuna et uolando dipari uolo giugbono alla decta fonte aun tracto . Uo sapere quanto lafonte sara presso a ciascuna torre

$$80 \longrightarrow 90 \longrightarrow 100$$
$$80 \smile 90 \smile 100 \smile$$

$$6400 \quad 8100 \quad 10000$$

$$\begin{array}{r} . 8100 \\ 6400 \\ \hline 1700 \end{array}$$

$$\begin{array}{r} 10000 \quad |\! 700 \\ \hline 11700 \\ 58 \tfrac{1}{2} \end{array}$$

sara presso alla torre dell . 8 o braccia a brac cia 5 8 ¼ et lauanzo in fino i 1 0 0 che ue 4 1 ¼ braccia sara presso a quella di 9 o braccia

60. Surveying exercise. From Filippo Calandri. *De arimethrica* (Florence, 1491), p. o viii v.

fact very simple: vision follows straight lines, and parallel lines going in any direction appear to meet at infinity in one single vanishing-point. The great difficulties and complexities of this convention arise in detail, in practice, in consistency, and in the

modifications of the basic principle necessary if the perspective of a painting is not to seem tendentious and rigid: they present themselves to the painter and not to the beholder, unless the painting has gone wrong in its perspective and one wants to say why. Many Quattrocento people were quite used to the idea of applying plane geometry to the larger world of appearances, because they were taught it for surveying buildings and tracts of land. There is a typical exercise in Filippo Calandri's treatise of 1491 (plate 60). There are two towers on level ground. One is 80 feet high, the other 90 feet high, and the distance from one tower to the next is 100 feet. Between the towers is a spring of water in such a position that, if two birds set off one from each tower and fly in a straight line at the same speed, they will arrive at the spring together. One is to work out how far the spring is from the base of each tower. The key to the problem is simply that the two hypotenuses or bird-flights are equal, so that the difference of the squares of the two tower heights—1700—is the difference of the squares of the two distances of tower from spring. The idea of perspective, of imposing a network of calculable

61. Fra Angelico. *Sts. Peter and Paul Appear to St. Dominic* (from the predella of the *Coronation of the Virgin* (about 1440)). Paris, Louvre. Panel.

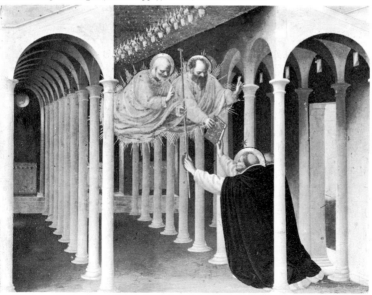

angles and notional straight lines on a prospect, is not outside the grasp of a man able to handle such an exercise in surveying.

If one brings these two types of thought together—geometrical experience enough to sense a conspicuous perspective construction, and a pious equipment for allegorizing it—one more shade in the Quattrocento painters' narrative performance suggests itself. Passages of perspective virtuosity lose their gratuitous quality and take on a direct dramatic function. Vasari picked out the foreshortened loggia in the centre of Piero della Francesca's *Annunciation* at Perugia as 'a beautifully painted row of columns diminishing in perspective'; it is very noticeable that many Quattrocento Annunciations, death scenes, and scenes of the visionary have something similar (plate 61). But, in terms of the pious culture we have been looking at, suppose such a perspective is apprehended not just as a *tour de force* but also as a type of visual metaphor, a device suggestive of, say, the Virgin's spiritual condition in the last stages of the Annunciation, as we have seen them in Fra Roberto's exposition. It is then open to interpretation first as an analogical emblem of moral certainty (*The Moral and Spiritual Eye*) and then as an eschatological glimpse of beatitude (*The Sensible Delights of Heaven*).

This sort of explanation is too speculative to have much historical use in particular cases. The point of noting here the harmony between the style of pious meditation in these books and the pictorial interest—proportionality, variety and clarity of colour and conformation—of some Quattrocento paintings is not to interpret individual works, but to remind us of the eventual impalpability of the Quattrocento cognitive style. Some Quattrocento minds brought a moral and spiritual eye of this kind to these paintings: there seems room in many of the paintings to exercise it (Colour Plate I). It is proper to end this chapter on a faltering note.

III. Pictures and categories

1. It may be objected that the Quattrocento man invoked by this last chapter is just a church-going business man, with a taste for dancing. There are both offensive and defensive replies to this. The one is that, in any case, church-going and dancing business men did exist, included as unavoidable a Quattrocento figure as Lorenzo de' Medici, and are a more balanced and representative type of the Quattrocento man than some that are current—'civic humanists', for example. The soft answer is more complicated.

The social practices most immediately relevant to the perception of paintings are visual practices. A society's visual practices are, in the nature of things, not all or even mostly represented in verbal records. The church-going dancing trader is the aspect of the public eye that emerged from the sort of sources available for Chapter II. He is not offered as an ideal type, in any sense, but he has the elements of the matter in him—religion, politeness, affairs. No Quattrocento man of the painter-paying classes had none of these. A prince like Leonello d'Este may have been higher on politeness and lower on mathematics, but he had some of the latter; as a matter of fact, some of the princes most active as patrons of good painting—in particular Lodovico Gonzaga of Mantua, the employer of Mantegna and Alberti, and Federigo da Montefeltro, Piero della Francesca's patron at Urbino—were quite highly trained in mathematics. A financier like Giovanni Rucellai was good at the Rule of Three and perhaps hardly danced at all, but he certainly absorbed his society's standards of decent social movement. For both kinds of man religious observance was institutional to the point of making the question of individual belief almost irrelevant.

Still, a great deal of the Quattrocento cognitive style most relevant to painting is not represented in Chapter II, and it is time to try a different approach. The reader will remember that Chapter I ended at an impasse, with an inability to read the Milanese agent's account of four painters working in Florence. In fact, if one looks back to the letter (p. 26) some of its problems

turn out to have clarified themselves a little in the light of the materials of Chapter II. The *virile* air of Botticelli is rather more acceptable now that one has learned to approach Botticelli's paintings as representations in a mode cognate with the *bassa danza* (p. 78): indeed, it is almost virile *aere*. Again, one knows now from the encounter with the Rule of Three (p. 95) that the writer was likely to have quite an immediate sense of what proportion is, and his remark about Botticelli's *integra proportione* is correspondingly likely to reflect a genuine sense of interval. Filippino Lippi's *aria piu dolce*, his sweeter air, is still relatively impenetrable, but given the stimulus to look for help, one finds a poem published by Francesco Lancilotti in 1508, in which a painter is urged:

> Ove bisogna *aria dolce*, aria fiera,
> Variare ogni atto, ogni testa e figura,
> Come fior varia a' prati primavera.

> Where a sweet or a proud air is needed,
> Vary every attitude, every head and figure,
> As spring varies the flowers in the meadows.

So *aria* relates to the character of movement, head and figure; and *dolce* contrasts with proud as well as virile—we can translate it as 'mild', perhaps. Perugino's *aria angelica* has already been a little clarified by information about such matters as religious gesture (p. 65). We will add to this the Four Corporeal Gifts of the Blessed, expounded in many Quattrocento sermons and tracts: *claritas, impassibilitas, agilitas, subtilitas*—splendour, invulnerability, quickness, keenness. Ghirlandaio's *buona aria* remains a nondescript description of a slightly characterless artist.

Now the opaqueness of the letter to Milan is partly due to the writer's uncertainty with his words: he does not have the verbal faculty to describe pictorial style very fully or exactly. In spite of this, once one has broken through his words to a meaning, they are very much to our purpose. Each of his terms looks two ways: towards his reaction to the paintings, clearly, but also towards the latent sources of his standards. *Virile, proportion* and *angelic* refer the paintings to the polite, business-like and religious systems of discrimination he is drawing on. If a text of this kind is penetrable, a text by a verbally more skilled man is likely to be even more so. For this reason it is profitable to read very carefully a short text by the best of the Quattrocento art critics—as opposed to art theorists—Cristoforo Landino. It is not the 'inno-

cent' account of painting we failed to find before: plain men do not write art criticism. But Landino, though he is himself more than usually sensitive and informed about painting and quite untypically articulate, was addressing plain men with a view to being understood by them. The text is part of a patriotic introduction to his commentary on Dante, presented to the government of Florence in 1481 and the standard edition of Dante for fifty years after. We shall look at sixteen terms Landino uses to describe four Florentine painters. Some of the terms will be specifically pictorial terms, familiar in the painter's workshop: these will tell us the sort of thing non-painters could be expected to know about the art—the pictorial *ragione* the Milanese agent referred to. Others of the terms will be of the type of *virile*, *proportion* and *angelic*, drawn from more general discourse: these will tell us something about the more general social sources of Quattrocento standards. And together the sixteen terms will constitute a compact Quattrocento equipment for looking at Quattrocento paintings.

2. But before doing this, it will be helpful to snatch a glimpse of what the general history of fifteenth-century painting seemed like at the time: looking back from the end of the century, who were the painters that stood out from the rest? It is surprisingly difficult to determine. For one thing, whereas fourteenth-century painting had been seen, at least at Florence, in a very clear pattern—Cimabue, Giotto, and the pupils of Giotto: prophet, saviour, and apostles of painting—the fifteenth century never produced a scheme as neat as this. For another, when someone gave a list of great artists, he naturally slanted it to artists who had worked in his own city, whether it was Florence or, say, Padua. The most detached and generally informed list occurs in a poem by a painter who worked in Urbino, Giovanni Santi. He had the advantage both of professional knowledge and of a neutral vantage point.

Giovanni Santi, who died in 1494, was the father of Raphael Sanzio. It is usual to dismiss him as an inconsiderable painter as well as a bad poet, but this is not quite just. He is not an important artist, but was a very tidy eclectic painter working in an east Italian school of which Melozzo da Forlì, whom he much admired, is the typical exponent. His signed altarpiece at Montefiorentino is reproduced here (plate 62) as a token of his professionalism and as a concrete statement of his standards. As for his poem, it is a very long rhymed chronicle—an unpretentious form—in *terza rima*, narrating the life and campaigns of

his employer Federigo da Montefeltro, Duke of Urbino; the occasion for the excursus on painting is a visit by Federigo to Mantua, where he sees the work of Andrea Mantegna, particularly praised as master of all the parts of painting:

> ... de tucti i membri de tale arte
> lo integro e chiaro corpo lui possede
> più che huom de Italia o de le externe parte.

62. Giovanni Santi. *The Virgin and Child with Sts. Crescentius, Francis, Jerome and Antony, and Count Oliva Pianiani* (1489). Montefiorentino, S. Francesco. Panel.

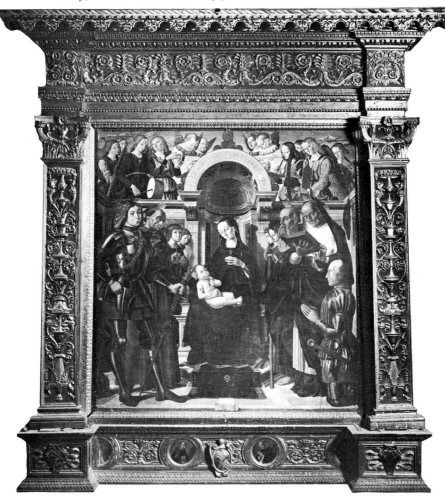

But presently a rhymed list is given of other great masters of painting:

> ne la cui arte splendida e gentile,
>> nel secul nostro, tanti chiar son stati,
>> che ciescun altro far parer pòn vile.
> A Brugia fu, fra gli altri più lodati,
>> el gran Jannès e 'l discepul Rugiero,
>> cum tanti di excellentia chiar dotati,
> ne la cui arte et alto magistero
>> di colorir, son stati sì excellenti,
>> che han superati molte volte el vero.
> Ma in Italia, in questa età presente,
>> vi fu el degno Gentil da Fabrïano,
>> Giován da Fiesol, frate al bene ardente,
> et, in medaglie e in pictura, el Pisano,
>> frate Philippo e Francesco Pesselli,
>> Domenico, chiamato el Venetiano,
> Massaccio et Andreín, Paülo Ocelli,
>> Antonio e Pier, sì gran designatori,
>> Pietro dal Borgo, antico più di quelli,
> dui giovin par d'etate e par d'amori,
>> Leonardo da Vinci e 'l Perusino
>> Pier dalla Pieve, ch'è un divin pictore,
> el Ghirlandaia, el giovin Philippino,
>> Sandro di Botticello, e 'l Cortonese
>> Luca, de ingegno e spirto pelegrino.
> Hor, lassando di Etruria el bel paese,
>> Antonel de Cicilia, huom tanto chiaro,
>> Giovan Bellin, che sue lode èn distese,
> Gentil, suo fratre, e Cosmo cum lui al paro,
>> Hercule ancora, e molti che or trapasso,
>> non lassando Melozo, a me sì caro,
> che in prospectiva ha steso tanto el passo.

> In this splendid, noble art
>> So many have been famous in our century,
>> They make any other age seem poor.
> At Bruges most praised were
>> Great Jan van Eyck and his pupil Rogier van der Weyden
>> With many others gifted with great excellence.
> In the art of painting and lofty mastery
>> Of colouring they were so excellent,
>> They many times surpassed reality itself.
> In Italy, then, in this present age
>> There were the worthy Gentile da Fabriano,
>> Fra Giovanni Angelico of Fiesole, ardent for good,

And in medals and painting Pisanello;
 Fra Filippo Lippi and Francesco Pesellino,
 Domenico called Veneziano,
Masaccio, Andrea del Castagno, Paolo Uccello,
 Antonio and Piero Pollauiuolo, great draughtsmen,
 Piero della Francesca, older than these;
Two young men like in fame and years—
 Leonardo da Vinci and Pietro Perugino
 Of Pieve, a divine painter;
Ghirlandaio and young Filippino Lippi,
 Sandro Botticelli, and from Cortona
 Luca Signorelli of rare talent and spirit.
Then, going beyond the lovely land of Tuscany,
 There is Antonello da Messina, a famous man;
 Giovanni Bellini, whose praises spread far,
And Gentile his brother; Cosimo Tura and his rival
 Ercole de' Roberti, and many others I omit—
 Yet not Melozzo da Forlì; so dear to me
And in perspective so far advanced.

If we reduce all these names to a scheme, we have the table on p. 115.

Unlike many Florentines, Santi is conscious of the fine painting being produced in Venice and northern Italy: he is also very alive to the quality of Netherlandish painting, known and bought at Urbino. But the weight is, as it had to be, with Florence—13 out of 25 Italian artists—and it is to Florence also that one must go for the best criticism. We have already seen four painters from Santi's list in the Milanese agent's report: Botticelli, Filippino Lippi, Ghirlandaio, Perugino. We shall now look at Cristoforo Landino's characterization of four others: Masaccio, Filippo Lippi, Andrea del Castagno, Fra Angelico.

3. Cristoforo Landino (plate 63) was a Latin scholar and Platonizing philosopher, a champion of the vernacular Italian language— Italian modernized in the light of Latin—and a lecturer in poetry and rhetoric at Florence university; he was also secretary for public correspondence to the Signoria of Florence. In short, his profession was the exact use of language. Two other things equipped him to say things about the painters: he was a friend of Leon Battista Alberti (1404–72), and he was the translator of Pliny's *Natural History* (A.D. 77).

Landino himself describes Alberti:

Where shall I put Alberti, in what class of learned men shall I set him? Among the natural scientists, I think. Certainly he was born to investi-

FLORENCE

Fra Angelico
(c. 1387–1455)

Paolo Uccello
(1396/7–1475)

Masaccio
(1401–1428(?))

Pesellino
(c. 1422–1457)

Filippo Lippi
(c. 1406–1469)

Domenico Veneziano
(died 1461)

Andrea del Castagno
(1423(?)–1457)

Ghirlandaio
(1449–1494)

Antonio and Piero
Pollaiuolo
(c. 1432–98; c. 1441–96)

Botticelli
(c. 1455–1510)

Leonardo da Vinci
(1452–1519)

Filippino Lippi
(1457/8–1504)

NETHERLANDS
Jan van Eyck
(died 1441)

MARCHES

Piero della
Francesca
(c. 1410/20–1492)

Melozzo da Forlì
(1438–1494)

Cosimo Tura
(c. 1425/30–1495)

Ercole de' Roberti
(1448/55–1496)

UMBRIA

Perugino
(c. 1445/50–1523)

Luca Signorelli
(c. 1450–1523)

Rogier van der Weyden
(1399/1400–1464)

VENICE→ROME

Gentile da Fabriano
(c. 1370–1427)

Pisanello
(1395–1455/6)

PADUA→MANTUA

Mantegna
(c. 1431–1506)

VENICE

Antonello da Messina
(c. 1430–1479)

Gentile Bellini
(c. 1430–1516)

Giovanni Bellini
(c. 1429/30–1507)

gate the secrets of nature. What branch of mathematics did he not know? He was geometrician, arithmetician, astronomer, musician, and more admirable in perspective than any man for many centuries. His brilliance in all these kinds of learning is shown in the nine books on architecture excellently written by him, which are full of every kind of

63. Cristoforo Landino expounding. From Cristoforo Landino. *Formulario di lettere et di orationi volgari* (Florence, 1492), frontispiece. Woodcut.

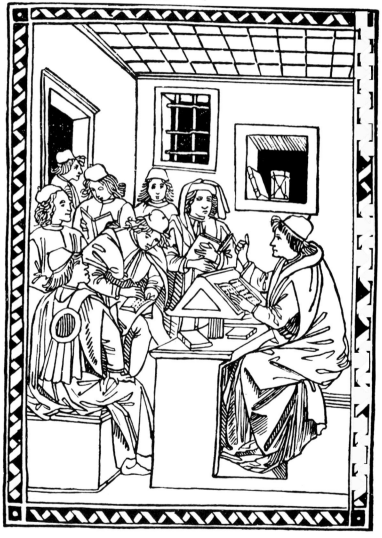

learning and illuminated by the utmost eloquence. He wrote on paint-
ing; he also wrote on sculpture in a book called *Statua*. He not only wrote
on these arts but practised them with his own hand, and I have in my
own possession highly prized works executed by him with the brush,
with the chisel, with the graver, and by casting of metal.

Alberti had written his treatise *On painting* in 1435, the first
surviving European treatise on painting, and it seems to have
circulated particularly among humanists interested in painting
or geometry or good plain prose. Book I is a geometry of per-
spective, Book II describes the good painting in three sections—
(1) 'Circumscription', or outlining bodies, (2) Composition, (3)
'Reception of light', or tones and hues; Book III discusses the
education and life-style of the artist. The treatise's influence was
slow to be felt outside learned circles, but Landino was clearly
impressed by it and in the text we are going to read he played a
part in bringing some of its central concepts to a wider public.

Pliny's *Natural History* was written in the first century A.D. and
includes in its Books 34–36 the fullest critical history of classical
art to survive from antiquity; this took both its facts and its
critical language from a tradition of art criticism developed in
Greek books now lost. Pliny's method depended very largely on
a tradition of metaphor: he described artists' style with words
that took much of their meaning from their use in non-pictorial,
social or literary, contexts—*austere, flowery, hard, grave, severe,
liquid, square* and other such oblique terms. Landino's translation
of Pliny was printed in 1473. Faced by Pliny's *austerus, floridus,
durus, gravis, severus, liquidus, quadratus* he was not adventurous;
he translated them as *austero, florido, duro, grave, severo, liquido* and
quadro. Now when Landino came in 1480 to describe the artists
of his own time one could expect him to use Pliny's terms. They
are subtle, rich and precise words for describing art; we ourselves
use most of them today, even though most of their metaphorical
quality has withered. But to his great credit Landino did not do
this. He used not Pliny's terms, with their reference to a general
culture very different from that of Florence in 1480, but the
method of Pliny's terms. Like Pliny he used metaphors, whether
of his own coinage or of his own culture, referring aspects of the
pictorial style of his time to the social or literary style of his time—
'prompt', 'devout' and 'ornate', for instance. Like Pliny too he
uses terms from the artists' workshop, not so technical as to be
unknown by the general reader, but yet carrying the painter's
own authority—'design', 'perspective' and 'relief', for instance.
These are the two methods of Landino's criticism.

The account of the artists occurs in the Preface to his commentary on the *Divine Comedy*, in which he sought to refute the charge that Dante was anti-Florentine; he defends Dante's loyalty, and then Florence's excellence by speaking of the city's distinguished men in various fields. The section on painters and sculptors, which comes after that on musicians, falls into four parts. The first describes ancient art in ten sentences: this is after Pliny. The second describes Giotto and a few fourteenth-century painters: this copies a fourteenth-century critic, Filippo Villani. The third describes the Florentine Quattrocento painters; it is Landino's own contribution and is the passage we shall read. The fourth describes a few sculptors. Cristoforo Landino on Masaccio, Filippo Lippi, Andrea del Castagno and Fra Angelico:

Fu Masaccio optimo imitatore di natura, di gran rilievo universale, buono componitore et puro sanza ornato, perche solo si decte all'imitatione del vero, et al rilievo delle figure: fu certo buono et prospectivo quanto altro di quegli tempi, et di gran facilita nel fare, essendo ben giovane, che mori d'anni ventisei. Fu fra Philippo gratioso et ornato et artificioso sopra modo: valse molto nelle compositioni et varieta, nel colorire, nel rilievo, negli ornamenti d'ogni sorte, maxime o imitati dal vero o ficti. Andreino fu grande disegnatore et di gran rilievo, amatore delle difficulta dell'arte et di scorci, vivo et prompto molto, et assai facile nel fare . . . Fra Giovanni Angelico et vezoso et divoto et ornato molto con grandissima facilita.

Masaccio was a very good imitator of nature, with great and comprehensive *rilievo*, a good *componitore* and *puro*, without *ornato*, because he devoted himself only to imitation of the truth and to the *rilievo* of his figures. He was certainly as good and skilled in perspective as anyone else at that time, and of great *facilita* in working, being very young, as he died at the age of 26. Fra Filippo Lippi was *gratioso* and *ornato* and exceedingly skilful; he was very good at *compositioni* and at variety, at *colorire*, *rilievo*, and very much at ornaments of every kind, whether imitated after the real or invented. Andrea del Castagno was a great *disegnatore* and of great *rilievo*; he was a lover of the difficulties of the art and of foreshortenings, lively and very *prompto*, and very *facile* in working . . . Fra Angelico was *vezzoso*, *divoto*, very *ornato*, and endowed with the greatest *facilita*.

4.

MASACCIO

Tommaso di Ser Giovanni di Mone Cassai, known as Masaccio, was born in San Giovanni Val d'Arno in 1401 and was admitted

to the painters' guild at Florence in 1422. Between 1423 and 1428 he painted his two surviving masterpieces at Florence, a fresco of the Trinity (plate 64) in S. Maria Novella (1425–26) and the several frescoes in the Brancacci chapel of S. Maria del Carmine (Colour Plate III), much damaged by fire in 1771. During 1426 he also painted a polyptych for a chapel in S. Maria del Carmine at Pisa; this was broken up by the eighteenth century and parts are now in London (the central panel), Pisa, Naples, Vienna and Berlin. Late in 1428 Masaccio went to Rome, where he seems almost immediately to have died.

(a) *Imitatore della natura*—imitator of nature

This and 'imitation of the truth' (*imitatione del vero*), in spite of their apparent simplicity, are varieties of one of the critical phrases most difficult to weigh in the Renaissance; a stronger form was to say a painter 'rivalled or surpassed nature or reality itself'. In many ways such phrases were inimical to discrimination. They were the easiest cliché of praise one could use and they set up an unspecified realism as a uniform standard of quality, none of which helps active consideration of an artist's particular strength and character. Nature and reality are different things to different people and unless a man defines them, as he rarely does, one is not much wiser: what nature and which reality? But the phrase undeniably invokes one of the principal values of Renaissance art, and the fact that Masaccio is the one Quattrocento painter Landino credits with this virtue suggests it had a meaning for him. Moreover, Leonardo da Vinci was soon to say much the same: 'Tomaso of Florence, called Masaccio, demonstrated with perfect skill that the painters who were arrogantly taking models other than Nature, mistress of master painters, were labouring in vain.' That is to say, one mark of the 'imitator of nature' is a relative independence from the pattern-books and formulas, the stock figures and accepted arrangements, which were a substantial part of the pictorial tradition. This is negative; elsewhere Leonardo offers a positive description of how the painter imitates nature:

Painting . . . compels the mind of the painter to transform itself into the mind of nature itself and to translate between nature and art, setting out, with nature, the causes of nature's phenomena regulated by nature's laws—how the likenesses of objects adjacent to the eye converge with true images to the pupil of the eye; which of objects equal in size appears larger to that eye; which of equal colours appears more or less dark, or more or less bright; which of objects equally low appears more or less

64. Masaccio. *The Trinity with the Virgin and St. John* (1425). Florence, S. Maria Novella. Fresco.

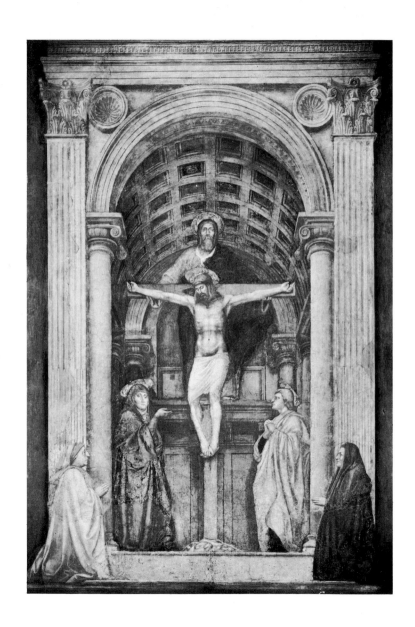

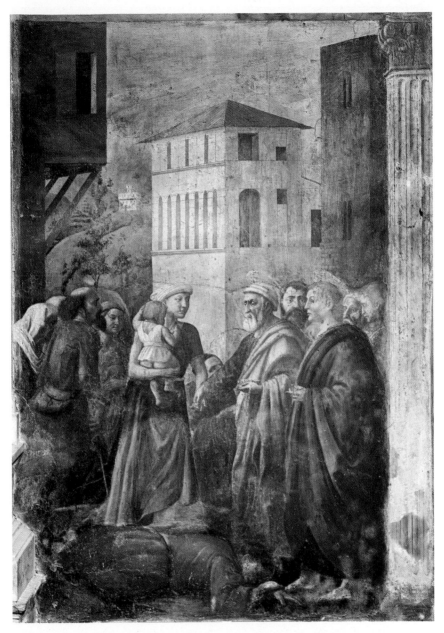

III. Masaccio. *St. Peter Distributing Alms*. Florence, S. Maria del Carmine. Fresco.

IV. Filippo Lippi. *The Holy Family with Sts. Mary Magdalen, Jerome and Hilarion* (about 1455). Florence, Uffizi. Panel.

low; which of objects standing at equal heights will appear more or less high; why, of two objects standing at different distances [from the eye], one will appear less clear than the other.

This is all very much to the point; Leonardo is talking about perspective and the light and shadow through which we perceive the forms of objects, and it is for his mastery of these—*prospectiva* and *rilievo*—that Landino goes on to praise Masaccio. So we may say that the imitator of nature is the painter who turns away from the pattern-books with their ready-made formulas and solutions, to the appearance of actual objects; and that he reckons on studying and re-presenting these appearances particularly through their perspective and their relief—an edited 'reality' and selective 'nature'.

(b) *Rilievo*—relief

Masaccio is the prime exponent of *rilievo*—*gran rilievo universale* and *rilievo delle figure*. In descending order, it seems, he is followed by Castagno (*gran rilievo*) and Filippo Lippi (*valse molto . . . nel rilievo*). Alberti, who uses *rilievo* to translate the Latin word *prominentia*, 'projection', had explained that it is the appearance of a form modelled in the round, attained by the skilful and discreet treatment of the tones on its surface:'. . . light and shade make real things appear to us in relief (*rilevato*); white and black make painted things appear the same . . .' The term was a technical one of the workshop, and Cennino Cennini used it freely in his early Quattrocento *Book of the Artist*:

How you should give your figures the system of lighting, light or shade, endowing them with a system of *rilievo*: If, when you are drawing or painting figures in chapels or painting them in other difficult places, it happens that you cannot control the lighting to your purpose, give the *rilievo* to your figures or design according to the arrangement of the windows in these places, since it is they that must provide the lighting (plate 66). And so, following the lighting, whichever side it is coming from, apply your *rilievo* and shadow after this sytem (Colour Plate III). . . . And if the light pours from one window larger than the others in the place, always accommodate yourself to this brighter light; and you should systematically study and follow it, because if you work fails in this, it will have no *rilievo* and it will turn out to be a simple thing with little mastery.

It is a good account of one of the principal strengths of Masaccio's *rilievo*, and has a bearing on how to look at it: it is a common-place of the guidebooks that there is a time of day, round 11 a.m., when the lighting is somehow right for Masaccio's frescoes in the

Brancacci chapel, and we in turn accommodate ourselves to this. Highlights and shadows are apprehended as a form only when one has a firm idea of where the lighting comes from; if we are deprived of this idea, as we can be in laboratory conditions and occasionally in normal experience too, even real complex solids are seen as flat surfaces blotched with light and dark patches—exactly the opposite illusion from that sought by the painters. Landino's emphasis on the *rilievo* of Masaccio's frescoes has remained a constant of art criticism, though sometimes in disguise: Bernard Berenson—'I never see them without the strongest stimulation of my tactile consciousness.' But Landino has the advantage of talking about the pictures, in the painters' terms, and not about himself.

(c) *Puro*—pure

Puro sanza ornato is almost pleonastic, since *puro* nearly means *sanza ornato*. *Puro* is one of Landino's latinisms and copies the literary critical sense of an unadorned, laconic style: Cicero had spoken of *purus* and clear, Quintilian of *purus* and distinct, Pliny the Younger of *purus* and plain style. It turns a negative idea—'without ornament'—into a positive one—'plain and clear'—with an element of moral overtone. It was necessary to do this because in the classical and renaissance system of criticism the opposite of 'ornate' could be either virtuous like 'plain' or vicious like 'mean': to say someone was un-ornate was not enough. *Puro*

65. Masaccio. *The Tribute Money* (about 1427). Florence, S. Maria del Carmine. Fresco.

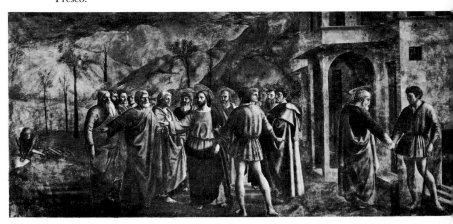

says that Masaccio was neither ornate nor bleak. It takes its meaning from its opposition to *ornato*: and what Landino means by *ornato* is a problem better left till he uses it in a positive way for other painters, Filippo Lippi and Fra Angelico. But Landino is setting Masaccio on a scale of styles—plain rather than florid or grand—that is essentially functional, in the sense that the style is adapted to a specific purpose. Quintilian described a pure style without ornament, clear, distinct, not lofty (*sermo purus et dilucidus et distinctus ceterum minime elatus ornatusque*), which people thought proper to intellectual argument, though Quintilian himself thought a little ornament does argument no harm. In a book Landino did not know, *De vulgari eloquentia* (II.vi), Dante himself had set a 'sapid but pure' (*pure sapidus*) style against both an ignorant *insipidus* style and a primitively rhetorical style. For Dante the pure style was the properly austere style of scholars and teachers, and had its own flavour. Masaccio had his own systematic scholarship, of *rilievo* and *prospectivo*. It would hardly strain the case to see his pictures as arguments, as well as models, for the imitation of nature through systematic *rilievo* and *prospectivo*: this is how Leonardo (p. 119) saw them. Of course, *puro* falls some way short of proposing that Masaccio's pictures are scholarly and instructive arguments in an austere mode; it is just consistent with their conspicuously being such.

(d) *Facilita*—ease

This means something between our 'facility' and 'faculty', but without the disapproving connotation of the first. It was much used in literary criticism and, strictly expounded, was the product of (1) natural talent and (2) acquirable skills developed through (3) exercise, though of course it was often used more freely and loosely than this. The practised fluency of *facilita* was one of the qualities most esteemed by the Renaissance, but it was and is difficult to pin down. Alberti treats of it under the name of diligence-with-quickness (*diligenza congiunta con prestezza*) or quickness-with-diligence (*prestezza di fare congiunta con diligentia*) and orthodoxly finds its source in talent developed by exercise. It shows itself in a painting that appears complete but not over-finished: its enemies are *pentimenti* or corrections, an unwillingness to leave off from working on a piece, and the sort of staleness that can be cured by taking a break. All this is specially related to fresco rather than panel painting—the Milanese agent's distinct categories of 'good at fresco' and 'good at panels' (p. 26) have critical point—and our own lack of the experience of seeing a man working fast on the drying plaster makes it difficult to react

properly to the term *facilita*. Masaccio's frescoes are what is called *buon fresco* or true fresco, painted almost entirely on fresh wet plaster, a new section of this being put on for each session of painting. In this they differ from most Quattrocento frescoes, which are not true fresco at all but *fresco secco*, painted more on dry plaster. Thus Masaccio's *facilita* is measurable in the astonishingly small number of fresco sections that have left their mark on the walls of the Brancacci chapel: just 27 fresco sessions for the *Tribute Money* (plate 65) constitutes a sort of *facilita* concretely visible in the seams between one session and the next, as well as in the broad, rich brush strokes that made this speed possible. For Vasari, looking back from the middle of the sixteenth century, *facilita nel fare* was the one quality Quattrocento painting had most conspicuously lacked. He admired in his own period 'a certain freedom' and 'a certain resolute spirit', the opposite of 'a certain hardness' or 'dryness' brought on by 'excessive study' in the Quattrocento, and he cannot see it in painting before Leonardo da Vinci. Critical calibrations shift and Vasari's had been influenced by a new sixteenth-century cult of the *buon fresco*: his complaint of 'dryness' is only partly metaphorical.

(e) *Prospectivo*—perspectivist

A *prospectivo* is simply someone who practices perspective with distinction. In his *Life of Brunelleschi* Antonio Manetti, a friend of Landino's, noted that

what the painters nowadays call perspective (*prospettiva*) . . . is that part of the science of Perspective which is in practice the good and systematic diminution or enlargement, as it appears to men's eyes, of objects that are respectively remote or close at hand—of buildings, plains, mountains and landscapes of every kind—and of the figures and other things at each point, to the size they seem to be from a distance, corresponding with their greater or lesser remoteness.

As Manetti says, pictorial perspective is related to the 'science of Perspective', an academic field much tilled in the later middle ages and which we would call optics. Dante had observed: 'One sees sensibly and rationally according to a science that is called Perspective, arithmetical and geometrical.' The mathematics of it were attractive to some painters because they seemed to make it systematic. Dante again: 'Geometry is lily-white, unspotted by error and most certain, both in itself and in its handmaid, whose name is Perspective.' Who was responsible for the pictorial adaptation of the optics is not certain, but Landino suggests

Brunelleschi: 'The architect Brunelleschi was also very good at painting and sculpture; in particular, he understood perspective well, and some say he was either the inventor or the rediscoverer of it. . . .' One of the people who said this was Landino's friend Antonio Manetti in the *Life of Brunelleschi*. On the other hand, we have seen that, in Landino's view, Alberti was 'more admirable

66. Masaccio. *The Tribute money* (detail). Florence, S. Maria del Carmine. Fresco.

67. Paolo Uccello. *Sinopia underdrawing for a fresco of the Nativity.* Florence, Soprin-
tendenza alle Gallerie. Sinopia.

in perspective than any man for many centuries.' In this context
'perspective' probably has its more general meaning of 'optics',
but perhaps Brunelleschi was the inventor, Alberti the developer
and expounder. The basic principles of the Quattrocento painter's
perspective were quite simple, as we have seen. Parallel lines
receding from the plane of the picture surface appear to meet at
a single point on the horizon, the vanishing point; lines parallel
with the picture plane do not converge. How the painter used
these principles to create a geometrically controlled picture space
is shown in the underdrawing of one of Paolo Uccello's frescoes
(plate 67). Lines at right angles to the base of the picture plane
meet at a central vanishing point on the horizon; at each side
are vanishing points for lines at 45 degrees to the picture plane.
The intersections of the latter with the former also determine the
progressive diminution of the chosen unit of measurement as it
recedes. The result is what Alberti called a 'pavement', a regular
receding chessboard of notional, and in many pictures actual,
squares on which the painter sets and calculates the size of his
pieces, as Leonardo did in his drawing for a picture of the
Adoration of the Magi (plate 68). The principle was simple; the
practice raised difficulties in detail, particularly in the proper

registration of complex solid objects, and one result was a great simplification of the physical ambience the artist cared to tackle. There are many more right angles, many more straight lines and many more regular solids in Quattrocento paintings than there are in nature or had been in earlier painting. What the young painter now had to learn is shown in a contract in which the Paduan painter Squarcione undertook in 1467 to teach the son of another Paduan painter, Uguccione:

the system of the floor [i.e. 'pavement'], well drawn in my manner; and to put figures on the said floor here and there at different points, and to put objects on it—chairs, benches and houses; and he is to learn how to do these things on the said floor; and he is to be taught a head of a man in foreshortening . . . ; and he is to be taught the method for a nude figure, measured, before and behind; and how to put in eyes, nose, mouth and ears in a man's head, measured in their places; and I am to teach him these things as thoroughly as I can and as far as the said Francesco has the capacity to learn them . . .

Systematic perspective noticeably and naturally brings systematic proportion with it: the first enables the painter to sustain the second. But there is a danger, for us as much as for Squarcione's pupil, of equating 'perspective' exclusively with systematic linear perspective constructions, since these are conveniently described

68. Leonardo da Vinci. *Perspective study for the Adoration of the Magi.* Florence, Uffizi. Pen, metalpoint, wash.

and taught by rules. The definition by Antonio Manetti which we began with is more inclusive, and in fact, within or without a pavement, Quattrocento perspective at its best is often intuitive. Masaccio followed a careful and detailed construction in his *Trinity* (plate 64), showily but not quite consistently calculated for the low viewpoint, but he clearly worked more freely in the Brancacci chapel. We ourselves do not have to draw a perspective construction for the *Tribute Money* (plate 65) to sense that the vanishing point is behind Christ's head and respond to this accent on Christ. The picture and our response would both lack *facilita* if we did.

FILIPPO LIPPI

Filippo Lippi was an orphan and became a Carmelite monk in 1421, aged about fifteen, at the same S. Maria del Carmine in Florence where Masaccio was presently to paint the Brancacci Chapel. He is not recorded as a painter until 1430 and it is not known by whom he was taught, though a connection with Masaccio is often argued. He became a client of the Medici family, who gave him help in a series of personal difficulties, including marriage to a nun. A large number of panel paintings by Filippo Lippi have survived. His largest works outside Florence were fresco cycles in the cathedrals at Prato (1452–64) and Spoleto (1466–9), where he died. Botticelli probably and his own son Filippino certainly were his pupils.

(f) *Gratioso*—gracious

The characterization of Filippo Lippi, a painter very different from Masaccio, begins with a word which was constantly veering between a more objective and a more subjective sense: (1) possessing *grazia* and (2) pleasing in general. The first was the more vernacular and precise, but the second was attractive to intellectuals like Landino because the Latin word *gratiosus* was commonly used with this meaning. It would be foolish to exclude either here, though *grazia* is the notion we shall address ourselves to. It is the quality he is praised for in the epigraph the humanist Poliziano wrote for him:

CONDITUS HIC EGO SVM PICTVRE FAMA PHILIPPVS
NVLLI IGNOTA MEE EST GRATIA MIRA MANVS

Here I lie, Filippo, the glory of painting:
 To no one is the wonderful *gratia* of my hand unknown.

69. Desiderio da Settignano. *Tabernacle* (detail). Florence, S. Lorenzo. Relief in marble.

Within Landino himself there is a useful crossbearing to start from, for another artist, the sculptor Desiderio da Settignano (1428–64), is praised for having 'the utmost *gratia*'. Filippo's paintings with Desiderio's reliefs is a comprehensible pairing. At the lowest level, it is clear that both artists produced delicate and elegant half-length Madonnas with sweet faces, *gratiose* in either sense of the word. But it is more interesting to see the comparison on less obvious ground: for instance we can set the bands of angels on Desiderio's Tabernacle in S. Lorenzo at Florence (plate 69) beside the young people in Filippo's fresco of *Salome dancing before Herod*—not just Salome herself but the maidens in attendance on each side of the hall (plate 70). These

seem essential *gratia*, and Leonardo wrote the recipe for such figures some years later:

The parts of the body should be arranged with *gratia*, with a view to the effect you want the figure to make. If you want it to display elegant charm (*leggiadria*), you should make it [1] delicate and elongated, [2] without too much exhibition of muscles, and [2a] the few muscles you do purposely show, make them soft, that is, with little distinctness and their shadows not much tinted, and [3] the limbs, specially the arms, relaxed—that is to say, [3a] no part of the body in a straight line with the part next to it.

70. Filippo Lippi. *The Feast of Herod* (detail). Prato, Cathedral. Fresco.

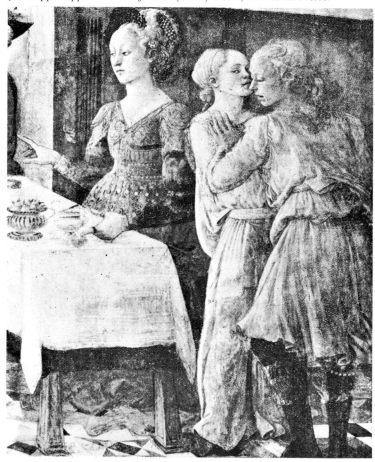

One begins to see why Filippo Lippi, so endowed with *gratia*, has less *rilievo* than Masaccio or Castagno: the two qualities are not fully compatible. Leonardo's recipe, and Desiderio and Filippo's common practice, make up a rough description of pictorial *gratia*, but not a definition. It is doubtful whether a definition is desirable: later, in the sixteenth century, philosophers and theorists of art tried very hard to define *grazia* in neo-platonic terms, especially its difference from beauty, but the results were over-elaborate and academic. But one definition helpful and also proper to Landino in 1480 was that of the neo-classical literary critics, his professional colleagues. In their system *gratia* was the product of (1) *varietà* and (2) *ornato*. It is precisely these two qualities Landino now goes on to attribute to Filippo Lippi.

(g) *Ornato*—ornate

The main difficulty in understanding the Renaissance sense of the term 'ornate' is that it evokes, for us, an idea so much of decorative embroidery and appliqué embellishment; for us it is the knobs on things. But in the Renaissance this was a small and questionable part of the *ornato*, which embraced much more. Here again neo-classical literary criticism gave the clearest formulations of what *ornato* was, and especially Book VIII of Quintilian's *Education of an Orator*. For the literary critics the first two virtues of language were clarity and correctness, insufficient however in themselves to make a production distinguished, and anything additional to clarity and correctness was the *ornato*; Quintilian stated: 'the ornate is whatever is more than just clear and correct.' Much of what makes up an artistic production is ornate. Quintilian lists the general qualities of ornateness: piquancy, polish, richness, liveliness, charm and finish (*acutum, nitidum, copiosum, hilare, iucundum, accuratum*). In literary theory all this was further subdivided and analysed; but it is the general notion of *ornato* that spread to such other activities as painting. To Landino Filippo Lippi's and Fra Angelico's paintings were *ornato*, where Masaccio was without *ornato* because he pursued other values. That is to say, Filippo Lippi and Fra Angelico were piquant, polished, rich, lively, charming and finished, whereas Masaccio sacrificed these virtues for clear and correct imitation of the real. It is important to realize that 'without *ornato*' is a very much stronger and more interesting remark about Masaccio than 'not ornate' would be to us; Masaccio, in Landino's view, sacrificed a great deal. This is all very general,

of course, and is bound to remain so: true *ornato* is too much an element diffused through a pictorial style to be isolated like *rilievo* or perspective. But it is noticeable that when the Quattrocento used the term in the context of particular motifs in pictures it is very often in relation to the attitude or the movement of a figure. Alberti, for instance, suggests: 'Let the movements of a man (as opposed to a boy or young woman) be *ornato* with more firmness, with handsome and skilful attitudes.' And here the Renaissance was close to classical antiquity. In a famous passage Quintilian, trying to explain the effect of ornate figures in rhetoric, uses the simile of a statue; the stiff, upright statue with its arms hanging straight down, lacks *gratia* and ornateness, whereas a curved, mobile and varied pose has *gratia* and is the equivalent of ornate prose. And this perhaps is the best mental image for our purpose: the foursquare straight figure (Masaccio) is without *ornato* (Colour Plate III), and the flexed, counterpoised one (Filippo Lippi) is *ornato* (plate 71).

Landino also notes that Filippo Lippi was good at '*ornamenti* of every kind, whether imitated from reality or invented.' In

71. Filippo Lippi. *The Nativity of St. Stephen*. Prato, Cathedral. Fresco.

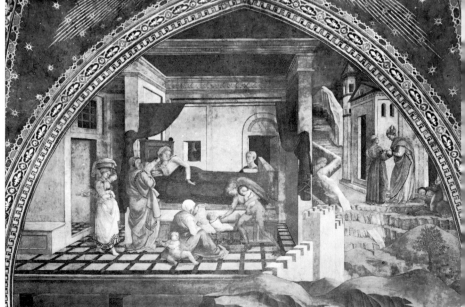

72. Nicolas Beatrizet. Engraving after Giotto's *Navicella*.

Quattrocento usage *ornamenti* are usually rather closer to our sense of ornaments and decorative trappings. Properly used on figures or buildings they are a part of *ornato*, but only in moderation; Leonardo: 'In narrative paintings never put so many *ornamenti* on your figures and other objects that they obscure the form and attitude of the figures or the essence (*essentia*) of the objects.'

(h) *Varieta*—variety

The classic Quattrocento account of pictorial variety and the one most familiar to Landino was in Alberti's *Treatise on Painting* of 1435. Alberti was concerned to refine the notion of variety and differentiate between it and sheer quantity of stuff. He therefore distinguished between two kinds of interest: (1) copiousness (*copia*), which is a profusion of matter, and (2) *varieta*, which is a diversity of matter. A picture is 'copious' when 'there are mingled together old men, young men, boys, women, girls, small children, fowls, puppy-dogs, small birds, horses, sheep, buildings, tracts of country, and so on'; one is reminded of the list in the Ghirlandaio-Tornabuoni contract of 1485 (p. 17). All this is pleasant enough as long as it is appropriate and not confused;

73. Filippo Lippi. *Study for a Crucifixion*. London, British Museum. Pen drawing.

but, says Alberti, 'I should wish this copiousness to be *ornato* with a certain *varietà*.' Variety is an absolute value while copiousness is not and, as Alberti expounds it, variety lies particularly in two things: firstly in a diversity and contrast of hues, as we have already seen (p. 85); secondly and above all, in a diversity and contrast of attitudes in the figures:

Some will stand upright and show all their face, with their arms high and hands spread joyfully, standing on one foot. Others will have their face turned away and their arms let fall, their feet together; and thus each figure will have its own attitude and curve of the limbs: some will sit, others rest on one knee, others lie down. And if it is allowable, let one figure be nude, and others partly nude and partly draped . . .

An example of variety is Giotto's mosaic of the *Navicella* (plate 72)

134

in which our Tuscan painter Giotto put eleven disciples, all moved by fear seeing one of their companions walk on the waters, because he represented each figure with its face and action indicating a disturbed mind, so that each had its own diverse movements and attitudes.

There are paintings by Filippo Lippi that are both copious and varied, but it is the pictures that are varied with an economy of elements that Quattrocento critics most admired: a drawing for a *Crucifixion* (plate 73) represents very well what Alberti and Landino meant by variety of figures. The resonances between the pictorial value of variety and other areas of Quattrocento culture —with literary criticism and with the experience of the heavenly, as we have seen (p. 104)—are very powerful.

(i) *Compositione*—composition

Composition, in the sense of a systematic harmonization of every element in a picture towards one total desired effect, was invented by Alberti in 1435: it is from him Landino takes the concept. Alberti found his model in the classical literary criticism of the humanists, for whom *compositio* was the way in which a sentence was made up, with a hierarchy of four levels:

Alberti transferred the word and the model to painting:

Pictures are composed of bodies, which are composed of parts, which are composed of plane surfaces: planes are composed into

135

members, members into bodies, bodies into pictures. With this notion the Quattrocento could analyse the make-up of a picture very thoroughly, scrutinizing its articulation, rejecting the superfluous, relating formal means to narrative ends. It was also the imaginative skeleton on which the artist built up, and the critic judged, *varietà*. Indeed the two concepts are complementary: neither the centrifugal *varietà* nor the centripetal *composizione* is complete without the other. *Composizione* disciplines *varietà*: *varietà* nourishes *composizione*. Landino realized this and praises Filippo for *compositione et varieta*, as a pair; and here we have another cross-bearing for he praises another artist, the sculptor Donatello, for the same qualities. Donatello is *mirabile in compositione et in varieta*. Now this is initially a disconcerting conjunction. What can the eloquent and energetic figures and groups of Donatello's

74. Filippo Lippi. *The Virgin and Child with Saints and Angels* (Barbadori Altarpiece, about 1440). Paris, Louvre. Panel.

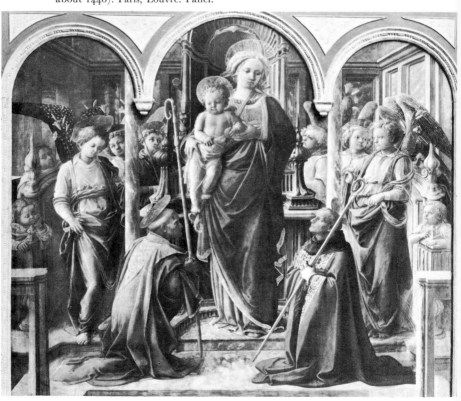

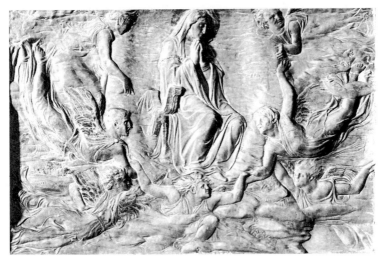

75. Donatello. *The Assumption of the Virgin* (Tomb of Cardinal Rinaldo Brancacci, about 1426). Naples, S. Angelo a Nilo. Relief in marble.

reliefs have to do with the gracious and restrained Filippo Lippi? A great deal, as it turns out, and Landino's perceptive match-making prods one into attending to a very real underlying similarity. Both artists composed groups in which varied figures combine into symmetrical groups, satisfying because of the tension between variety and symmetry (plates 74, 75). Both could gear this to narrative purposes, composing into a rich coherence a variety of 'movements of body and of mind' (plates 73, 76), and both sometimes extended this to very large numbers of figures. Both constructed uncanny but completely composed worlds behind their protagonists, pushing their composed space deep into the picture, whether the elements are trees and rocks, as often in Filippo (Colour Plate IV), or architectural fantasies, as usually in Donatello (plate 76). The general dissimilarity of the artists is therefore an opportunity for us: the principle of order these two have in common—plate 74 with plate 75, and plate 73 with plate 76, and plate IV with plate 76—uncluttered with accidental or superficial similarities, is *compositione e varieta* distilled. And once we learn to see this quality, we have a finger on one of the prime bearings of Quattrocento cognition.

(j) *Colorire*—colouring
This does not mean 'colouring' in our current sense, which refers mainly to hues. In fact, it is an important negative of

Landino's criticism that he never praises a painter for his colour, in our sense, as such: for that sort of thing one must go outside Florence. Giammario Filelfo addresses the Venetian Gentile Bellini:

> Veduta ho lopra tua col suo cholore,
> La venustà col suo sguardo benegno,
> Ogni suo movimento e nobil segno,
> Che ben dimonstri il tuo gientil valore.

> I have seen your work with its colour,
> Its comeliness and generous glance,
> Its every movement and noble gesture,
> Well showing your lofty merit.

Content with a comely impression, this is a more naive and passive sensibility than Landino's. By *colorire* Landino means the application of pigment. It was sometimes used in a very general sense, almost equivalent with 'painting'; according to the biographer Vespasiano da Bisticci, Federigo da Montefeltro, 'because he did not find masters to his taste in Italy who knew

76. Donatello. *The Feast of Herod* (about 1435). Lille, Musée Wicar. Relief in marble.

how to *colorire* on panels with oil, sent to Flanders'. But there was a more special and interesting sense, which is what Landino has in mind, and this is given a definition by Piero della Francesca in his treatise *On the painter's perspective*: 'By *colorare* [sic] we mean applying colours as they show themselves in objects, lights and darks according to how the illumination makes them change.' In other words, *colorire* partly overlaps with *rilievo* and coincides with the section of Alberti's treatise which he calls 'Reception of light'. To the painter the phenomenon of an objects' reception of light presented itself as the art of manipulating black and white, on the one hand, and red, blue, green and the rest of the colours, on the other: tones and hues. But *colorire* gains its full sense in opposition to the next value Landino invokes, not for Filippo Lippi but for Andrea del Castagno, *disegno*.

ANDREA DEL CASTAGNO

Castagno signed some frescoes in S. Zaccaria at Venice in 1442. It is not known who his teacher was, nor exactly when he was born, though 1423 is now considered a likely date. By 1444 he was back in Florence. The main line of his work thereafter lies in a series of frescoes in S. Apollonia (*The Last Supper, Crucifixion, Entombment* and *Resurrection* (plate 77: about 1445–50), SS. Annunziata (*St. Julian; The Trinity with the Virgin, St. Jerome and a Saint* (plate 79), the Villa Carducci at Soffiano outside Florence (a cycle of famous men and women, now removed to S. Apollonia), and the equestrian portrait of Niccolò da Tolentino in the Cathedral, 1456. He died in 1457.

(k) *Disegnatore*—exponent of design
The term was associated with linear, as opposed to tonal, representation of the object. Francesco da Buti, a late fourteenth-century commentator on Dante: '[Giotto] was a master of the brush—that is, a finished painter (*dipintore*)—and also of the pencil (*stile*)—that is, *disegnatore* with pencil on panels.' This brings us immediately to the distinction between *disegno* and *colorire*. Cennino Cennini in his handbook: 'The foundations of the art of painting and the starting point for all these works of the hand are *disegno* and *colorire*.' *Colorire* (Filippo Lippi) goes with brush, tones, the representation of surfaces, *rilievo*; *disegno* (Castagno) goes with pencil, lines, the representation of edges, perspective. As it happens we can see Castagno's *disegno* isolated

77. Andrea del Castagno. *The Resurrection* (detail). Florence, S. Apollonia. Sinopia.

pure from his art, since the underdrawing of some of his frescoes at Sant'Apollonia was uncovered in 1953 beneath the painted layer of fresco plaster: the two soldiers in the foreground of the *Resurrection* (plate 77) represent Castagno *disegnatore*—that is, drawing lines that define forms and their position in space by registering precisely the edges they and their parts present to the beholder. One sees why Landino valued him for this quality. Alberti—who usually called *disegno* 'circumscription', a latinizing word—remarked that 'perhaps it is more useful to practise at *rilievo* than at *disegno*', which goes strangely with his preoccupation with the perspective of outlines. But he was probably thinking of a kind of north Italian painter who worked mainly with outlines, depending on the suggestive delicacy of his *disegno* and the local precision of his contours to make the beholder supply in his own mind the relief of surfaces not modelled by the painter in any detail. Pisanello was a painter of this kind (plate 42), and was aptly praised for his *disegno* (not *colorire*, nor *rilievo*) by Angelo Galli in the poem we met earlier (p. 77). In the first half of the Quattrocento this powerful *disegno* convention, nimble and clearly popular, was a real competitor of the Florentine tonal

painting, and Alberti was trapped by the ambiguity of the term *disegno*. Piero della Francesca tried to solve the confusion by dividing off the perspective aspect of *disegno*:

Painting contains three principal parts, which we call *disegno*, measurement and colouring. By *disegno* we mean profiles and contours which enclose objects. By measurement we mean the profiles and contours put proportionally in their proper places. By colouring we mean how colours show themselves on objects, lights and darks as the lighting changes them.

The dichotomy between *disegno* and *colorire*, lines and tones—a tendentious simplification of visual experience—has now long been built very deep into the European visual culture; it gives us a curiously disjunctive, Jekyll-and-Hyde sensibility marking us off from that represented by, say, Chinese painting and criticism. It was the Renaissance that gave this analytic habit its systematic formulations, and made drawing and painting, edges and surfaces, lines and tones, the 'foundation of the art of painting' as it was taught and is observed.

(1) *Amatore delle difficulta*—lover of difficulties

The performance of difficult things was valued in itself, as an exhibition of skill and talent. In Landino's time Lorenzo de' Medici, for instance, praised the form of the sonnet 'arguing from its difficulty—since noble accomplishment (*virtù*), according to the philosophers, consists in the difficult'. This held for painting too, and we are here again very close to the clients' demand for conspicuous skill: a painter publicly recognized as a successful lover of difficulties is one whose skill is publicly perceptible. Castagno is also *facile nel fare*, as Masaccio was too, but there is no contradiction here. The action is *difficile*, the agent *facile*: the good painter does hard things easily. This false paradox fascinated Renaissance critics and a sixteenth-century writer, Lodovico Dolce, played on it to differentiate between the styles of Michelangelo and Raphael: 'Michelangelo always sought *difficulty* in his works, while Raphael sought *facility*—a *difficult* thing to do.' It is a linguistic accident one would try to avoid nowadays, speaking of the action as difficult or intricate, perhaps, but of the agent as, say, fluent or adroit. But what sort of thing were the difficulties of the art, loved so publicly and successfully by Castagno? Landino's friend Antonio Manetti, in his biography of Brunelleschi told of the competition of 1401 for the doors of the Baptistry at Florence; Brunelleschi was one of those who

submitted a trial relief of *The Sacrifice of Isaac* (plate 78) and this had flaunted difficulties. All the judges

were astonished at the *difficulties* he had set himself—the pose of Abraham, the placing of the finger under Isaac's chin, his prompt movement, and his drapery and manner, and the delicacy of the boy Isaac's body; and the manner and drapery of the Angel, and his action and way of seizing Abraham's hand; and the pose and manner and delicacy of the man taking a thorn from his foot, and also of the other man leaning over and drinking. They were astonished at how many *difficulties* there are in these figures, and how well they carry out their functions. . . .

78. Filippo Brunelleschi. *The Sacrifice of Isaac* (1401). Florence, Bargello. Relief in bronze, part gilt.

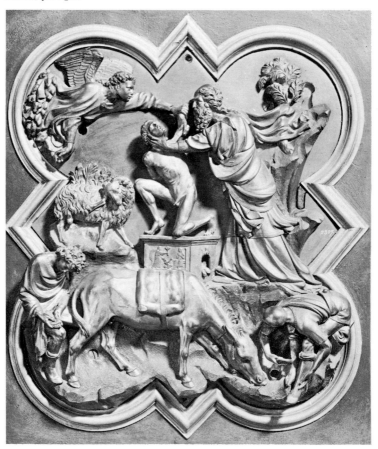

Brunelleschi's 'difficulties' were functional exploits of skill, *tours de force* that pointed up the narrative by conspicuously avoiding the stock solutions: Abraham's hand on Isaac's throat and the Angel's hand on Abraham's wrist are noticed first as strokes of virtuosity and then as accents in the story. Castagno's self-imposed difficulties too were not barren feats of dexterity but narrative devices of emphasis, and for Landino they lay particularly in his *scorci* or foreshortenings.

(m) *Scorci*—foreshortening

These are the special area of Castagno's difficulty. In his fresco of *The Trinity adored by the Virgin, St. Jerome and a Saint* (plate 79) the extraordinary foreshortening of the Trinity and the similar accents of skill on the faces of the three adoring figures are the main basis of the narrative. They replace gold accents; their localized character, the notion of difficulty or skill as something laid on in patches, is a survival from the gold-emphasis sensibility the skill-emphasis sensibility was replacing. It was as offensive to the later Renaissance as gilding itself became to the Quattrocento. *Scorci* are a local application of perspective. Landino said of Paolo Uccello that he was 'skilful in *scorci*, because he understood perspective well': perspective is thus the science or theory, *scorci* the local appearance of its practice. In fact, a picture can be done in the light of systematic perspective without having any foreshortenings strident enough to call for comment on the *scorci*: Masaccio's *Tribute Money* (plate 65) is an example. A picture can also have flashy *scorci* without adhering to any careful method of perspective construction: the face of a squire attending to the spurs of the young Magus in the centre of Gentile da Fabriano's *Adoration of the Magi* (plate 21) is a trick effect quite common in late gothic painting, learned and taught from a pattern model, not from a method. But in practice the term *scorci* often covers two kinds of interest. The first is foreshortening proper—a long thing viewed from one end so as to present a short stimulus to the eye: in this the exercise of the mind, inferring the long from the short, is pleasant. The second is the unfamiliar view. A human face seen from its own level, full-face or in profile, is hardly less 'foreshortened' than faces seen from above or below; but these are less familiar and more easily claim our attention. We notice the foreshortening of the nose seen from above more than we notice the foreshortening of the ear on a head seen full-face, because we have to make a little more effort to recognize it and the achievement is satisfying. Both these kinds

79. Andrea del Castagno. *The Trinity adored by the Virgin, St. Jerome and a Saint.* Florence, SS. Annunziata. Fresco.

of interest are involved in, for instance, the figure of Christ in Castagno's *Trinity*. And it is essential to realize that the difficulty is something that is to tax the beholder as well as the artist: *scorci* and other such kinds of interest were considered difficult to see and understand, the painter's skill making demands on the beholder's skill. The effort demanded was what directed attention. It is a very fundamental difference between the Quattrocento and the sixteenth century that the first realized this while the second, with its taste for blandness, did not. In Lodovico Dolce's *Dialogo della pittura* of 1557 the naive character Fabrini feeds the cultivated one Aretino by saying: 'I have heard that *scorci* are one of the principal *difficulties* of the art. So I would suppose that the painter deserves the more praise the more often he puts them in his work' It is a caricature of the Quattrocento attitude, and Aretino corrects him. It is true, he says, that *scorci* cannot be done without great skill, and a painter should use them occasionally 'to show he knows how to.' But this should only be done rarely: '*Scorci* are understood by few beholders, and so are pleasant to few; even to the knowledgeable beholder they are sometimes more irritating than pleasing.' From the same point of view Vasari condemned the *scorci* in such Quattrocento painters as Castagno for being too studied and obtrusive, 'as painful to see as they were *difficult* to execute.'

(n) *Prompto*—prompt

Leonardo da Vinci warned the painter: '. . . if you want to please people who are not masters of painting, your pictures will have few *scorci*, little *rilievo*, and little *pronto* movement.' Landino has already said that Castagno was a lover of difficulties, and he has drawn attention to his *scorci* and *rilievo*; by now calling him *vivo e prompto* he completes his characterization of him as the painter's painter, the artist appreciated by people understanding the skills of the art. Landino ascribes the same virtue to two other artists. In Giotto's *Navicella* (plate 72) each of the Apostles 'has *vivo* and *prompto* movements'; Donatello is '*prompto*' and with great *vivacita* both in the arrangement and the placing of the figures (plate 76). Castagno's *David* (plate 80) represents the *vivo* and *prompto* quality of attitude he has in common with Giotto and Donatello. It is a stronger diversification of the figure, more suggestive of particular movements, than Filippo Lippi's *gratia*, but the terms have one very important thing in common. They both involve a degree of conflation, probably less rather than more conscious, between two kinds of movement—depicted

145

80. Andrea del Castagno. *David* (about 1450). Washington, National Gallery of Art. Tempera on leather.

movement of the painter's figures, naturally, but also inferred movement of the painter's hand. Leonardo speaks of *gratia* as a quality of painted figures; Filippo Lippi's epitaph speaks of the *gratia* of his hand. Landino refers to the *prompto* movements of Giotto's Apostles; Alberti invokes the term for his discussion of the sources of facility, 'diligence-with-quickness': 'The intellect moved and warmed by exercise becomes very *pronto* and quick in its work, and the hand follows speedily when a sure intellectual method leads it.' It is once more the Quattrocento sense of mind and body in the most immediate relationship: as a figure's movement directly expresses thought and feeling, the movement of a painter's hand directly reflects his mind. When Landino says that Filippo Lippi 'is' *gratioso* or that Castagno 'is' *prompto* it is impossible to exclude either sense. This ambiguity is not a problem, unless one makes it one by demanding a distinction alien to the Quattrocento itself. On the contrary, the conflation is the key to the Quattrocento sense of personal style—*gratioso* or *prompto*, *aria virile* or *aria dolce*; style or aria is something lying between the movement of figures and the movement of brush.

FRA ANGELICO

Fra Giovanni da Fiesole became a Dominican friar at Fiesole in 1407, aged about 20, and came under the influence of Giovanni Dominici, a great Dominican teacher whose pupils also included S. Antonino, later Archbishop of Florence. He appears to have come late to painting. The first recorded commission from him was in 1433, the *Madonna of the Linen Guild* (plate 3) now at S. Marco in Florence. From 1436 he painted many frescoes in the convent of S. Marco (plate 31). From about 1446 until his death at Rome in 1455 he spent two extended periods painting at the Vatican: his frescoes in the Chapel of Nicolas V there survive.

(o) *Vezzoso*—blithe

This word is untranslateable. John Florio, in the first Italian-English dictionary (1598 and 1611), tried hard to find synonyms:

> *Vezzoso*, wanton, mignard, full of wantonnesse, quaint, blithe, buckesome, gamesome, flattring, nice, coy, squeamish, peart, pleasant, full of affectation.

This is fair warning of its elusiveness. A *vezzo* was a caress and,

by extension, a delight; *vezzoso* was delightful in a caressing way. It was not a manly quality and in some contexts it was not a virtue at all. Though Boccaccio spoke approvingly of *vezzose donne, vezzosi fanciulli,* a *vezzoso* man was an over-delicate and effete thing. Landino is talking not about a man—though his syntax may seem to say he is—but again about a quality lying somewhere between the character of Fra Angelico's skill and the character of the human figures painted by Fra Angelico. As with *gratia,* there is a cross-reference within Landino's text to Desiderio da Settignano (plate 69), who also is *vezzoso.* Perhaps 'blithely (to take a hint from Florio) charming' is a rough translation. But to what formal qualities in Fra Angelico does this particularly refer? Leaving aside the obviously blithe and charming character of such figures as the dancing angels in his pictures, it is likely that the word is saying something especially about the tonal values of his art. At least, it is in this sort of context that Alberti chose to use the word. He was anxious that the painter should not over-emphasize the tonal contrast of lights and darks, particularly lights, by adding much white or black pigment to his hues:

Much to be blamed is the painter who uses white or black without much moderation . . . It would be a good thing if white and black were made of pearls . . . because the painters would then be as sparing and moderate with them as they ought, and their works would be more true, more agreeable, and more *vezzoso.*

There was a physiological basis for this; in a popular treatise of the Quattrocento Girolamo di Manfredi had explained:

Why our vision is better with green colours than with whites and blacks: Every extreme weakens our perception, whereas the moderate and temperate strengthens it, since extremes affect the organ of perception immoderately. Thus white has an expansive effect, while intense black has an excessively concentrating effect. But a moderate colour, like green, has a temperate effect, not expanding nor concentrating too much; and therefore it strengthens our vision.

In this special sense, of a style in which strong tonal extremes do not assault us, *vezzoso* is clearly a true description of Fra Angelico's painting (plate 24(d))—as also of Desiderio's shallow and softened relief sculpture; they avoid the strong contrasts of such *rilievo* painters as Castagno. *Vezzoso* is blandly as well as blithely charming.

(p) *Devoto*—devout
With a word like this the problem is to steer a course between the

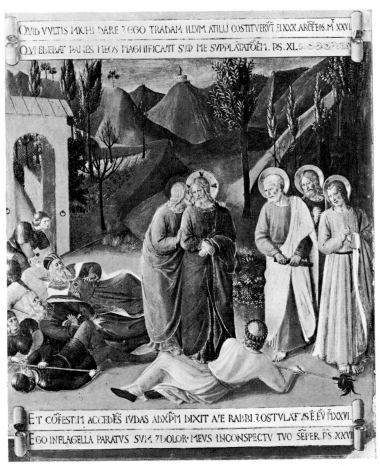

QVID VVLTIS MICHI DARE 7 EGO TRADAM ILIVM ATILLI COSTITVERVT EI XXX ARGETEOS M.XXVI.

QVI EDEBAT PANES MEOS MAGNIFICAVIT SVP ME SVPPLATATOEM. PS.XL

ET COFESTIM ACCEDES IVDAS ADXPM DIXIT AVE RABBI 7 OSTVLAT SE EV MXXVI.

EGO INFLAGELLA PARATVS SVM 7 DOLOR MEVS INCONSPECTV TVO SEPER PS XXVI

81. Fra Angelico. *The Kiss of Judas* (from the Armadio degli Argenti, about 1450). Florence, SS. Annunziata. Panel.

blankness of our words 'devoted' or 'devout' and over-interprettion. What, first of all, was devotion? Fra Angelico certainly and Landino probably would have referred one to the classic account by St. Thomas Aquinas: devotion is the conscious and willed turning of the mind to God; its special means is meditation; its effect is mingled joy at God's goodness and sadness at man's inadequacy. But how does the *devoto* particularly show itself in artistic productions that are in any case expositions of religious matter? Here the late medieval and Renaissance classification

149

of sermon styles is helpful; we have seen that the relation between preaching and painting was close, and the categories of sermon are much to the point:

There are four styles of preaching . . . The first style is more keenly exact (*subtilis*) and is for men who are wise and expert in the art of theology. Its function is to search into matters. The second style is more easily accessible (*facilis*), and is for people newly introduced to theology. Its function is to treat matters thoroughly. The third is more elaborate (*curiosus*) and is for those who want to make a display. As it is unprofitable, it should be avoided. The fourth style is more devout (*devotus*) and is like the sermons of the saints which are read in church. It is the most easily understood and is good for edifying and instructing the people. . . . The fathers and holy doctors of the Church, St. Augustine and other saints, kept to this style. They shunned elaboration and told us their divine inspirations in one coherent discourse. . . .

This is the sort of framework from which Landino seems to be taking his term. So we have a style: contemplative, blending joy and sadness; unelaborate, certainly, and intellectually unassertive; 'easily understood and good for edifying and instructing people.' It would be difficult to quarrel with this as a description of the emotional colour of Fra Angelico (plate 81). But to what pictorial qualities, particularly, does this correspond? Positively, of course, to the *vezzoso*, the *ornato*, and the *facilita* Landino also attributes to Fra Angelico; negatively to the absence of *difficulta*—accented *scorci*, sharp *rilievo*, or very *prompti* movements—which he does not attribute to him. What is absent from Fra Angelico's painting is seen as something purposefully renounced by him, much as *ornato* was purposefully renounced by Masaccio: the term *devoto* is of the same order as the term *puro* applied to Masaccio, and that the one belongs to the classification of Christian preaching, the other in that of classical rhetoric, is part of Landino's critical richness and sureness.

Pure, easy, gracious, ornate, varied, prompt, blithe, devout; relief, perspective, colouring, composition, design, foreshortening; imitator of Nature, lover of the difficulties. Landino offers a basic conceptual equipment for addressing Quattrocento pictorial quality. His terms have a structure: one is opposed to, or is allied with, or is subsumed by, or overlaps another. It would not be difficult to draw a diagram in which these relationships were registered, but the diagram would imply a systematic rigidity which the terms in practice do not and should not have. We can use them now as a complement and stimulus, and naturally not as a substitute, for our own concepts; they will give us some

assurance of not altogether losing sight of what these painters thought they were doing. Quattrocento intentions happened in Quattrocento terms, not in ours.

Terms like Landino's have the advantage of embodying in themselves the unity between the pictures and the society they emerged from. Some relate the public experience of pictures to what craftsmen were thinking about in the workshops: 'perspective' or 'design'. Others relate public experience of pictures to experience of other sides of Quattrocento life: 'devoutness' or 'graciousness'. And still others point to a force which was quietly changing the literate consciousness at this time.

For there is one area of metaphor here, very important for Landino, which was not considered in Chapter II. Categories like 'pure' or 'ornate' or 'composition' draw on the classical system of literary criticism, a complex and mature categorization of human activity to which humanist scholars like Landino gave a great deal of study. It did not belong in Chapter II because most churchgoing, dancing bankers were not humanist scholars: it was a skill of the learned. But in the course of the Renaissance some of this vocabulary for criticizing art and life trickled across from the scholars and writers to other people. The banker took to using many of these words and concepts without any particular awareness of their classical source. This process was an important part of the lasting classicization of European culture in the Renaissance, more important than some superficially more obvious parts: experience was being re-categorized—through systems of words dividing it up in new ways—and so re-organized. One facet of this reorganization was that the different arts were brought together by a uniform system of concepts and terms: *ornato*, in the sense we noticed, was applicable to painting and music and manners as well as literature. The affinity this lent the different arts was sometimes illusory, but much affected their practice. Landino's use of 'pure' and 'ornate' and 'composition' to an audience of plain men is a small part of this great process.

5. This book began by emphasizing that the forms and styles of painting respond to social circumstances; much of the book has been given up to noting bits of social practice or convention that may sharpen our perception of the pictures. It is symmetrical and proper to end the book by reversing the equation—to suggest that the forms and styles of painting may sharpen our perception of the society. Half the point of the exercise has been to imply that this is so.

It would be foolish to overstate the possibilities, but they are real. They arise from the fact that the main materials of social history are very restricted in their medium: they consist in a mass of words and a few—in the case of the Renaissance a very few—numbers. These cover some kinds of activity and experience repetitively and neglect others. Much of the most important experience cannot conveniently be encoded into words or numbers, as we all know, and therefore does not appear in the documents that exist. Besides this, many of the Renaissance words we must rely on are now almost completely worn out: it is difficult to close with Machiavelli's words about what was important in the Renaissance because so many other words, comment and reformulation, have since got in the way. It is very difficult to get a notion of what it was to be a person of a certain kind at a certain time and place.

It is here that pictorial style is helpful. A society develops its distinctive skills and habits, which have a visual aspect, since the visual sense is the main organ of experience, and these visual skills and habits become part of the medium of the painter: correspondingly, a pictorial style gives access to the visual skills and habits and, through these, to the distinctive social experience. An old picture is the record of visual activity. One has to learn to read it, just as one has to learn to read a text from a different culture, even when one knows, in a limited sense, the language: both language and pictorial representation are conventional activities. And there are various destructive uses of pictures which must be avoided. One will not approach the paintings on the philistine level of the illustrated social history, on the look out for illustrations of 'a Renaissance merchant riding to market' and so on; nor, for that matter, through facile equations between 'burgess' or 'aristocratic' milieux on the one side and 'realist' or 'idealizing' styles on the other. But approached in the proper way—that is, for the sake of the argument, in the way followed in this book—the pictures become documents as valid as any charter or parish roll. If we observe that Piero della Francesca tends to a gauged sort of painting, Fra Angelico to a preached sort of painting, and Botticelli to a danced sort of painting, we are observing something not only about them but about their society.

These may seem to students of charters and parish rolls a hopelessly lightweight sort of fact. They are certainly a distinct kind of fact: what they offer is an insight into what it was like, intellectually and sensibly, to be a Quattrocento person. Such

insights are necessary if the historical imagination is to be fed, and the visual is here the proper complementary to the verbal. But the last word on this is best left to Feo Belcari of Florence, to the first lines of his play *Abraham and Isaac*, acted in 1449:

> Lo Occhio si dice che e la prima porta
> Per la quale lo Intellecto intende e gusta.
> La secunda e lo Audire con voce scolta
> Che fa la nostra mente essere robusta.

> The Eye is called the first of all the gates
> Through which the Intellect may learn and taste.
> The Ear is second, with the attentive Word
> That arms and nourishes the Mind.

Texts and References

I

1. Borso d'Este: Francesco Cossa's letter of complaint about Borso's method of payment is printed in E. Ruhmer, *Francesco del Cossa* (Munich, 1959), p. 48.
 Giovanni de' Bardi: see p. 16 below.
 Rucellai: *Giovanni Rucellai ed il suo Zibaldone*, I. 'Il Zibaldone Quaresimale', ed. A. Perosa (London, 1960) pp. 24 and 121.

2. Filippo Lippi and Giovanni de' Medici: G. Gaye, *Carteggio inedito d'artisti dei secoli XIV, XV, XVI*, I, (Florence, 1840) pp. 175–6, and H. Mendelsohn, *Fra Filippo Lippi* (Berlin, 1909) pp. 154–9 and 235–6:

Io feci quanto mimponesti della tavola, et missimi inpunto dongni chosa. el santo michele è in tal perfezione, che per chelle sue armadure, sono dariento e doro e chosì laltre sue vesta, ne fui chon bartolomeo martello; disse delloro e di quello vi bisogniava lo direbbe chon Ser franciescho, e chio altutto faciessi quanto era di vostra volontà; e molto mi riprese mostrando io avere el torto contro divoi. — Ora giovanni io sono qui al tutto esservi schiavo, effarò chon effetto. Io ò auto da voi quatordici fiorini, et io vi scrissi vi sarebbe trenta di spesa, e stia cosí, perché bella dornamenti. priegovi per dio chomettiate in bartolomeo martelli, sopra questo lavoro chonducitore, essio oddi bisognio dalchuna chosa per rispaccio dellopera, io vada a lui e vedralla, io liene farò honore; e olgli detto che tra voi e me lui ne sia mio malevadore, ellui dicie essere chontento, e vuollo fare, pure chio vi spacci, eppiú chio vene scriva. esse vi pare fatelo, chio mi sto; perché io non nò piú oro, neddanari per chille mette. Io vi priegho chio non mi stia; è tre dí chio non fo niente, e aspetto ci siate.
 Eppiú se vi pare che a ongni mia spesa, chome è di sopra trentta fiorini, ched dogni e ciascheduna chosa, finita di tutto, voi mene diate sessanta fiorini larghi di legniame, doro, di mentitura, eddipintura, e chome detto bartolomeo sia quanto eddetto, per meno impaccio di voi io larò di tutto finita per tutto dí venti dagchosto dalla parte mia, e bartolomeo fia mio mallevadore. essella spesa non vè, starò a quello vi fia, e perché voi siate bene avisato, vi mando el disengnio chomè fatta di legniame e daltezza e larghezza; e voglio perramore di voi non torvene piú chellavoro di ciento fiorini; dimandogni altro. Prieghovi rispondiate, che qui ne muoro; e vore' poi partirmi. essio fussi pro-

sontuoso innavervi scritto, perdonatemi. effarò sempre quell piú e quell meno piacerà alla reverenza vostra. valete addí xx luglio 1457

frate filippo dipintore in firenze

Ghirlandaio and the Spedale degli Innocenti: P. Küppers, *Die Tafelbilder des Domenico Ghirlandajo* (Strasbourg, 1916) pp. 86–7:

Sia noto e manifesto a qualunque persona che vedrà o legierà questa presente scritta come a preghiera del venerabile religioso messer Francesco di Giovanni Tesori, al presente priore dello spedale degli Inocenti di Firenze, e Domenico di Tomaso di Curado dipintore, Io frate Bernardo di Francesco da Firenze, frate ingiesuato, a frate questa scritta di mia mano per convegna e patto e allogagione d'una tavola d'altare a andare nella chiesa del sopradetto spedale degli Inocenti con patti e modi che qui di sotto si dirà, cioè:

Che oggi questo di xxiii d'ottobre 1485 el detto messer Francesco dà e alluoga al sopradetto Domenico a dipignere uno piano, el quale è fatto e à avuto da detto messer Francesco, el quale piano à fare buono detto Domenico, cioè à pagare, e à a colorire e dipignere detto piano, tutto di sua mano in modo come apare uno disegno in carto con quelle figure e modi che in esso apare, e piú e meno secondo che a me frate Bernardo parrà che stia meglio, non uscendo del modo e composizione di detto disegno; e debbe colorire detto piano tutto a sua spese di colori buoni e oro macinato nelli adornamenti dove acadranno, con ogn'altra spesa che 'n detto piano acadessi, e l'azurro abbia a esse oltramarino di pregio di fiorini quatro l'oncia in circa; e debba aver fatto e dato fornito el detto piano da oggi a trenta mesi prossimi a venire; e debba avere per pregio di detto piano com'è detto, e tutto a sua spese, cioè di detto Domenico, fiorini centoquindici larghi se a me frate Bernardo soprascritto parrà se ne venghino, e possi pigliare parere di detto pregio o lavoro da chi mi paressi, e quando no mi paressi se ne venissi detto pregio, n'abbia avere quel meno che a me frate Bernardo parrà; e debba in detto patto dipignere la predella di detto piano come parrà a fra Bernardo detto; e detto pagamento debba avere in questo modo, cioè: ch'el detto messer Francesco debba dare al sopradetto Domenico ogni messe fiorini iii larghi, cominciando a di primo di novembre 1485, seguendo di mano in mano, come è detto. ogni mese fiorini tre larghi . . .

E non avendo detto Domenico fornito detto piano frallo infrascritto tempo, abbia a cadere in pena di fiorini xv larghi; e cosi se 'l detto messer Francesco non oservassi il sopradetto pagamento, abbia a cadere nella sopradetto pena in tutta la soma, cioè che finito detto piano, gli abbia a dare intero pagamento del tutto la soma che restassi.

Pietro Calzetta at Padua: V. Lazzarini, 'Documenti relativi alla pittura padovana del secolo XV', in *Nuovo Archivio Veneto*, XV, ii, 1908, p. 82.

Neri di Bicci: G. Poggi, 'Le ricordanze di Neri di Bicci', in *Il Vasari*, I, 1927–8, 317 and III, 1930, 133–4.

Starnina: O. Giglioli, 'Su alcuni affreschi perduti dello Starnina', in *Rivista d' Arte*, III, 1905, p. 20.

Mantegna and the Gonzagas: P. Kristeller, *Andrea Mantegna* (Berlin, 1902) pp. 516–17, 526, 527, 538 and 541:

Nui voressimo, che vedestive ad ogni modo de ritrarne due galine de India del naturale un maschio et una femina et mandarcele qua retracte, per che le voressimo far mettere suxo la tapezaria nostra: potereti veder le nostre che sono ne lo zardino li a Mantua.

... prego la S.V. che li piacia ordinar, che Andrea Mantegna ... venga e stia continuamente cum me. Cum Andrea pigliaro spasso de mostrarli miei camaini, e figure di bronzo et altre belle cose antique: sopra le quale studiaremo e conferiremo de compagnia.

... mandiamo li certi designi de penture quali pregamo che vi piacia farli retrare per el vostro D. Andrea Mantegna pentore celebre.

... ho recevuto el ritracto de la pictura che la E.V. me ha mandato, et facto ogni instantia ad Andrea mantegna mio pictore lo riduca ad elegante forma, el quale me dice che la seria opera piú presto da miniatore che sua perche lui non e assueto pingere figure picole, anzi assai meglio faria una nostra dona aut qualche altra cosa de longeza de uno brazo aut uno brazo e mezzo quando piacesse ala cel.ne V.Ill.ma madona ...

Io ho praticato mercato cum Io. Marco orefice de quelle ole vechie e di li bocali secondo il disigno de Andrea Mantegna. Esso Io. Marcho adimanda de le ole lire 3 soldi 10 de la marcha et deli vali predecti ducati uno e mezo de la marcha ... mando a vostra excel.cia il designo del fiasco fato per Andrea Mantagna acio quella possa judicare de la forma inanti se incominciano.

For contracts in general: H. Lerner-Lehmkuhl, *Zur Struktur und Geschichte des Florentinischen Kunstmarktes im 15. Jahrhundert* (Wattenscheid, 1936); M. Wackernagel, *Der Lebensraum des Künstlers in der florentinischen Renaissance* (Leipzig, 1938), translated by A. Luchs as *The World of the Florentine Renaissance Artist* (Princeton, 1981), with recent bibliography; H. Glasser, *Artists' Contracts of the Early Renaissance* (New York, 1977). Good selections of material are G. Gaye, *Carteggio inedito d'artisti dei secoli, XIV, XV, XVI, I* (Florence, 1840); G. Milanesi, *Nuovi documenti per la storia dell'arte toscana* (Rome, 1893), and in English, D. Chambers, *Patrons and Artists in the Italian Renaissance* (London, 1970).

3. Alfonso V. and the Sienese ambassador: Vespasiano da Bisticci, *Vite di uomini illustri*, ed. P. D'Ancona and E. Aeschlimann (Milan, 1951) p. 60:

Era a Napoli uno ambasciadore sanese, della loro natura, molto

borioso. La Maestà del re il piú delle volte vestiva di nero, con qualche fermaglio nel cappello, o qualche catena d'oro al collo: i broccati e vestiti di seta poco gli usava. Questo ambasciadore vestiva di broccato d'oro molto ricco, e sempre quando veniva al re aveva questo broccato d'oro. Il re piú volte con quegli sua domestici se ne rideva 'di questo vestire di broccato. Un dí, ridendo disse a uno de' sua; per certo che io voglio che noi facciamo che questo broccato muti colore; e per questo ordinò una mattina di dare udienza in uno luogo molto misero; e fece chiamare tutti gli ambasciadori, e ordinò con alcuno de' sua, che la mattina in quella calca ognuno si stropicciasse addosso allo amba-sciadore sanese, e stropiciassino quello broccato. La mattina, non solo dagli ambasciadori, ma dalla Maestà del re era pinto e stropicciato in modo quello broccato, che uscendo da corte, non era uomo che potesse tenere le risa, vedendo quello broccato, ch'era di chermisi, col pelo allucignolato, e cascatone l'oro, e rimasta la seta gialla, che pareva la cosa piú brutta del mondo. A vederlo la Maestà del re uscir dalla sala, col broccato tutto avviluppato e guasto, non poteva tenere le risa ...

Petrarch on skill and preciousness: De remediis utriusque fortu-nae, I. xli, in Petrarch, *Opera omnia* (Basle, 1581) p. 40.

Alberti on the depiction of gold: L. B. Alberti, *Opere volgari*, ed. C. Grayson, III (Bari, 1973) p. 88:

Truovasi chi adopera molto in sue storie oro, che stima porga maestà. Non lo lodo. E benché dipignesse quella Didone di Virgilio, a cui era la faretra d'oro, i capelli aurei nodati in oro, e la veste purpurea cinta pur d'oro, i freni al cavallo e ogni cosa d'oro, non però ivi vorrei punto adoperassi oro, però che nei colori imitando i razzi dell'oro sta più ammirazione e lode all'artefice.

Giovanni de' Bardi and Botticelli: H. P. Horne, *Sandro Botticelli* (London, 1908) p. 353 (Document XXV):

Mercholidí adí III d'Aghosto. A chappella di Santo Spirito fior. settantotto, sol. XV a oro larghi, per fior. 75 d'oro in oro, paghati a Sandro del Botticello, a lui contanti: che fior. 2 sono per azurro, e fior. 38 per l'oro e mettitura della tavola, e fior. 35 pel suo pennello.

4. Pinturicchio and S. Maria de' Fossi: G. B. Vermiglioli, *Bernardino Pinturicchio* (Perugia, 1837) p. vi (Appendix II):

Anche promette nel vacuo delli quadri o vero campi de le figure pegnere paese et aiere et tutti li altri campi dove se mette colore excepto li cornicioni dove se ha a ponere loro ...

Ghirlandaio and Giovanni Tornabuoni: C. S. Davies, *Ghirlandaio* (London, 1908) p. 171:

figuras hedifitia castra, civitates, montes, colles, planities, lapides, vestes, animalia, aves, bestias quascunque ...

Fra Angelico at Rome: E. Müntz, *Les Arts à la Cour des Papes*, I (Paris, 1878), p. 126:

23 mai. A frate Giovanni di Pietro dipintore a la chapella di s.to Pietro dell'ordine di san Domenicho adi xxiii di Maggio d. quarantatre, b. vinti sette, sono per la provisione di d. 200 l'anno dadi 13 di Marzo perinfino adi ulltimo di Maggio prossimo a venire: f. xliii, b. xxvii.—

A Benozo da Leso dipintore da Firenze a la sopradetta chapella adi detto f. diciotto, b. dodici, e quali sono per sua provisione di f. vii il mexe dadi xiii di Marzo sino adi ultimo di Maggio prossimo: fl. xviii, b. xii.—

A Giovanni d'Antonio de la Checa dipintore a la detta chapella adi detto d. due, b. quaranta due, sono per la provisione di f. i il mexe, dadi xiii di Marzo adi ulltimo di Maggio prossimo: fl. ii, b. xlii . . .

A Jachomo d'Antonio da Poli dipintore ala detta chapella adi xxiii di Maggio fl. tre, sono per la sua provisione di 3 mexe e quali debano finire adi ultimo di Maggio prossimo a f. i il mexe: f. iii . . .

Piero della Francesca and the Madonna della Misericordia: G. Milanesi, *Nuovi documenti per la storia dell'arte toscana* (Rome, 1893) p. 91:

MCCCCXLV etc. die xi mensis iunii.

Egregii viri Petrus Luce benedicti, prior, Papus Simonis de Doctis, Guasparre, Nicolai Martini, Ambrosius Massi, consiliarii dicti prioris; Johachinus de Pichis, Julianus de Doctis, Julianus Mathei Ciani, et Michelangelus Massi, homines electi ad hec; vice et nomine Societatis et hominum Sancte Marie de Misericordia—dederunt et concesserunt Petro benedicti petri benedicti pictori ad faciendum et pingendum vnam tabulam in oratorio et ecclesia dicte Societatis ad foggiam eius que nunc est, cum toto suo lignamine et omnibus suis sumptibus et expensis de toto fornimento et ornamento picture et positure et locature in dicto oratorio; cum illis ymaginibus et figuris et ornamentis sicut sibi expressum fuerit per suprascriptos priorem et consilium uel per suos successores in officio, et per dictos alios supra electos: et deauratam de fino auro et coloratam de finis coloribus et maxime de azurro ultramarino: cum hac condictione, quod dictus Petrus teneatur ad reaptandum suis expensis omnem maganeam quam faceret et ostenderet dicta tabula in processu temporis usque ad decem annos propter defectum lignaminis vel ipsius Petri. Et pro predictis omnibus constituerunt sibi de mercede florenos CL ad rationem librar. v et sol. v pro floreno. De qua promiserunt dare nunc ad eius petitionem florenos quinquaginta, et residuum, finita dicta tabula. Et dictus Petrus promisit dictam tabulam facere et pingere et ornare et ponere ad latitudinem et altitudinem et foggiam prout est illa que nunc est ibi de ligno; et dare expletam et positam et locatam infra tres annos proxime futuros; cum suprascriptis condictionibus, et qualitatibus colorum et auri finorum: et quod nullus alius pictor possit ponere manum de penello preter ipsum pictorem.

Filippino Lippi at S. Maria Novella: A. Scharf, *Filippino Lippi* (Vienna, 1935) p. 88 (Document VIII).
Signorelli at Orvieto: R. Vischer, *Luca Signorelli* (Leipzig, 1879) pp. 346–9:

> Item quod teneatur dictus magister Lucas et sic promisit pingere manu propria omnes figuras fiendas in dictis voltis, et maxime facies et omnia membra figurarum omnium a medio figure supra, et quod non possit pingi sine ejus presentia ... Item quod teneatur omnes colores mictendos per ipsum mag. Lucam ...

S. Antonino on differential payment of painters: S. Antonino, *Summa Theologica* III, viii. 4, many editions:

> ... et plus ei [i.e. the goldsmith] debetur qui melius opera artis exercet. Sicut etiam in pictoria arte in faciendo similem figuram, multo plus petet in duplo vel triplo magnus magister quam rudis.

5. The Milanese agent's report on Florentine painters: P. Müller-Walde, 'Beiträge zur Kenntnis des Leonardo da Vinci', in *Jahrbuch der Königlich Preussischen Kunstsammlungen*, XVIII, 1897, p. 165, and often reprinted.

II

1. The notion of 'cognitive style' used here adapted H. A. Witkin's concept (for which, 'A cognitive style approach to cross-cultural research', *International Journal of Psychology*, II, 1967, 233–50) in the light of the kind of anthropological findings described in, for instance, M. H. Segall, D. T. Campbell and M. J. Herskovits, *The Influence of Culture on Visual Perception* (New York, 1966).

2. Boccaccio on painting and illusion: Boccaccio, *Il Comento alla Divina Comedia*, ed. D. Guerri, III (Bari, 1918) p. 82 (Inferno XI. 101–5):

> Sforzasi il dipintore che la figura dipinta da sé, la quale non è altro che un poco di colore con certo artificio posto sopra una tavola, sia tanto simile, in quello atto ch'egli la fa, a quella la quale la natura ha prodotta e naturalmente in quello atto si dispone, che essa possa gli occhi de' riguardanti o in parte o in tutto ingannare, facendo di sé credere che ella sia quello che ella non è ...

Leonardo on the limits of illusion: Leonardo da Vinci, *Treatise on Painting*, ed. A. P. McMahon (Princeton, 1956) I, 177 and II 155 v:

> Impossibil e' che la pittura imitata con soma perfectione di lineamenti, ombra lume colore, possa parere del medesimo rilevo qual

pare esso naturale se già tal naturale in lunga distantia non e' veduto con un sol occhio.

Vergerio on art appreciation: Petri Pauli Vergerii, *De ingenuis moribus et liberalibus studiis adulescentiae etc.*, ed. A. Gnesotto (Padua, 1918) pp. 122–3.

3. 'The beauty of the horse . . . ': Giordano Ruffo, *Arte de cognoscere la natura d'cavael*, tr. G. Bruni, (Venice, 1493) pp. b. i v.–b. ii r.:

La beleza del cavallo se die cognoscer in questo modo in prima vo haver el cavallo el corpo grando & longo in tanto che coresponda le tue membre al suo grando & longo corpo come se convene ordinatamente. Ell capo del cavallo dieba esser gracile secco & longo convenientemente. La bocha granda & lacerata. Le narisse grande & infiate. I ochi non concavi ne oculti. Le orechie picolle & portate a modo de aspido el collo longo & ben gracile verso el capo. Le maxille ben gracile & seche. Le crine poche & plane. El pecto grosso & quasi rotondo. El garesse non accuto ma quasi destesso & dreto. La schena curta & quasi piana. I lombi rotondi & quasi grossi. Le coste grosse & i altri membri bovini. Le anche longe & destesse. La gropa longa & ampla . . .

El cavallo dieba esser piu alto davanti che da driedo alquanto come el cervo el dieba portare el colo levato. & la grosseza del colo arente el pecto. Qui vora ictamente cognoscere la beleza del cavalo bisogna el considera i suprascipti membri cossi ala alteza come ala longeza del cavallo ordinatamente & proportionabilmente convenirli del pelo del cavallo perche diversi hano diverse sententie . . .

4. John of Genoa: Joannes Balbus, *Catholicon* (Venice, [1497] p. V. v r. (s.v. Imago):

Item scire te volo quod triplex fuit ratio institutionis imaginum in ecclesia. *Prima* ad instructionem rudium, qui eis quasi quibusdam libris edoceri videntur. *Secunda* ut incarnationis mysterium et sanctorum exempla magis in memoria nostra essent dum quotidie oculis nostris representantur. *Tertia* ad excitandum devotionis affectum, qui ex visis efficacius excitatur quam ex auditis.

Fra Michele da Carcano: *Sermones quadragesimales fratris Michaelis de Mediolano de decem preceptis* (Venice, 1492) pp. 48 v.–49 r. (Sermo XX, De adoratione):

. . . imagines Virginis et sanctorum introducte fuerunt triplici de causa. *Primo* propter ruditatem simplicium, ut qui non possunt scripturas legere in picturis possunt sacramenta nostre salutis et fidei cernere. Ideo scribitur de consecratione distinctione 3 c. perlatum. Perlatum ad nos fuerunt quod inconsiderato zelo successus sanctorum imagines sub hac quasi excusatione ne adorari debuissent confregeris: et quia adorari eas vetuisse omnino laudamus: fregisse vero reprehendimus . . . Aliud enim est picture adorare, aliud per pictam hystoriam quid sit adorandum

adiscere. Nam quod legentibus scriptura, hoc idiotis prostat pictura cernentibus: quia in ipsa ignorantes vident quod sequi debeant: in ipsa legunt qui litteras nesciunt. Unde et precipue gentibus pro lectione pictura est. Verba hec scribit Gregorius Sireno episcopo marsiliensi. *Secundo* sunt imagines introducte propter tarditatem affectivam: ut homines qui non excitantur ad devotionem, cum aliqua audiunt de sanctorum memoria, saltem moveantur dum ea in picturis quasi presentia cernunt. Plus enim excitatur affectus noster per ea que videt, quam per ea que audit. *Tertio* introducte sunt propter memorie labilitatem: . . . Et ideo quia multi que audiunt tenere non possunt, sed cum imagines vident recordantur: ideo introducte sunt.

For the quotation from St. Gregory, see Gregory, Epistulae, XI. 13 (*Patrologia Latina*, LXXVII, 1128); the letter was written in 787 to Serenus the iconoclast Bishop of Marseilles.

The miraculous St. Antony: Sicco Polentone, *Sancti Antonii Confessoris de Padua Vita* (Padua, 1476) p. 41 v.:

Bonifacius quoque ille ipse qui nominis eius Papa octavus fuit : . . Basilicam sancti Iohannis in laterano cum bellis tum vetustate dirutam exaedificari exornarique multa cum cura & sumptu fecit. & quos pingi in ea sanctos nominatim dedit. Istam ad rem fratrum minorum praecipui pictores acque illam in arte singulares duo magistri. erant. hii depictis perfectisque uti summo a pontifice iussi erant omnibus sanctis vacuo in loco ymagines sanctorum Francisci & Antonii suo arbitrio depinxerunt. Id audiens Papa moleste tullit acque dedigatus per contemptum ad suos iubens in hec verba inquit. Sancti Francisci picturam postea quam facta est aequo animo tolleremus. Sed que illius sancti Antonii de Padua est ymago poenitus deleatur volo missi autem qui pontificis iussa implerent alii acque alii omnes. terribili quadam a persona ac ingenti furia in terram proiecti verberatique aeriter acque expulsi sunt. Papa vero ut hec audivit. sinatis inquit Sanctum illum Antonium. sicut vult remanere nam ut videmus. perdere potius certando cum eo quam lucrari possemus.

Salutati on idolatry: Coluccio Salutati, 'De fato et fortuna', Vatican Library, MS. Vat. lat. 2928, fols. 68 v.–69 r.; printed in M. Baxandall, *Giotto and the Orators* (Oxford, 1971) p. 61 n. 21:

Qui [Caecilius Balbus] michi videtur de simulacris suis non aliter autumasse quam et nos ipsi de memoriis pictis vel sculptis sanctorum martyrorumque nostrorum in fidei nostre rectitudine faciamus. ut hec non sanctos, non deos, sed dei sanctorumque simulacra sentiamus. Licet vulgus indoctum plus de ipsis forte et aliter quam oporteat opinetur. Quoniam autem per sensibilia ventum est in spiritualium rationem atque noticiam, si gentiles finxerunt fortune simulacrum cum copia et gubernaculo tamquam opes tribuat, et humanarum rerum obtineat regimen, non multum a vero discesserunt. Sic etiam cum nostri figurant ab effectibus quos videmus fortunam quasi reginam aliquam manibus

rotam mira vertigine provolventem, dummodo picturam illam manu
factam non divinum aliquid sentiamus sed divine providentie dis-
positionis et ordinis similitudinem, non etiam eius essentiam sed mun-
danarum rerum sinuosa volumina representantes, quis rationabiliter
reprehendat?

S. Antonino on the faults of painters: S. Antonino, *Summa Theo-
logica*, III. viii. 4, many editions:

Reprehensibiles etiam sunt cum pingunt ea, quae sunt contra fidem,
cum faciunt Trinitatis imaginem unam Personam cum tribus capitibus,
quod monstrum est in rerum natura; vel in Annuntiatione Virginis
parvolum puerum formatum, scilicet Jesum, mitti in uterum Virginis,
quasi non esset de substantia Virginis ejus corpus assumptum; vel
parvulum Jesum cum tabula litterarum, quum non didicerit ab homine.
Sed nec etiam laudandi sunt, quum apochrypha pingunt, ut obstetrices
in partu Virginis, Thomae apostolo cingulum suum a Virgine Maria in
Assuntione sua propter dubitationem ejus dimissum, ac hujusmodi. In
historiis etiam sanctorum seu in ecclesiis pingere curiosa, quae non
valent ad devotionem excitandum, sed risum et vanitatem, ut simias et
canes insequentes lepores, et hujusmodi, vel vanos ornatus vesti-
mentorum, superfluum videtur et vanum.

The passage has been printed and discussed by C. Gilbert, 'The
Archbishop on the Painters of Florence, 1450', *Art Bulletin*, XLI,
1959, 75–87.

The medieval background to image theory: S. Ringbom, *Icon to
Narrative* (Åbo, 1965) pp. 11–39 and H. Belting, *Das Bild und sein
Publikum im Mittelalter* (Berlin, 1981), Ch. III.

5. The Garden of Prayer: *Zardino de Oration* (Venice, 1494) pp. x.
ii v.– x. iii r. (Cap. XVI. Chome meditare la vita di christo ...):

La quale historia acio che tu meglio la possi imprimere nella mente,
e piu facilmente ogni acto de essa ti si reducha alla memoria ti sera utile
e bisogno che ti fermi ne la mente lochi e persone. Come una citade,
laquale sia la citade de Hierusalem, pigliando una citade laquale ti sia
bene praticha. Nella quale citade tu trovi li lochi principali neliquali
forono exercitati tutti li acti dela passione: come e uno palacio nelquale
sia el cenaculo dove Christo fece la cena con li discipuli. Anchora la
casa de Anna e la casa de Cayfas dove sia il loco dove fu menato la
nocte Miser Iesu. E la stantia dove fu menato dinanti da Cayfas, e lui
deriso e beffato. Anche il pretorio de Pilato dove li parlava con li iudei:
et in esso la stantia dove fu ligato Misser Iesu alla colonna. Anche el
loco del monte de Calvario, dove esso fu posto in croce, e altri simili
lochi ...
Anchora e dibisogno che ti formi nela mente alcune persone, le quale
tu habbi pratiche e note, le quale tute representino quelle persone che
principalmente intervenero de essa passione: come e la persona de Misser

Iesu, della nostra Madonna, Sancto Pietro, Sancto Ioanne Evangelista, Sancta Maria Magdalena, Anna, Cayfas, Pilato, Iuda, e altri simili, liquali tutti formarai nella mente. Cosi adunque havendo formate tutte queste cose nela mente, si che quivi sia posta tutta la fantasia, e entrarai nel cubiculo tuo e sola e solitaria discaciando ogni altro pensiero exteriore. Incominciarai a pensare il principio de essa passione. Incominciando come esso Misser Iesu vene in Ierusalem sopra lasino. E morosamente tu transcorrendo ogni acto pensarai faciando dimora sopra ogni acto e passo, e se tu sentirai alcuna divotione in alcuno passo ivi ti ferma: e non passare piu oltra fino che dura quella dolcecia e divotione . . .

Fra Roberto: Robertus Caracciolus, *Sermones de laudibus sanctorum* (Naples, 1489) pp. lxv r.–lxvii r. (Nativity), clii r.–cliv r. (Visitation), cxlic r.–clii r. (Annunciation):

Lo tertio misterio da dechiarare circa la annuntiatione della madonna si chiama angelica confabulatione: dove si conteneno cinque laudabile conditione de essa virgine benedicta.

La prima si chiama conturbatione.
La seconda cogitatione.
La tertia interrogatione.
La quarta humiliatione.
La quinta meritatione.

La prima laudabile conditione si chiama conturbatione secondo scrive Luca. Havendo odita la virgine la salutatione di l'angelo si conturbo: la quale conturbatione non fu per alcuna incredulita secondo scrive Nicolo de Lira: ma per una admiratione: perho che lei era solita videre gli angeli: e perho non si maraveglio tanto della apparitione quanto de quella alta e magna salutatione: dove l'angelo explicava di lei tante cose stupende e grande de che lei per la humilita stava attonita e stupefacta.

La seconda laudabile sua conditione si chiama cogitatione che pensava quale era tale salutatione: dove appare la prudentia di essa virgine sacratissima. Allhora li disse l'angelo: Non timere o Maria perho che tu hai trovata gratia appresso a dio: non solo per te ma per tutta la humana generatione. Ecco che conceperai nel tuo ventre e parturirai uno figliolo e chiamerai el suo nome Iesu . . .

La terza laudabile conditione si chiama de interrogatione. Domando la virgine e disse a l'angelo: Quomodo fiet istud quoniam virum non cognosco idest non cognoscere propono. Come sera questa cosa che io ho lo fermo mio proposito da Dio a mi inspirato e poi confirmato per voto da me non cognoscere mai homo. E in questa parte secondo dice Francisco de Marone nel suo terzo alla iiii dist.: si poteria dire che la virgine gloriosa desiderava piu essere virgine che concipere el figliolo de dio senza la virginita: perhoche la virginita e del numero delle cose laudabile: concipere el figliolo e delle cose honorevele dove non consiste virtu ma lo premio della virtu: E la virtu si deve piu desiderare che lo

premio de essa virtu: perche circa la virtu consiste el merito e non circa lo premio. Domando donque quella pudicissima mundissima castissima figliola amatrice de la virginita come virgine potesse concipere . . .

La quarta laudabile conditione si chiama humiliatione. Quale lingua poteria mai exprimere ne quale intellecto contemplare con quale gesto con quale modo e manera pose in terra li soi sancti ginochii e abassando la testa disse: Eccomi ancilla del signore. Non disse donna: non disse regina: o profuna humilita: o mansuetudine inaudita. Eccomi disse schiava e serva del mio signore. Et poi levando li occhi al cielo stringendo le mani con le braze in croce fece quella desiderata conclusione da dio da li angeli dalli sancti padri. Sia facto in mi secondo la tua parola.

La quinta laudabile conditione si chiama meritatione . . . E dicte quelle parole l'angelo si parti. E la virgine benigna subito hebbe Christo dio incarnato nel suo ventre con quelle mirabile conditione delle quale dissemo nel sermone nono. Dove noi possiamo meritamente contemplare che in quello puncto che la virgine Maria concepi Christo l'anima sua fu levata in tanta contemplatione alta e sublime con gesto e dolceza delle cose divine che citra la beatifica visione passo el modo de ogni altra creatura. E della presentia del figliolo el quale tenia nel ventre si recreavano ancora li corporei sentimenti con suavita inenarrabile. E verisimile e che per la humilita sua profunda levasse gli occhi al cielo e poi li abassaso al suo ventre con molte lachrime dicendo simile parole: Chi son io la quale ho conceputo virgine dio in mi incarnato chi se tu infinito bene signore del cielo e della terra el quale stai rinchiuso o vero nascosto nel mio piccolino ventre . . .

Leonardo on violent Annunciations: Leonardo da Vinci, *Treatise on Painting*, ed. A. P. McMahon (Princeton, 1956) I, 58 and II, 33 r.:

. . . come io vidi a' questi giorni un angelo, che pareva nel suo annuntiare che volessi cacciare la nostra donna della sua camera con movimenti che dimostravano tanta d'ingiuria quanto far si potessi a un vilissimo nimico, e la nostra donna pareva che si volesse come disperata gittarsi giu duna finestra si che siati a' memoria di no' cader in tali diffetti.

6. Lentulus's description of Christ: a Renaissance translation of a Greek forgery popular in the fifteenth century and printed in, for example, *Zardino de Oration* (Venice, 1494) p. s. iv r.–v.:

Homo di statura tra gli altri mediocre, cioe mezana e molto spectabile. E ha una facia venerabile, laquale quelli che risguardano el possono amar e haver paura. E ha li capelli di colore de una noxella matura cioe come de oro, liquali capelli sono piani quasi fino alle orechie: da lorechie ingiuso sono rici e crespi, e alquanto piu risplendenti liquali gli discorreno giuso per le spalle. E dinanci sono partiti in due parte havendo in mezo el discriminale secondo lusancia e costume deli nazarei. La fronte sua e piena e polita e serenissima, e tutta la facia sua e sencia crespa e ruga e macula alcuna: la quale e adornata da una temperata rossecia, cioe uno piuoco colorita. El naso e la bocca sua niuna ripren-

sione gli si po dare alla barba copiosa, cioe folta over spessa: e come
hanno li gioveni di prima barba de colore simile alli capelli, non tropo
longa, ma nel mezo partita in due parte. Esso ha il suo aspecto simplice
e maturo. Li ochi soi ha relucenti varii, chiari, e risplendenti. Nel
riprendere terribile nelle admonitione piacevole et amabile. Aliegro ma
servando sempre la gravita. Elquale mai non fu veduto ridere ma
pianger si. Nela statura del suo corpo largo nel pecto e dritto. Le mane
sue e le bracia delectevole a vedere. Nel suo parlare grande e raro cioe
poco e modesto tra li figlioli delli homini.

The Virgin's colouring: Gabriel de Barletta, *Sermones celeberrimi*,
I (Venice, 1571) 173:

> ... Sed quaeris modo. Utrum fuit nigra aut alba? Respondit Alber.
> super missus est. c. 45. Quod non nigra simpliciter neque rubea, neque
> alba: quia isti colores dant quandam imperfectionem in persona. Unde
> dici solet: Deus me protegat a Lombardo russo, Alemano nigro, Hispano
> albo, Flammineo cuiusvis pili. Fuit Maria mixta coloribus, participans
> de omnibus, quia illa facies est pulchra, quae de omnibus coloribus
> participat. Unde dicunt autores medicinae: quod ille color qui est
> compositus ex rubeo, et albo, est optimus cum commixtione tertii coloris,
> scilicet nigri, et hunc inquit Alber. concedimus in Mariam fuisse. Fuit
> nigra aliquantulum. Et hoc triplici ratione. Primo ratione complexionis,
> quia judaei tendunt in brunedinem quandam, et ipsa fuit Judaea.
> Secundo testificationis, quia Lucas qui tres fecit imagines, una Romae,
> alia Loreti, alia Bononiae, sunt brunae. Tertio assimilationis: Filius
> matri communiter assimilatur, et e converso, sed Christi facies fuit
> bruna, igitur, ...

Eyes as the windows of the soul: Galeottus Martius, *De homine*
(Milan, 1490) p. a. iii v.:

> Sed oculorum prognostica longum esset referre. Nam cum fenestrae
> sint animorum, quid eorum color, quid vero frequens motus, quid item
> acrimonia indicent nemo fere ignorat. Unum tamen non reticendum
> est eos maleficos esse pessimisque moribus quibus oculi sunt longi. Si
> candida pars oculi extenta est aperiturque tota, impudentiam, cum
> autem aperitur nec omnino ostenditur, inconstatiam indicat de oculis
> hucusque.

Leonardo on physiognomy: Leonardo da Vinci, *Treatise on Paint-
ing*, ed. A. P. McMahon (Princeton, 1956) I, 157 and II, 109 v.:

> ... ver' e' che li segni de' volti mostrano in parte la natura de gli
> huomini di lor vitij e complessioni, ma nel volto li segni che separano
> le guancie da labri della bocca, elle nari del naso e casse de gli occhi
> sono evidenti sono huomini allegri e spesso ridenti, e quelli che poco li
> segnano sono huomini operatori della cogitazione, e quelli ch'anno le
> parti del viso di gran rilevo e profondità sono huomini bestiali et
> iracondi con pocha raggione et quelli ch'anno le linee interposte infra
> le ciglia forte evidenti sono iracondi e quelli che hanno le linee trasversali

de la fronte forte liniate sono huomini copiosi di lamentationi occulte
o' palesi.

Alberti on movement: L. B. Alberti, *Opere volgari*, ed. C. Grayson,
III (Bari, 1973) p. 74:

> [Ma questi movimenti d'animo si conoscono dai movimenti del corpo
> …] Sono alcuni movimenti d'animo detti affezione, come ira, dolore,
> gaudio e timore, desiderio e simili. Altri sono movimenti de' corpi.
> Muovonsi i corpi in più modi, crescendo, discrescendo, infermandosi,
> guarendo e mutandosi da luogo a luogo. Ma noi dipintori, i quali
> vogliamo coi movimenti delle membra mostrare i movimenti dell'
> animo, solo riferiamo di quel movimento si fa mutando el luogo.

Guglielmo Ebreo on movement: *Trattato dell'arte del ballo di
Guglielmo Ebreo Pesarese*, ed. F. Zambrini (Bologna, 1873) p. 7:

> La qual virtute del danzare è una azione dimostrativa di fuori di
> movimenti spirituali li quali si ànno a concordare colle misurate e
> perfette consonanze d'essa ermonia, che per lo nostro audito alle parti
> intellettive trai sensi cordiali con diletto disciende, dove poi si genera
> cierti dolci commovimenti, i quali, come contro a sua natura rinchiusi,
> si sforzano quanto possono d'uscire fuori e farsi in atto manifesti.

Leonardo on movement: *Treatise on Painting*, ed. cit., I, 148–57
and II 48 r.

Monks' gestures: G. van Rijnberk, *Le Langage par signes chez les
moines* (Amsterdam, 1954) which collates the surviving lists:

> Affirmatio: leva manum moderate et move, non inversam, sed ut
> exterior superficies sit sursum …
> Demonstrare: extenso solo poterit res visa notari …
> Dolor: palma premens pectus dat significare dolorem …
> Pudor: lumina quando tego digitis designo pudorem.

Preacher's gestures: *Tractatulus solennis de arte et vero modo predicandi*
(Strasbourg, n.d.) p.a. ii r. and v.

> Aliquando cum horrore et commotione, ut ibi, Nisi conversi fueritis
> et cetera.
> Aliquando cum yronia et derisione, ut ibi, Adhuc permanes in sim-
> plicitate tua.
> Aliquando cum gratia vultus et manuum attractione, ut ibi, Venite
> ad me omnes et cetera.
> Aliquando cum quadam elatione, ut ibi, De terra longinqua venerunt
> ad me.
> Aliquando cum tedio et indignatione, ut ibi, Constituamus nobis
> ducem et cetera.
> Aliquando cum gaudio et manuum elevatione, ut ibi, Venite benedicti
> et cetera,

Thomas Waleys, 'De modo componendi sermones', reprinted in T.-M. Charland, *Artes praedicandi* (Paris, 1936) p. 332:

> Valde tamen caveat ne motibus inordinatis jactet corpus suum, nunc subito extollendo caput in altum, nunc subito deprimendo, nunc vertendo se ad dextrum, nunc subito cum mirabili celeritate se vertendo ad sinistrum, nunc ambas manus sic extendendo simul quasi posset simul orientem occidentemque complecti, nunc vero subito eas in unum conjungendo, nunc extendendo brachia ultra modum, nunc subito retrahendo. Vidi enim aliquos qui quoad alia in sermonibus se habebant, tamen ita motibus corporis se jactabant quod videbantur cum aliquo duellum inisse, seu potius insanisse, in tantum quod seipsos cum pulpito in quo stabant nisi alii succurissent praecipitassent.

'Mirror of the World', ca. 1527, cit. in W. S. Howell, *Logic and Rhetoric in England 1500–1700* (Princeton, 1956) 89–90.

Maidenly bearing: *Decor pueliarum*, (Venice, 1471) pp. 51–2:

> ... et cosi stando et andando sempre cum la mano dextra sopra la sinistra, al mezo del cenzer nostro davanti ...

7. Religious drama: see A. d'Ancona, *Origini del teatro italiano*, 2nd ed., I (Turin, 1891) especially pp. 228 (Matteo Palmieri on the 1454 St. John's Day pageant), 251 (on the Russian Bishop and the Ascension play of 1439) and 423 (on *festaiuolo* and *sedie*).

Abraham and Hagar: printed in A. d'Ancona, *Sacre rappresentazioni dei secoli XIV, XV, e XVI*, I (Florence, 1872) 1–41 and especially p. 13:

> Finita l'annunziazione il festaiuolo va a sedere. Et Abraam sta a sedere in luogo un poco rilevato e Sarra appresso a lui et a' piedi loro da mano destra debbe stare Isac, e da mano sinistra un poco piú discosto debbe stare Ismael con Agar sua madre; et alla fine del palco da man destra debbe essere un altare, dove Abraam va a fare orazione, et alla mano sinistra alla fine del palco ha a essere uno monte in sul quale sia uno bosco con uno arbore grande, dove arà apparire una fonte d'acqua a modo di pozo, quando sarà il tempo.

Angelo Galli on Pisanello: Vasari, *Le Vite; I, Gentile da Fabriano ed il Pisanello*, ed. A. Venturi (Florence, 1896) pp. 49–50:

> Arte, mesura, aere et desegno,
> Manera, prospectiva et naturale
> Gli ha dato el celo per mirabil dono.

Domenico da Piacenza's dancing treatise: 'De arte saltandi et choreas ducendi', Bibliothèque Nationale, Paris, MS. it. 972. fols. 1 v.–2 r.

On *maniera*:

> ... tenire el mezo del tuo movimento che non sia ni tropo, ni poco, ma

cum tanta suavitade che pari una gondola che da dui rimi spinta sia per quelle undicelle quando el mare fa quieta segondo sua natura, alzando le dicte undicelle cum tardeza et asbassandosse cum presteza.

On *misura*:

... tardeza ricoperada cum presteza.

Cupid, Phoebus, Venus, Jealousy: all in *Trattato dell' arte del ballo di Guglielmo Ebreo Pesarese*, ed. F. Zambrini (Bologna, 1873) pp. 47–8, 50–2, 65–8, 95–7:

> *Bassa danza, chiamata Venus, in tre, composta per Lorenzo di Piero di Cosimo de' Medici.*
>
> In prima faccino una contenenza, e poi vadino insieme con duo passi sciempi, cominciando col pie manco; e poi quello di mezo torni indietro, attraverso, con dua riprese, l'una in sul pie manco, cosi per lato, el l'altra in sul pie ritto pure attraverso; et in quello tempo, che quello di mezo fa quelle riprese, gli altri dua vadino innanzi con dua passi doppi, e poi diano meza volta in sul pie ritto, tanto che si voltino l'uno verso l'altro; e poi faccino due riprese, l'una in sul pie manco e l'altra in sul pie ritto; e poi venghino incontro l'uno all'altro con uno passo doppio, cominciando col pie manco; e poi faccino la volta del gioioso tutti insieme; poi quello di mezo venga incontro agli altri con duo passi sciempi; et in quel tempo gli altri faccino una riverenza in sul pie manco ...

On *aere* (p. 17):

> ... aierosa presenza et elevato movimento, colla propria persona mostrando con destreza nel danzare un dolcie et umanissimo rilevamento.

8. Colour codes: S. Antonino, *Summa Theologica*, I. iii. 3; L. B. Alberti, *Opere volgari*, ed. C. Grayson, III (Bari, 1973) pp. 22–4, and S. Y. Edgerton Jr., 'Alberti's colour theory', *Journal of the Warburg and Courtauld Institutes*, XXXII, 1969, 109–34; on Leonello d'Este's clothes, Angelo Decembrio, *De politia litteraria* (Basle, 1562) p. 3.

Lorenzo Valla against colour symbolism: 'Epistola ad Candidum Decembrem', in *Opera* (Basle, 1540) pp. 639–41, and Baxandall, *Giotto and the Orators* (Oxford, 1971) pp. 114–16 and 168–71:

> Intueamur nunc rationes tuas de coloribus ... Color aureus est, inquit, nobilissimus colorum, quod per eum figuratur lux. Si quis enim vellet figurare radios solis, quod est corpus maxime luminosum, non posset commodius facere quam per radios aureos, constat autem luce nihil esse nobilius. Animadvertite stuporem hominis, stoliditatemque pecudis. Si aureum colorem accipit eum solum, qui ab auro figuratur, sol quidem non est aureus. Si aureum pro fulvo, rutilo, croceo, quis

unquam ita caecus atque ebrius fuit, nisi similis ac par Bartolo, qui solem croceum dixerit? Sustolle paulisper oculos asine ... et vide an sol est aureus vel argenteus ... Quid postea, quae proximo loco colorem ponit? ... Sapphireus, inquit, est proximus, quem ipse, ut est barbarus, et quasi cum foeminis, et non cum viris liquatur, azurum vocat: per hunc colorem, ait significatur aer. Nonne tibi hic aliquid dicere videtur, qui ordinem sequitur elementorum? certe. Sed nescio quare lunam praetermisit, ... quum solem primum feceris, lunam debueras facere secundam, quae et altior aere est, et magis suum quendam colorem habet quam aer, et quum illum dixeris aureum, hanc oportebat argenteam nominare et proximam a sole facere, ut argentum secundum est ab auro: ... Sapphireum igitur secundo numeras loco, delectatus, ut dixi, ordine elementorum: a metallis enim, a lapidibus preciosis, ab herbis et floribus, non putasti tibi exempla sumenda: quae si propria magis et accomodata erant, tum humilia tibi et abiecta duxisti, tu qui ex sole tantum es factus et aere. Nam quum seriem elementorum prosequeris, de duobus dicis, de duobus alteris obmutescis, et nobis expectantibus tam altum venerandumque processum, quodam modo illudis. Si primus color est igneus, sequens aerius, tertius aquaticus erit: quartus terreus ... Pergamus ad caetera. Paulo post ait album esse nobilissimum colorum, nigrum abiectissimum, alios vero ita quenquam optimum, ut est albo coniunctissimus, rursum ita quenquam deterrimum: ut est nigredini proximus. Horum quid primum reprehendam? an quod aurei caloris non meminit ... ? Aut cur serica fila murice tingerentur, lanae candidae rubricarentur, nisi rubeus color albo putaretur esse venustior? Nam si candor est simplicissimus et purissimus, non continuo est praestantissimus ... De nigro autem quid dicam? quem cum albo comparatum invenio, nec minoris praestantiae putatum, unde corvus et cygnus propter hanc ipsam causam dicuntur Apollini consecrati: ... Et mea sententia Aethiopes Indis pulchriores, eo ipso quod nigriores sunt. Quid ergo autoritatem homini affero, quos ille aethereus parvifacit? ... Quod si rerum conditor nullam in operibus suis putavit colorum differentiam, quid nos homunculi faciemus? an volemus plus deo sapere? aut eum imitari et sequi erubescemus? O bone et sancte Jesu, si non cogitavit de lapidibus et herbis, de floribus et multis aliis Bartolus quum de vestibus et operimentis hominum loqueretur, poteratne oblivisci de avium, prope dixerim, vestibus, ut galli, pavonis, pici, picae, phasiani, et aliorum complurium? ... Eamus nunc et hominem audiamus, a divinis atque humanis rebus dissentientem: et puellis Ticinensibus, ver enim adventat, legem imponamus, ne serta, nisi quomodo Bartolus praescribit, texere audeant, ... Nunc illud dixisse satis est. Stolidissimum esse aliquem de dignitate colorum legem introducere.

Filarete on hues: Filarete, *Treatise on Architecture*, ed. J. R. Spencer (New Haven, 1965) I, 311 and II, 182 r.:

> Guarda dalla natura come stanno bene compartiti i fiori ne' campi
> e l'erbe. A presso al verde ogni colore se gli confà: el giallo e il rosso, e

anche l'azzurro non si disdice. El bianco appresso al nero tu sai come si conformano; el rosso col giallo non cosí bene si confà, assai si confà allo azzurro, ma piú al verde; el bianco al rosso si confà assai.

Alberti on colour harmonies: *Opere volgari*, ed. cit., III, p. 86:

Sarà ivi grazia quando l'uno colore appresso, molto sarà dall'altro differente; che se dipignerai Diana guidi il coro, sia a questa ninfa panni verdi, a quella bianchi, all'altra rosati, all'altra crocei, e così a ciascuna diversi colori, tale che sempre i chiari sieno presso ad altri diversi colori oscuri. Sarà per questa comparazione ivi la bellezza de' colori più chiara e più leggiadra. E truovasi certa amicizia de' colori, che l'uno giunto con l'altro li porge dignità e grazia. Il colore rosato presso al verde e al cilestro si danno insieme onore e vista. Il colore bianco non solo appresso il cenericcio e appresso il croceo, ma quasi presso a tutti posto, porge letizia. I colori oscuri stanno fra i chiari non sanza alcuna dignità, e così i chiari bene s'avolgano fra gli oscuri. Così adunque, quanto dissi, il pittore disporrà suo colori.

Colour theory: J. Gavel, *Colour: A Study of its Position in the Art Theory of the Quattro- and Cinquecento* (Stockholm, 1979), and J. S. Ackerman, 'On Early Renaissance Color Theory and Practice', *Memoirs of the American Academy in Rome*, XXXV, 1980, 11–44.

9. Schools: C. Bec, *Les Marchands écrivains* (Paris-Hague) pp. 383–91; R. Goldthwaite, 'Schools and Teachers of Commercial Arithmetic in Renaissance Florence', *The Journal of European Economic History*, I, 1972, 418–433; and W. Van Egmond, 'The Commercial Revolution and the Beginnings of Western Mathematics in Renaissance Florence 1300–1500', Ph.D. thesis, Indiana University, 1976 (University Microfilms, Ann Arbor, Michigan, 1977). For an explanation of the techniques taught, R. Franci and L. T. Rigatelli, *Introduzione all' aritmetica mercantile del Medioevo e del Rinascimento* (Siena, 1982).

Piero della Francesca on gauging a barrel: Piero della Francesca, *Trattato d'abaco*, ed. G. Arrighi (Pisa, 1970) p. 233:

Egl'è una bocte che i suoi fondi è ciascuno per diametro 2 bracci; et al cochiume è $2\frac{1}{4}$, et tra i fondi e 'l cochiume è $2\frac{2}{9}$, et è lunga 2 bracci. Domando quanto serà quadrata.

Questa è de spetie di piramide taglate, però fa' cosí. Montiplica il fondo in sé, ch'è 2, fa 4, poi montiplica $2\frac{2}{9}$ in sé fa $4\frac{76}{81}$; giogni insieme fa $8\frac{76}{81}$. Poi montiplica 2 via $2\frac{2}{9}$ fa $4\frac{4}{9}$, giogni con $8\frac{76}{81}$ fa $13\frac{31}{81}$, parti per 3 ne vene $4\frac{112}{243}$ cioè radici de $4\frac{112}{243}$ che in sé montiplicato fa $4\frac{112}{243}$: e questo tieni a mente. Tu ài che montiplicato $2\frac{2}{9}$ in sé fa $4\frac{76}{81}$, hora montiplica $2\frac{1}{4}$ in sé fa $5\frac{1}{16}$, giogni insiemi fa $10\frac{1}{1296}$, et montiplica $2\frac{2}{9}$ via $2\frac{1}{4}$ fa 5 giogni insemi fa $15\frac{1}{1296}$; parti per 3 ne vene $5\frac{1}{3888}$, cioè la radici de $5\frac{1}{3888}$, che in sé

montiplicato fa $5\frac{1}{3888}$. Giognilo chon quello de sopra ch'è $4\frac{112}{243}$ fa $9\frac{1792}{3888}$ il quale montiplica per II e parti per 14, ne vene $7\frac{23600}{54432}$: tanto è quadrata la dicta botte.

10. Onofrio Dini's problem: Luca Pacioli, *Summa de arithmetica* Venice, 1494) p. 158 r.:

> Uno vien a morte, e a sua donna gravida. E fa testamento de duc. 600 che si trova in tutto. Di quali la donna facendo maschio, ne die havere 200. el fio 400. E facendo femina, la donna ne deba havere 400. E la fia 200. Acade che feci fio et fia. Dimandase che ne toca per uno, aciò sia salva la intentione del testatore ...

Piero della Francesca on the Rule of Three: *Trattato d'abaco*, ed. cit., p. 44:

> La regola de le tre cose dici che se dèi montiplicare la cosa, che l'omo vole sapere, per quella che non è simiglante e, la somma che fa, partire per l'altra; et quello che ne vene è de la natura de quello che non è simiglante, et sempre il partitore è simile a la cosa che l'omo vole sapere.
> Exemplo. Bracci 7 di panno vaglano 9 Libre, che varà 5 bracci?
> Fa' cosí: montiplica la quantità che tu voi sapere per quella quantità che vale li 7 bracci di panno, ch'è 9 Libre, cosí 5 via 9 fa 45, parti per 7 ne vene 6 Libre e resta 3 Libre: fanne soldi sono 60, parti per 7 ne vene 8 soldi e resta 4 soldi; fanne d[e]nari sono 48, parti per 7 ne vene 6 denari $\frac{6}{7}$. Adunqua 5 bracci di panno a quella ragione vaglano 6 Libre 8 soldi 6 denari $\frac{6}{7}$.

Harmonic proportion: for a clear and accessible account of its visual application, R. Wittkower, *Architectural Principles in the Age of Humanism*, 3rd. ed. (London, 1962) especially pp. 103–10.

11. The sensible delights of paradise: Bartholomeus Rimbertinus, *De deliciis sensibilibus paradisi* (Venice, 1498) pp. 15v.–26r., in particular p. 17r.:

> ... intersticidium non impedit visum oculorum beatorum ... Nam si christus existens in celis post ascensionem suam videbat matrem suam dulcissimam: adhuc in terra existentem et in cubiculo orantem, patet quod nec situs nec paries impedit.
> Item non plus impedit opacitas intersticii quam inversio rei visibilis ab ante et retro: ut de facie locuti sumus. Unde Christus poterat faciem matris prostrate in terram intueri et nunc mater eius beatissima, quemlibet devotum suum: ac si in faciem eius de directo respiceret. Et sic patet quod per dorsum videre potest pectus: et per occiput faciem.

Celsus Maffeus, *De sensibilibus deliciis paradisi* (Verona, 1504) pp. A viii v.-B ii r., in particular pp. B i v.-B ii r.:

> Et visus erit ita acutus ut minimas differentias colorum et varietates

discernere poterit. Nulla etiam distantia aut corporum interpositio erit impedimento.

The moral and spiritual eye: Petrus Lacepiera [Lemovicensis], *Liber de oculo morali* (Venice, 1496) or, in Italian translation, *Libro de locchio morale et spirituale* (Venice, 1496), in general pp. A vii r.- B vii v., and in particular pp. A iii r. and B vii v.:

> Se diligentemente vorremo col spirito pensare nella lege del signore, facilmente cognosceremo che nelli sacri eloqui spesso si recitano quelle cose che alla visione & occhio materiale si apartengano. Donde e manifesto che la consideratione del occhio & di quelle cose che ad esso si apartengano e assai utile ad havere piu piena notitia de la sapientia divina.

> Undecimo mirabile in la visione.

> E provato per la antedecta scientia, che sottracti li ragi over linee non si puo certificar la quantita dela cosa che si vede, ma si puo ben discernere se si vede per deritte linee: come e manifesto in alcuna cosa laquale hora se vede in aere & hora in acqua. Similmente, el peccato si puo certitudinalmente comprendere secondo el grado della propria quantita da quello elqual derittamente risguardo el peccato con locchio della ragione. Et in questo modo alcuno doctore over qualunque altro huomo studioso risguarda el peccato, elqual speculando in ciaschun peccato la vita, considera & investiga cio che si dee cognoscere de li gradi de peccati ... El peccatore adonque quando commette el peccato, non discerne la colpa di esso peccato ne risguarda quello per dericta linea ma per obliqua & interrota ...

See also A. Parronchi, 'Le fonti di Paolo Uccello, II, I "filosofi"', *Studi su la dolce prospettiva* (Milan, 1964) pp. 522–26.

III

1. Lancilotti's poem: Francesco Lancilotti, *Trattato di pittura* (Rome, 1509) p. a iii r., and in *Scritti d'Arte del Cinquecento*, ed. Paola Barocchi, I (Milan-Naples, 1971), p. 746.

The four corporeal gifts of the Blessed: the idea of these derived from St. Augustine and they are expounded in many Quattrocento books and sermons—for instance, Matteo Bossi, *De veris ac salutaribus animi gaudiis* (Florence, 1491).

2. Giovanni Santi: The edition of the *Cronaca rimata* by H. Holtzinger (Stuttgart, 1893) has been superseded by Giovanni Santi, *La Vita e le Gesta di Federico da Montefeltro, Duca d'Urbino*, ed. L. Michelini Tocci, 2 vols. (Vatican City, 1985), this text (II, pp. 668 and 673–4) being used here. See also Lise Bek, 'Giovanni Santi's "Disputa

della pittura"—a polemic treatise', *Analecta Romana Instituti Danici*,
V, 1969, 75–102.

3. Cristoforo Landino: on Landino in general, see M. Santoro,
'Cristoforo Landino e il volgare', *Giornale storico della letteratura
italiana*, CXXXI, 1954, pp. 501–47.

Landino on Alberti: *Comento di Christophoro Landino fiorentino sopra
la comedia di Danthe Alighieri* (Florence, 1481) p. iv r.:

> Ma dove lascio Battista Alberti o in che generazione di dotti lo ripongo?
> Dirai tra' fisici. Certo, affermo lui esser nato solo per investigare e'
> secreti della natura. Ma quale spezie di matematica gli fu incognita?
> Lui geometra, lui aritmetico, lui astrologo, lui musico e nella prospettiva
> maraviglioso piu che uomo di molti secoli. Le quali tutte dottrine quanto
> in lui risplendessino manifesto lo dimostrono nove libri De Architetura
> da lui divinissimamente scritti, e' quali sono referti d'ogni dottrina e
> illustrati di somma eloquenzia. Scrisse De Pictura, scrisse De Sculptura,
> el quale libro e intitolato Statua. Ne solamente scrisse ma di mano
> propria fece, e restano nelle mani nostre commendatissime opere di
> pennello, di scalpello, di bulino e di getto da lui fatte.

Landino's Pliny: C. Plinius Secundus, *Historia naturale*, trs. C.
Landino (Rome 1473) and later editions.

Landino on the artists: 'Fiorentini excellenti in pictura et sculp-
tura', *Comento*, ed. cit., p. viii r. See also O. Morisani, 'Art Historians
and Art Critics, III, Cristoforo Landino', *Burlington Magazine*,
XCV, 1953, p. 267, and M. Baxandall, 'Alberti and Cristoforo
Landino: The Practical Criticism of Painting', Accademia Nazion-
ale dei Lincei, *Atti del Convegno Internazionale indetto nel V° Centenario
di L. B. Alberti, 1972* (Rome, 1974) pp. 143–56.

4. (a) *imitatore della natura*: Leonardo da Vinci, *The Literary Works*,
ed. J. P. Richter, I (Oxford, 1939) 372 and *Treatise on Painting*, ed.
A. P. McMahon (Princeton, 1956) I, 41 and II, 24v.–25r.:

> La pittura ... costringe la mente del pittore a trasmuttarisi nella propria
> mente di natura e sia interprete infra essa natura e l'arte comentando
> con quella le cause delle sue dimostrazioni constrette dalla sua legge et
> in che modo le similitudini delli obbietti circonstanti al occhio con-
> corrino con li veri simulacri alla poppilla del occhio, e infra gli obbietti
> eguali in grandezza quale si dimostrerà maggiore a esso occhio; e infra
> li colori eguali qual si dimostrerà piú o men oscuro, o piú o men chiaro;
> e infra le cose d'egual bassezza quale si dimostrerà piú o men bassa et
> di quelle che sono poste in altezza eguale quale si dimostrerà piú o men
> alta et delli obbietti eguali posti in varie distantie perché si dimo-
> streranno men noti l'un che l'altro.

For representative classical and renaissance contexts for the phrase

see Pliny, *Natural History*, XXXIV, 61 (natura ipsa imitanda esse) and Lorenzo Ghiberti, *I commentarii*, ed. J. v. Schlosser, I (Berlin, 1912) p. 48 (II. 22): 'mi ingegnai con ogni misura osservare in esse [the Gates of Paradise] cercare imitare la natura quanto a me fosse possibile'.

(b) *rilievo*: Alberti, *Opere volgari*, ed. C. Grayson, III (Bari, 1973) pp. 80–84 (. . . il lume e l'ombra fanno parere le cose rilevate, cosí il bianco e 'l nero fa le cose dipinte parere rilevate . . .); Cennino Cennini, *Il libro dell' arte*, 8–9, ed. D. V. Thompson (New Haven, 1932) pp. 5–6:

> *Come tu de' dare la ragione della luce, chiaroscuro alle tue figure, dotandole di ragione di rilievo.*
>
> Se per ventura t'avvenisse, quado disegnassi o ritraessi in cappelle, o colorissi in altri luoghi contrari, che non potessi averre la luce dalla man tua, o a tuo modo, seguita di dare el rilievo alle tue figure, o veramente disegno, secondo l'ordine delle finestre che trovi ne' detti luoghi, che ti hanno a dare la luce. E cosí, seguitando la luce da qual mano si sia, da' el tuo rilievo e l'oscuro, secondo la ragione detta . . . E se la luce prosperasse con finestra che fusse maggiore d'altra che fusse ne' detti luoghi, seguita sempre la piú eccellente luce, e voglia con debito ragionevole intenderla e seguitarla; perché, ciò mancando, non sarebbe tuo lavorio con nessuno rilievo, e verrebbe cosa semprice, e con poco maestoro.

(c) *puro*: Cicero, *Orator*, XVI, 53; Quintilian, *Institutiones oratoriae*, XI, i, 53; Pliny the Younger, *Epistulae*, VII, ix, 8.

(d) *facilità*: Alberti, *Opere volgari*, ed. cit., III, pp. 100–6; Vasari, *Le vite de' più eccellenti pittori, scultori ed architettori*, Proemio alla parte terza, ed. G. Milanesi, IV (Florence, 1879) 9–11; for *fresco*, see E. Borsook, *The Mural Painters of Tuscany*, 2nd ed. (Oxford, 1980).

(e) *prospettiva*: Antonio Manetti, *Filippo Brunellesco*, ed. H. Holtz-inger (Stuttgart, 1887) p. 9:

> . . . quello ch' e dipintori oggi dicono prospettiva; . . . è una parte di quella scienza, che è in effetto porre bene e con ragione le diminuzioni et accrescimenti che appaiono agli occhi degli uomini delle cose di lungi e da presso: casamenti, piani e montagne e paesi d'ogni ragione e in ogni luogo, le figure e l'altre cose, di quella misura che s'apartiene a quella distanza che le si mostrano di lungi . . .

Dante, *Convivio*, II. iii. 6 (sensibilmente e ragionevolmente è veduto . . . secondo che per un' arte che si chiama perspettiva, e arismetrica e geometria) and II. xiii. 27 (la Geometria è bianchissima, in quanto è sanza macula d'errore e certissima per sé e per la sua ancella, che si chiama Perspettiva). Squarcione's contract of 1467

in V. Lazzarini, 'Documenti relativi alla pittura padovana del secolo XV', in *Nuovo Archivio Veneto*, XV, i, 1908, 292–3:

> le raxon d'un piano lineato ben segondo el mio modo e meter figure sul dicto piano una in zà l'altra in là in diversi luogi del dicto piano e metere masarizie, zoè chariega, bancha, chasa, e darge intendere queste chose sul dicto piano e insegnarge intendere una testa d'omo in schurzo per figura de isomatria, zoè d'un quadro perfeto con el soto quadro in scorzo e insegnarge le raxon de uno corpo nudo mexurado de driedo e denanzi e metere ochi, naxo, bocha, rechie in una testa d'omo ai so luogi mexuradi e darge intendere tute queste cose a parte a parte, quanto a mi serà posibele e 'l dicto Franzesco serà chapaze a inparare . . .

For Uccello's perspective underdrawing, R. Klein, 'Pomponius Gauricus on Perspective', *Art Bulletin*, XLIII, 1961, 211–30; for accessible explanations of the perspective system see D. Gioseffi s. v. 'Perspective' in *Encyclopedia of World Art*, XI, New York, 1966, especially 203–9 and B. A. R. Carter s.v. 'Perspective' in *Oxford Companion to Art*, ed. H. Osborne (Oxford, 1970), especially 842–3 and 859–60, and for its origins, M. Kemp, 'Science, Non-Science and Nonsense: The Interpretation of Brunelleschi's Perspective', *Art History*, I, 1978, 134–61.

(f) *grazioso*: for Filippo Lippi's epigraph, H. Mendelsohn, *Fra Filippo Lippi* (Berlin, 1909) p. 34; for Leonardo on *grazia*, *Treatise on Painting*, ed. cit., I, 382 and II, 114 r.:

> Le membra col corpo debbono esser acomodate con gratia al proposito dell'effetto che tu voi che faccia la Figura, et se tu voi fare Figura che dimostri in sé leggiadria, debbi fare membra gentili e distese senza dimostratione di tropo muscoli e que pochi ch'al proposito farai dimostrare fagli dolci cioè di poca evidentia con ombre non tinte, et le membra massimamente le braccia, disnodate, cioè che nissun membro non istia in linea diritta col membro che s'aggiongie con seco.

For *gratia* and literary criticism, see, for example, Quintilian, *Institutiones oratoriae*, IX. 111. 3.

(g) *ornato*: Quintilian, *Institutiones oratoriae*, VIII. iii. 49 and 61 (Ornatum est, quod perspicuo ac probabili plus est), and XII. x. 66; Alberti, *Opere volgari*, ed. cit., III, p. 78 (Sia nell' uomo movimenti con più fermezza ornati con belli posari e artificiosi); Leonardo on *ornamenti*, *Treatise on Painting*, ed. cit., I, 275 and II, 60 v. (Non fare mai nelle istorie tanti ornamenti alle tue figure e' altri corpi che impedischino la forma e l'attitudine di tal figure e l'essentia de predetti altri corpi).

(h) *varietà*: Alberti, *Opera volgari*, ed. cit., III, pp. 68–74. On diversity of objects:

> ... a' suo luoghi sieno permisti vecchi, giovani, fanciulli, donne, fanciulle, fanciullini, polli, catellini, uccellini, cavalli, pecore, edifici, province, e tutte simili cose.

On diversity of attitudes:

> Ivi adunque stieno alcuni ritti e mostrino tutta la faccia, con le mani in alto e con le dita liete, fermi in su in piè. Agli altri sia il viso contrario e le braccia remisse, coi piedi aggiunti. E così a ciascuno sia suo atto e flessione di membra: altri segga, altri si posi su un ginocchio, altri giacciano. E se così ivi sia licito, sievi alcuno ignudo, e alcuni parte nudi e parte vestiti ...

On Giotto's *Navicella*:

> Lodasi la nave dipinta a Roma, in quale el nostro toscano Giotto pose undici discepoli tutti commossi da paura vedendo uno de' suoi compagni passeggiare sopra l'acqua, ché ivi espresse ciascuno con suo viso e gesto porgere suo certo indizio d'animo turbato, tale che in ciascuno erano suoi diversi movimenti e stati.

(i) *composizione*: Alberti, *Opere volgari*, ed. cit., III, pp. 60–80, and see M. Baxandall, *Giotto and the Orators* (Oxford, 1971) pp. 129–39.

(j) *colorire*: Filelfo on Gentile Bellini, Biblioteca Apostolica Vaticana, MS. Urb. lat. 804, fol. 247v.; Vespasiano da Bisticci on Federigo da Montefeltro, *Vite di uomini illustri*, ed. P. D'Ancona and R. Aeschlimann (Milan, 1951) p. 209 (... per non trovare maestri a suo modo in Italia, che sapessino colorire in tavole ad olio, mandò infino in Fiandra); Piero della Francesca, *De prospectiva pingendi*, ed. cit., p. 63 (Colorare intendiamo dare i colori commo nelle cose se dimostrano, chiari et uscuri secondo che i lumi li devariano).

(k) *disegno*: Francesco da Buti, *Commento sopra la Divina Commedia*, II (Pisa, 1860) p. 285 ([Giotto] *di pennel fu maestro*; cioè fino dipintore, o *di stile*; cioè o disegnatore con stilo ne le taule ...); Cennino Cennini, *Il libro dell'arte*, ed. cit., p. 3 (El fondamento dell'arte, e di tutti questi lavorii di mano principio è il disegno e 'l colorire); for Castagno's sinopie, U. Procacci, *Sinopie e affreschi* (Milan, 1961) pp. 67–8 and Plates 120–9; Alberti, *Opere volgari*, ed. cit., III, p. 100; Piero della Francesca, *De prospectiva pingendi*, ed. cit., p. 63:

> La pictura contiene in sé tre parti principali, quali diciamo essere disegno, commensuratio et colorare. Desegno intendiamo essere profili et contorni che nella cosa se contene. Commensuratio diciamo essere essi profili et contorni proportionalmente posti nei luoghi loro. Colorare intendiamo dare i colori commo nelle cose se dimostrano, chiari et uscuri secondo che i lumi li devariano.

(l) *difficoltà*: Lorenzo de' Medici, *Opere*, ed. A. Simioni, I (Bari, 1939) p. 22 (. . . arguendo dalla difficultà, perche la virtú, secondo i filosofi, consiste circa la difficile); Lodovico Dolce on Michelangelo and Raphael, 'Dialogo della pittura 1557', in *Trattati d'arte del Cinquecento*, ed. P. Barocchi, I (Bari, 1960) p. 196 (. . . sí come Michelangelo ha ricerco sempre in tutte le sue opere la difficultà, cosí Rafaello, all'incontro, la facilità, parte, come io dissi, difficile a conseguire . . .); Antonio Manetti, *Filippo Brunellescho*, ed. cit., pp. 14–15:

> stupivano e maravigliavansi delle difficultà ch'egli aveva messo innanzi, come fu l'attitudine d'Abram, l'attitudine di quel dito sotto el mento, la sua prontezza, e panni, e 'l modo e la fine di tutto quel corpo del figliuolo, e 'l modo e panni di quello Angelo e suoi reggimenti, e come gli piglia la mano; l'attitudine e 'l modo e la fine di quello che si trae lo stecco del piè, e cosí di quello che bee chinato; e di quanta difficultà sono quelle figure, e quanto bene elle fanno l'uficio loro . . .

(m) *scorci*: Landino on Uccello, *Comento*, ed. cit., p. viii r. (. . . artificioso negli scorci, perché intese bene di prospectiva); Lodovico Dolce, op. cit., I, 180–81 (Ho inteso, che gli scorti sono una delle principali difficultà dell'arte. Onde io crederei, che chi piú spesso gli mettesse in opera, piú meritasse laude . . . Gli scorti sono intesi da pochi, onde a pochi dilettano, et anco a gl'intendenti alle volte piú apportano fastidio, che dilettatione); Vasari, *Le vite*, ed. cit., IV, 11 (. . . sí come erano a loro duri a condurli, cosí erano aspri a vederli).

(n) *pronto*: Leonardo, *Treatise on Painting*, ed. cit., I, 89 and II, 33 v. (. . . se tu vorrai piacere a quelli che no' son maestri le tue pitture hanno pochi scorci e poco rilevo, o' movimento pronto . . .); Alberti, *Opere volgari*, ed. cit., III, p. 100 (Et l'ingegnio mosso et riscaldato per excitatione molto si rende pronto et expedito al lavoro et quella mano seguita velocissimo quale sia da certa ragione d'ingegnio ben guidata).

(o) *vezzoso*: Alberti, *Opere volgari*, ed. cit., III, p. 84:

> Per questo molto si biasimi ciascuno pittore il quale senza molto modo usi bianco o nero . . . Sarebbe certo utile il bianco e nero si facesse di quelle . . . perle . . ., che né sarebbono quanto debbono avari e massai e sarebbero loro opera più al vero dolci e vezzose.

[Girolamo di Manfredi,] 'Albertus Magnus', *El libro chiamato della vita, costumi, natura dellomo* (Naples, 1478) p. lxxvii r.:

> Perche il nostro vedere e megliore nei colori verdi che nei bianchi e nei negri.
> Ogni obiecto extremo debilita il sentimento e il megio e temperato conforta perche li extremi movano distemperamente lorgano del sentire

come il tropo bianco move disgregando il forte negro move tropo uniendo e paucificando. Ma il colore megio come e il verde temperatamente move ne tropo desgregando ne tropo uniendo. Impero conforta molto il vedere.

(p) *devoto*: St. Thomas, *Summa Theologica*, 2ᵃ–2ᵃᵉ, q. 180, aa. 1 and 7; the four preaching styles in 'Ars predicandi et syrmocinandi', Biblioteca Nazionale, Florence, MS. Magl. VIII, 1412, fol. 18v.:

> Quattuor sunt genera predicationis ... Primum genus est subtilius pro sapientibus et expertis in arte: et istud est investigandum. Secundum est facilius pro noviter introductis in theologia istud est penitus observandum. Tertium curiosius pro illis qui solum volunt apparere. Istud est tanquam inutile fugiendum. Quartum devotius sicut sunt sermones sanctorum quae leguntur in ecclesia. Istud est plurimum tenendum et est bonum pro populo edificando et informando ... Quartum genus predicandi servaverunt antiqui patres, et doctores sancti et Augustinus, et alii sancti qui omnem curiositatem devitantes in quadam massa nobis divinas inspirationes ediderunt sine divisione vel subdivisione aut concordantia aliquali.

5. Feo Belcari on sight: A. d'Ancona, *Sacre rappresentazioni dei secoli XIV, XV, e XVI, I* (Florence, 1872) 44.

Index

Aesop, 74–5, 86.
Albert the Great, St., 57
Alberti, Leon Battista, 16, 60, 61, 72, 78, 81, 85, 109, 115–17, 123, 125–6, 132, 133–6, 139, 140–1, 147.
Alfonso V. of Aragon, King of Naples, 3, 14–15.
Andrea del Castagno, *see* Castagno
Angelico, Fra, 8–9, 19–20, 55, 66, 112–15, 118, 131, 147–50, 152.
Anthony of Padua, St., 42
Antonello da Messina, 92, 112–15.
Antonino, St., Archbishop of Florence, 23, 43, 81, 147.
Aristotle, 78.

Baldovinetti, Alesso, 53.
Bardi, Giovanni de', 2, 16–17.
Barletta, Fra Gabriele, 57
Bartolo da Sassoferrato, 32, 84–5.
Belcari, Feo, 153
Bellini, Gentile, 112–15, 137.
Bellini, Giovanni, 47–8, 90, 112–15.
Benizi, Carlo, 8.
Bernard, St., 43.
Bernardino of Siena, St., 61–2.
Bernardo di Francesco, 6.
Bisticci, Vespasiano da, 14, 138.
Boccaccio, 33, 148.
Boniface VIII, Pope, 42.
Botticelli, 16–17, 26–7, 55–6, 68–70, 78–81, 110, 112–15, 152.
Brasca, Santo, 30.
Brunelleschi, Filippo, 124–5, 126, 141–3.

Calandri, Filippo, 89, 97, 106–7.
Calzetta, Pietro, 8.
Cannuzio, Pietro, 101–2.
Cantansanti, Francesco, 3.
Caracciolo, Fra Roberto, 48–55, 68, 108.
Caraffa, Cardinal Oliviero, 8.
Carpaccio, Vittore, 65.

Castagno, Andrea del, 2, 112–15, 118, 121, 131, 139–47, 148.
Cavalli, Gian Marco, 12.
Cennini, Cennino, 121, 139.
Checha, Antonio della, 19–20.
Cicero, 122.

Dante, 86, 111, 118, 123, 124, 139.
Desiderio da Settignano, 129, 131, 148.
Dini, Onofrio, 94–5.
Dolce, Lodovico, 141, 145.
Domenico da Piacenza, 77–8.
Domenico Veneziano, 2, 35, 112–15.
Dominici, Fra Giovanni, 147.
Donatello, 5, 136–7, 145.
Dotti, Antonfrancesco de', 8.

Erasmus, 48.
d'Este, Borso, Duke of Ferrara, 1–2.
d'Este, Leonello, Marquis of Ferrara, 81, 109.
Euclid, 31.

Fazio, Bartolomeo, 58.
Federigo da Montefeltro, *see* Montefeltro.
Fibonacci, Leonardo, 94–5.
Filarete, Antonio Averlino *called*, 85.
Filelfo, Giammario, 137.
Florio, John, 147–8.
Francesca, Piero della, *see* Piero.
Francesco da Buti, 139.

Gafurio, Franchino, 100–101.
Galli, Angelo, 77–8, 140.
Gentile da Fabriano, 43, 112–15, 143.
Ghiberti, Lorenzo, 25.
Ghirlandaio, Domenico, 6–7, 11, 17–18, 26–7, 110, 112–15, 133.
Giotto, 111, ·118, 134–5, 139, 145–7.
Girolamo di Manfredi, 148.
Gonzaga, Federico, Marquis of Mantua, 12.
Gonzaga, Cardinal Francesco, 12–13.

181

Gonzaga, Lodovico, Marquis of Mantua, 12–13, 68, 109.
Gozzoli, Benozzo, 19–20.
Gregory the Great, St., 41.
Guglielmo Ebreo, 60, 77–8.

Jacobus de Cessolis, 67.
Jacomo da Poli, 20.
Jan van Eyck, 112–15.
John of Genoa, 41.

Landino, Cristoforo, 110, 115–51.
Lancilotti, Francesco, 110.
Leonardo da Vinci, 33, 39, 55–6, 58, 60–61, 97–101, 112–15, 119–21, 126–7, 130, 133, 145.
Lippi, Filippino, 8, 20–3, 26–7, 110, 112–15.
Lippi, Filippo, 2, 3–5, 51, 74, 112–15, 118, 121, 128–39, 145, 147.

Maffei, Celso, 104.
Manetti, Antonio, 124–5, 128, 141–3.
Mantegna, Andrea, 12–14, 58, 68, 109, 112, 115.
Mariano da Genazzano, Fra, 65.
Martelli, Bartolomeo, 3–4.
Masaccio, 11, 47, 61, 91–2, 112–15, 118–28, 131, 132, 141, 143, 149.
Matteo di Giovanni, 44.
Mayron, Francis, 51.
Medici, Cosimo di Giovanni de' (il Vecchio), 48.
Medici, Giovanni di Cosimo de', 3–4.
Medici, Lorenzo di Pierfrancesco de', 78.
Medici, Lorenzo di Piero de' (il Magnifico), 26, 78–80, 89, 109, 141.
Melozzo da Forlì, 111, 112–15.
Michelangelo, 141.
Michele da Carcano, Fra, 41.
Montefeltro, Federigo da, Duke of Urbino, 109, 112, 138.

Neri di Bicci, 8.
Niccolò da Tolentino, 89–91, 139.
Nicholas V., Pope, 19.
Nicholas of Lyra, 51.

Pacioli, Luca, 94–5.
Palmieri, Matteo, 71, 94.

Perugino, Pietro Vannucci *called*, 26–7, 46–7, 66–7, 110, 112–15.
Pesellino, Francesco, 112–15.
Peter of Limoges, 104–5.
Petrarch, 16.
Philippe le Bon, Duke of Burgundy, 15
Piero della Francesca, 20, 32–6, 75–6, 86–7, 95, 102, 104–5, 108, 112–15, 138, 141, 152.
Piero di Cosimo, 73.
Pietro di Luca, 20.
Pinturicchio, Bernardino, 17, 59, 68–70.
Pisanello, 38, 77–9, 92–3, 112–15, 140.
Pliny the Elder, 25, 115, 117.
Pliny the Younger, 122.
Polentone, Sicco, 42.
Poliziano, Angelo, 65, 128.
Pollaiuolo, Antonio, 2, 112–15.
Pollaiuolo, Piero, 112–15.
Pythagoras, 101.

Quintilian, 122, 131, 132.

Raphael, 101, 111, 141.
Rimbertinus, Bartholomew, 103–4.
Roberti, Ercole de', 112–15.
Rogier van der Weyden, 112–15.
Rucellai, Giovanni, 2–3, 109.

Salutati, Coluccio, 42.
Salviati, Giuliano, 94.
Santi, Giovanni, 111–15.
Sassetta, Stefano di Giovanni *called*, 10–11.
Sforza, Gian Galeazzo, Duke of Milan, 12, 25–6.
Signorelli, Luca, 22–3, 112–15.
Sixtus IV., Pope, 26.
Squarcione, Francesco, 127.
Starnina, Gherardo, 11, 82.
Strozzi, Palla, 43.

Tesori, Francesco di Giovanni, 6.
Thomas Aquinas, St., 149.
Tornabuoni, Giovanni, 17–18.
Tura, Cosimo, 112–15.

Uccello, Paolo, 2, 89–91, 112–15, 126, 143.

Valla, Lorenzo, 84–5.

182

Vasari, Giorgio, 124, 145.
Veneziano, Domenico, *see* Domenico.
Vergerio, Pier Paolo, 34.
Verrocchio, Andrea del, 2.

Vespasiano da Bisticci, *see* Bisticci.
Villani, Filippo, 118.

Waleys, Thomas, 64.